I am
irene andessner

Retrospektive der Werkgruppen 1995 – 2003 / Retrospective of the Works 1995 – 2003

 I am
irene andessner – Herausgeber/Editor: **Stadthaus Ulm, Raimund Kast**

Hatje Cantz

Peter Sloterdijk

Sphären – Mikrosphärologie, Band I,

Suhrkamp Verlag, 1998

Seite 194 ff

Wo Francis Bacons schreiender Papst noch ein Gesicht in Explosion zeigt, erreichen Andy Warhols Selbstportraits den Zustand der Selbstlosigkeit im Selbstverkauf. Beide Werke haben noch einen Ort am Rand der expressiven Kunst, da nicht nur die Zerfleischung, sondern auch die Erstarrung des Gesichts dem Prinzip Ausdruck untersteht. Von diesem lösen sich neuere Verfahren der fazialen Ästhetik in der bildenden Kunst entschieden ab. Cindy Shermans Montage Untitled, #314c hat das Gesicht aufgelöst in eine faltige Landschaft von bösen und eigensinnigen Gewebeteilen, mit einem Mund, dessen Labien ein obszönes Aufklappen zeigen. Hier ist von dem, was Benjamin den Sex-Appeal des Anorganischen genannt hat, nichts mehr zu spüren; das Fleisch ist zu einer Kunststoffkopie seiner selbst geworden. Es dürfte in der zeitgenössischen Kunst wenige Werke geben, die mit ähnlicher Gewalt die Wandlung des Portraits ins Détrait bezeugen.

Ironisch gebrochene Züge zum Détrait enthüllt auch die Serie von Quasi-Selbstportraits der Malerin Irene Andessner, die der Gesichtserwartung des Betrachters ausweicht, indem sie weder Gesicht noch Maske zeigt. Was sie zu sehen gibt, bildet eine Folge von Vor-Gesichtern oder Gesichts-Vorstufen im ernsten Ton – faziale Rohstoffe, Zutaten der Schönheit, die gleichsam auf die Wiedererhebung in den Rang des vollen Frauenantlitzes warten. Durch starre Augen blickt eine Forschungsenergie hindurch, die dieses Frauengesicht wie ein wechselhaftes Medium durchdringt. Das siebenfach variierte Gesicht ist durchschienen von einer immergleichen gefaßten Grausamkeit, die, von weit her kommend, nicht ganz seine eigene werden kann. Es hält die Balance zwischen einer schrecklichen Wahrheit, die beinahe schon entstellt, und einem Überlebenswillen, der fast schon die schöne Maske erzeugt. Am Schwebepunkt zwischen Portrait, Abstrait und Détrait illustriert Irene Andessners Gesichter-Serie eine postmoderne Alternative zur modernen Gesichtsentstellung; gemalt mit einem Humor ohne Lachen und einer Verzweiflung ohne Tränen, bekundet sie das Warten des immer noch menschlichen Gesichts auf sein entzogenes adäquates Gegenüber; dies ist ein Warten, das die Menschengestaltigkeit zugleich postuliert und bezweifelt; zugleich verrät sich in der Gesichter-Serie, fast wider Willen, das ungläubige Zögern vor der Bitte um die genugtuende Rücksicht des anderen. Wie man die postmoderne Ornamentik als Zeitvertreib beim Warten auf das unverfügbar Schöne ansehen könnte, so läßt sich Irene Andessners malerische Vorbereitung für die Schönheit lesen als Zeichen des Wartens auf den Augenblick des wahren Gesichts.

Peter Sloterdijk

Spheres – Microspherology, Vol I,

Suhrkamp Verlag, 1998

Pages 194 ff

Where Francis Bacon's screaming pope still shows a face in explosion, Andy Warhol's self-portraits reach the state of selflessness in self-selling. Both works still have a place on the fringes of expressive art, which subordinates to the expressive principle not only the tearing apart but also the solidifying of the face. More recent methods of the facial aesthetic in the visual arts diverge decisively from them. Cindy Sherman's montage Untitled, #314c dissolved the face into a crumpled landscape of nasty and stubborn tissue fragments, with a mouth whose lips show an obscene opening. Here there is no more a sense of what Benjamin identified as the sex appeal of the inorganic; the flesh has become a synthetic copy of itself. There may be few works in contemporary art which testify with similar power to the conversion of the portrait into détrait.

The series of quasi-self-portraits by the painter Irene Andessner also reveal ironically broken tuggings towards distraction; the portraits evade the viewer's expectations of a face, showing neither face nor mask. What they offer to the viewer shows, in sombre tones, a succession of pre-faces or preliminary stages of faces – facial raw materials, ingredients of beauty, which as it were wait for re-installation into position in the complete female countenance. An enquiring energy looks through unblinking eyes, coming through this woman's face like a capricious medium. The face, in its sevenfold variations, is suffused with a constantly grasped cruelty which, coming from afar, cannot quite become itself. It holds the balance between a dreadful truth which almost exists already, and a will to survive which almost creates the beautiful mask already. Hovering between portrait, abstrait and détrait, Irene Andessner's Face Series illustrates a postmodern alternative to modern distortions of the face; painting with humour without laughter and despair without tears, she expresses the waiting of the still-human face for its elusive, adequate opposite; this is a waiting that the human urge towards form simultaneously postulates and doubts; simultaneously betrays itself in the Face Series, almost against its will; the unbelievable hesitation before the request for that consideration of the other which will suffice. Just as one could look at postmodern ornament as a way of passing the time while waiting for unavailable beauty, so Irene Andessner's artistic preparation for beauty can be read as a symbol of the waiting for the moment of the true face.

Im Angesicht der Ewigkeit ...

Die Rollen-Bilder der Irene Andessner 1995 bis 2003

von Michaela Knapp

„Porträts funktionieren nur über Blicke", sagt Irene Andessner. Seit über zehn Jahren beschäftigt sich die gebürtige Salzburgerin, die bei Max Weiler und Arnulf Rainer an der Akademie der Bildenden Künste in Wien und in Venedig studiert hat, mit dem Körper. Und mit der Porträt-Ästhetik der Zukunft. Mit stringenter Intensität recherchiert sie das Thema Selbstporträt und das „Gefühl des Gesichts". Initialzündung war eine Ausstellung der Renaissancemalerin Sofonisba Anguissola im Kunsthistorischen Museum Wien: „Als ich ihre Selbstporträts sah, entdeckte ich diesen Blick. Einen Blick, der über Jahrhunderte gehalten hat. Ein Blick, der immer noch zu berühren vermag. Weshalb hat der Blick aus dem Selbstbildnis dieser Frau heute noch so eine Kraft?"

Vorbilder

Bei ihren „Experimenten mit Licht und Haltung" war sich Andessner selbst das geduldigste Modell. Doch der Versuch, im gemalten Ölbild den besonderen Blick zu konservieren, scheiterte. „Ich habe festgestellt, das funktioniert für mich nicht mehr." So kreierte sie ihr erstes größeres Projekt „Vorbilder": Andessner-Porträts nach Selbstporträts berühmter Malerinnen, für die die Künstlerin Pinsel und Farbe gegen Fotoapparat und Videokamera tauschte. Eine Selbstinszenierung mit Rollenspiel anstelle des eigenen Konterfeis. Höchst aufwändig stellte Andessner Frida Kahlo oder Angelica Kauffmann nach, switchte zwischen dem eigenen Ich und dem fremden – und archivierte diesen Dialog zwischen Wandlung und Verwandlung via Videokamera. Parallel dazu entstanden Fotos und Leuchtkästen.

Lebende Bilder

Bei ihrer Identitätssuche im „Selbstbildnis" bewegt sich Irene Andessner in der Dualität einer „Selbstdarstellerin" fremder Rollen auf dem Terrain der Tableaux vivants, lebender Bilder, die in der Kunstgeschichte seit der Antike Tradition haben: Die Attitüden-Kunst von Readymade-Erfinder Marcel Duchamp diente in den 20er Jahren vor allem dazu, die bürgerliche Vorstellung von Meisterwerken zu attackieren; in den 60er Jahren ging es vorrangig darum, mittels Körperinszenierungen den Konflikt von Kunst und Alltag zu demonstrieren. Seit den 80er Jahren hat sich das Genre der lebenden Bilder im Zuge der Postmoderne in allen Bereichen weiterentwickelt – Andessner hat die Posen-Performance einer Vanessa Beecroft und die fotografischen Montagen einer Cindy Sherman um das zeitgemäße historische Gemälde und die performte Lebensgeschichte erweitert.

Nie geht es dabei um erstarrte, geschönte Posen oder das bloße dekorative Element. Andessner spielt mit der dem Selbstporträt immanenten Manipulation – der Spannung zwischen der „objektiven" Darstellung und der zwangsläufigen Interpretation des menschlichen Antlitzes. 1998 etwa thematisiert die Künstlerin, inspiriert vom „Kunstmenschen" Rachel aus Ridley Scotts Science-Fiction-Klassiker „Blade Runner" Identität, Manipulation und Replikation.

In the Face of Eternity...

The Role Pictures of Irene Andessner 1995 to 2003

by Michaela Knapp

"Portraits only function through looks," says Irene Andessner. Born in Salzburg and a student of Max Weiler and Arnulf Rainer at the Akademie der Bildenden Künste in Vienna and in Venice, she has for more than 10 years concerned herself with the body and with the portrait aesthetic of the future. With compelling intensity she has investigated the subject of the self-portrait and the "feeling of the face." The inspiration was an exhibition of the Renaissance painter Sofonisba Anguissola at the Kunsthistorisches Museum in Vienna: "As I saw her self-portraits I discovered this look. A look which had held good for centuries. A look which was still capable of moving us. Why did the look from the self-portrayal of this woman still have such a power today?"

Models

With her "Experimente mit Licht und Haltung" [experiments in light and posture] Andessner was herself the extremely patient model. But the attempt to preserve the special look in painted oil pictures failed. "I have discovered that for me, that does not work any more." So she created her first large project "Vorbilder" [models]: Andessner portraits after self-portraits of famous woman painters, for which the artist exchanged brush and paint for photo camera and video camera. A self-staging with role-play instead of her own picture. Andessner made extremely lavish reconstructions of Frida Kahlo or Angelica Kauffmann, switched between her own "I" and that of the other – and archived this dialogue between reformation and transformation using a video camera. Parallel to this she created photos and light boxes.

Living Pictures

Through her search for identity in the "portrait of the self" Irene Andessner has moved in the duality of a "self actress" playing unfamiliar roles on the territory of tableaux vivants, living pictures, which have a tradition in art history going back to antiquity. The gestural art of Readymade inventor Marcel Duchamp served in the 20th century to attack above all the bourgeois idea of the masterpiece; in the 60s the priority was to demonstrate, by means of body stagings, the conflict of art and the everyday. Since the 80s the genre of the living picture has further developed in the course of the post-modern in all areas – Andessner has extended the pose performance of a Vanessa Beecroft and the photographic montages of a Cindy Sherman into modern historical paintings and performed life histories.

In this respect her work is never about rigid, embellished poses or the purely decorative element. Andessner plays with the manipulation immanent in the self-portrait – the tension between "objective" portrayal and inevitable interpretation of the human face. In 1998 for instance, inspired by "artificial human" Rachel from Ridley Scott's science-fiction classic "Blade Runner," the artist focused on identity, manipulation and replication. Andessner's face, a portrait cloned by a computer, is released in a cold ambience by the Copy and Reset commands of a computer technologised world,

Als vom Computer geklontes Bildnis ist Andessners Gesicht in kaltem Ambiente den Copy- und Reset-Befehlen einer computertechnologisierten Welt freigegeben, die jede falsche Bewegung als Error im System registriert und: bestraft. Ungeschminkt und nackt präsentierte sich die Künstlerin dann wiederum in ihrer Werkgruppe „Wasserfest": Selbstporträts unter Wasser. Für Künstler wie Betrachter verschwimmen die Konturen. Geläutert, geborgen und wie aus Flüssigkeit (neu) geboren präsentiert sich Andessner hier in einer überdimensionalen – übermenschlichen – Leuchtkasten-Installation.

Salzburger Bilder

„Ich bin bildende Künstlerin, die mit unterschiedlichen Mitteln in verschiedenen Medien arbeitet. Der Anlass bestimmt die Wahl meiner Mittel". Wie etwa bei dem viel diskutierten Performanceprojekt „Frauen zu Salzburg" für die Salzburger Festspiele 1999: Andessner in den Rollen fünf historischer Frauen, die – verwitwet, geschieden oder verlassen – einen Mann suchen. Was wäre, würden sich Mozarts Witwe Constanze oder Caroline Auguste heute verheiraten wollen, war die Ausgangsfrage. Wie würde das vonstatten gehen? Andessners Antwort: Videos in einer Partnervermittlungsagentur, SMS oder kurze Inserate im Internet.

Andessner recherchierte das Wesen der Protagonistinnen. Bis sie den Punkt fand, der „das Historische nachvollziehen lässt". Sie verinnerlichte die Frauengestalten, ging vor die Kamera und präsentierte in ihren Bildern eine Mischung aus vergangener Gegenwart und gegenwärtiger Vergangenheit.

Kontrollierte Bilder

Schauspiel? Wohl kalkulierte Posen? „Mit Schauspielen hat das nichts zu tun, ich erarbeite mit einem Coach einen ganz bestimmten Gefühlsmoment und versuche, den zum Bild gerinnen zu lassen: Auf diesen Moment richte ich alles aus". In diesem Moment verwandelt sich Andessners Gesicht, geht auf im anderen. Vergegenwärtigung, so die wissenschaftliche Auslegung, ist kein einfacher Vorgang, sondern das komplizierteste, was das menschliche Gehirn zustande bringt.

Andessner geht bei jeder ihrer Performances nur bis zu einem gewissen Punkt. Sie will – muss – alles gerade noch unter Kontrolle behalten. „Sonst", so die Künstlerin „wäre es mir zu psychotherapeutisch, ich arbeite mit meinen Aktionen ja nichts auf. Ich bin auch keine Verwandlungsartistin oder Gefühlsarchäologin. Ich würde mich schlicht als Frau bezeichnen, die Recherchen macht. Denn die Hauptarbeit ist die Recherche, aus der ich ein Projekt inhaltlich und bildnerisch entwickle. Es ist mir wichtig, die adäquate Umsetzung für eine Idee zu finden."

„Intensiv" ist für die Nach-Stellende nur, „was innerlich, emotional authentisch ist". Dafür setzt sie sich mit aller Kraft ein, treibt sich und ihren beträchtlichen Mitarbeiterstab – Regisseure, Architekten, Fotografen, Komponisten, Stylisten, Visagisten und Frisöre oft an die Grenze des Machbaren – für die „Archivierung eines Augenblicks".

which registers each false move as System Error, and then punishes it. Without make-up and naked, the artist then presents herself in the "Wasserfest" [water festival] group of works: self-portraits under water. The shapes become blurred for both artist and viewer. Reformed, made safe and as if (new) born from liquidity, Andessner here presents herself in an super-dimensional – super-human – light box installation.

Salzburg Pictures

"I am a visual artist who works with different means in various media. The purpose determines my choice of method." As for instance in the much discussed performance project "Frauen zu Salzburg" [Women of Salzburg] for the 1999 Salzburg Festival: Andessner in the roles of five historical women who – widowed, divorced or deserted – are looking for a husband. The starting point was how it would be if Mozart's widow Constanze or Caroline Auguste wanted to get married today. What is the procedure for that? Andessner's answer: videos in a dating agency, SMS or short ads on the Internet.

Andessner looked into the nature of the protagonists. Until she found the point where "the historical could be apprehended." She internalised the women's forms, went in front of the camera and presented in her pictures a mixture of former present and current past.

Controlled Pictures

Acting? Well-calculated poses? "It doesn't have anything to do with acting; I work out with a coach a completely determined moment of feeling and try to have it develop into a picture: in this moment I am arranging everything." In this moment Andessner's face changes, goes into the other. Visualising is, according to the academic interpretation, no simple process, but rather the most complicated activity that the human brain manages.

At each of her performances Andessner only goes to a certain point. She wants to – has to – keep everything absolutely under control. "Otherwise," says the artist "it would be too psychotherapeutic for me; I do not really work things through with my actions. Nor am I a transformation artist or archaeologist of the feelings. I would simply describe myself as a woman who makes enquiries. Because the main work is the enquiry, from which I develop a project in terms of its content and pictorially. It is important for me to find the fitting realization for an idea."

"Intense," for the one who follows on, is only "what is inwardly and emotionally authentic." This is what she sets everything in motion for – herself and her considerable staff of directors, architects, photographers, composers, stylists, make-up artists and hair stylists, often working at the boundaries of the possible for the archiving of a moment.

Lichtbilder

Um auch scheinbar „unbedeutende" Schicksale ins rechte Licht zu rücken, schreckt Irene Andessner auch nicht davor zurück, in den eiskalten Traunsee vor Schloss Orth zu springen, wo sie für die Gmundener Festspiele die Geschichte der Ludmilla Hildegard, „Milli" Stubel, recherchierte: Die Hofopern-Balletttänzerin, als Geliebte und (bürgerliche) Gattin Erzherzog Johanns eine Randfigur der Geschichte, wird bei Andessner zur kraftvollen Lichtgestalt. Ihre tragisch endende Liebesgeschichte mutiert zu einer Kulturgeschichte des Lichts. Als Höhepunkt der mehrteiligen Performance verhilft die Künstlerin Milli zu einem letzten großen Auftritt und tanzt in der Winterreithalle des Wiener Museumsquartiers in einem Glühbirnenkostüm, zu jener Musik, zu der einst auch Milli in der Hofoper über die Bühne schwebte: das von Erzherzog Johann unter Pseudonym verfasste Ballett „Die Assassinen".

Ein stimmiger Werkkomplex, der dem Betrachter einiges Vorwissen abverlangt. „Es ist mir egal, ob man die Zusammenhänge sofort versteht, ob man sich eingelesen hat oder meine Arbeit ohne historischen Hintergrund betrachtet", relativiert die Künstlerin. „Es ist mir wichtig, dass die Menschen beim Betrachten meiner Bilder etwas fühlen, über das Wissen um die Konzeption hinaus."

„Medial topfit", nennt die Kunstkritik Andessners zeitgemäße Einstellung zum Porträt, die Malerei, Video und Fotografie einschließt, und stellt die Künstlerin in eine Reihe mit Tracy Moffatt oder Pipilotti Rist. Wiewohl Andessners Arbeit längst weit über die Oberfläche hinausgeht und in den Performances nicht bloß Rollen, sondern Gedanken Gestalt annehmen.

Medienbilder

Für ihr letztes Projekt – über Marlene Dietrich – ging Andessners Rollenidentifikation bis zur Eheschließung. „Über den Mythos Dietrich zu arbeiten, hat mich besonders gereizt. Mich mit einer Frau zu beschäftigen, deren politische Einstellung ich sehr bewundert habe, wie auch das Konzept, sich selbst zu schaffen und sich ab einem bestimmten Augenblick aus der Öffentlichkeit zurückzuziehen. Das hat sehr viel mit meiner Arbeit zu tun. Weil auch ich mich immer einem bestimmten Konzept unterstelle. Und dann den Blick von außen auf mich habe. Ich spreche manchmal sogar, wenn ich meine Fotos sehe, in der dritten Person von mir. Ich habe aber nicht die Dietrich nachinszeniert, sondern mich in die Vorstellung hineinversetzt, eine Frau zu sein, die so aussehen möchte wie Marlene Dietrich und am Ende glaubt, die Dietrich zu sein."

Andessner kleidete sich tagtäglich so wie die Dietrich, ließ sich deren Hosenanzüge nach Originalschnitten nähen, trug Herrenschuhe, rasierte sich die Augenbrauen, sang in Berliner Travestiebars „Lilli Marlen" und ließ diese zunehmende Veränderung an sich lückenlos festhalten: Zehn Fotografen und sechs Kameraleute waren für eine spielfilmartige Dokumentation rund um die Uhr im Einsatz, zeigten den Zusammenhang zwischen Physis und Psyche, zwischen Antlitz und psychischem Befinden.

Da die pedantische Dokumentaristin die entstandenen Fotos auch authentisch mit „Dietrich" signieren wollte, wurden zudem Männer mit diesem Nachnamen gecastet, die bereit waren zu einer „Ehe für die Kunst". „Den Geeignetsten habe ich dann genommen und in Charlottenburg geheiratet." Die Scheidung erfolgte nach Vollendung der das Projekt abschließenden Videoarbeit.

Light Pictures

To move even apparently "insignificant" destinies into their proper light, Irene Andessner does not shrink from jumping into the icy Traunsee in front of Schloss Orth, where she was investigating the history of Ludmilla Hildegard "Milli" Stubel for the Gmundener Festival: the ballet dancer at the court opera, a minor historical figure as lover and (commoner) wife of Archduke Johann, becomes through Andessner a powerful light form. Her tragically ended life story mutated into a cultural story of light. At the high point of the performance, which was in several parts, the artist helps Milli to make a final great entrance and dances in the Winterreithalle of the Vienna Museumsquartier in a lightbulb costume, accompanied by the same music to which Milli herself once floated over the stage in the court opera: music from Archduke Johann's pseudonymously written ballet "Die Assassinen" [The assassins].

A consistent complex of works which demands from the viewer some prior knowledge. "It is all the same to me whether one immediately understands the connections, or whether one has familiarized oneself with them, or looks at my work without historical background," qualifies the artist. "The most important thing for me is that people looking at my pictures feel something, above knowledge of the concept."

"Media work at its best" is what the art critics called Andessner's modern take on the portrait, which includes painting, video and photography, and places the artist in a line with Tracy Moffatt or Pipilotti Rist. At the same time, Andessner's work has for a long time gone beyond the surface, and in the performances it is not simply roles that take form, but thoughts.

Media Pictures

For her last project – about Marlene Dietrich – Andessner's role identification went as far as the marriage ceremony. "To work on the Dietrich myth was especially appealing to me. Involving myself with a woman whose political attitude I had very much admired, as well as the concept of creating her and at a certain point withdrawing from the public – that has a great deal to do with my work. Because I am also always subordinating myself to a definite concept. And then I have the view on myself from outside. When I see my photos I sometimes even speak of myself in the third person. I have not re-staged Dietrich, but rather myself put myself in the position, in the presentation, of being a woman who wants to look like Marlene Dietrich and in the end believes herself to be Dietrich."

Andessner dressed every day like Dietrich, had her trouser suit sewn after the original cut, wore men's shoes, shaved her eyebrows, sang "Lili Marlene" in Berlin transvestite bars and let this growing change completely take hold of her: ten photographers and six cameramen were in action for a feature film-like documentation round the clock, showing the connection between physis and psyche, between face and psychic condition.

Because the pedantic documentalist wanted to sign the resulting photos authentically with "Dietrich," men with this surname were cast who were ready to be a "husband for art." "I then took the most suitable man and got married in Charlottenburg." The divorce took place after completion of the video documentation which concluded the project.

Leitbilder

Die Dietrich – die Frau, die mit allen Regeln gebrochen hat – lieferte auch den nahtlosen Übergang zu jenem Projekt, das Irene Andessner für Graz 2003 vorbereitet hat: „Wanda Sacher-Masoch". Mit der radikalen Performance-Reihe archivierte die Künstlerin Augen-Blicke der Urmutter aller Dominas für die Ewigkeit. Auch dieser aufwändigen mehrteiligen Arbeit ging exakt strukturierte Organisation voran.

Noch im Outfit der Dietrich ließ sich Andessner in einer Wiener Bar – auf das masochistische Verhältnis der Dietrich und ihres Leib-Regisseurs Sternberg anspielend – von 50 Männern die Krawatte binden: Ein kurzer Weg zu Bondage und Leopold von Sacher-Masoch, dessen Roman „Venus im Pelz" zu einem Klassiker der Sexual-Literatur zählt. Vorbild für Wanda, die Schlüsselfigur des in Graz geschriebenen Klassikers, war Masochs erste Ehefrau Angelica Aurora Rümelin. Sie hat für Sacher-Masoch jene starken Frauenfiguren dargestellt, die er sich in seiner Fantasie wünschte, von der Venus im Zobel bis zu Katharina der Großen mit ihrer Hundepeitsche. Aus der Lebensbeichte von Masochs Ehefrau und der Figur der Wanda schuf sich Andessner ein Regiebuch und gestaltete in einjähriger Vorbereitungszeit jede einzelne Rolle minutiös genau zum lebenden Bild einer Performance-Reihe.

Leidbilder

Bei der ersten Inszenierung in einem Brautmodengeschäft am Gürtel, das nach Wandas Interieurbeschreibungen ausgestattet wurde, empfing Andessner über 20, überwiegend männliche Laiendarsteller zu Demütigungsritualen: „Ich habe sie auf Knien Gedichte aufsagen lassen, sie verhöhnt, ausgepeitscht, davongejagt. Sechs Stunden lang im Hochsommer, im Pelz."

Als Katharina die Große thronte Andessner dann in einem riesigen Bett auf einem Eislaufplatz. Sie lässt eine angeheuerte Eishockey-Mannschaft in Unterwäsche zu absurden Befehlen antreten, so wie die grausame Zarin einst ihre Soldaten vorführen ließ und bei der Exekutierung beobachtete.

Im Kunsthistorischen Museum stellt Andessner vor Tizians Gemälde „Mädchen im Pelz" die Sacher-Masoch-Ikone nach. Konsequent dem literarischen Vorbild folgend, wurde zuvor ein Vertrag mit einem Maler abgeschlossen, in dem sich dieser verpflichtete, auf Veranlassung seiner „Herrin" im Verlies im Glockenturm des Grazer Schlossberges (in der Folge abgelöst von anderen Künstlern) wochenlang Fetischzeichnungen von ihr herzustellen. Die Aktion wurde über 64 Monitore live in die Andessner-Ausstellung im „Dom im Berg" übertragen.

Innere Bilder

„Ich weiß, wie meine Arbeit am Ende aussehen soll, da ist nichts dem Zufall überlassen," unterstreicht Perfektionistin Andessner. Daher wurde beim Projekt „Wanda SM" noch eine Psychotherapeutin hinzugezogen, um das authentische Spiel zwischen absoluter Liebenswürdigkeit und unverhoffter Grausamkeit nicht aus der Bahn laufen zu lassen. Dazu lässt Andessner Musik produzieren, die „beim Zuschauen die Intensität des Sehens erhöht" und „die Innerlichkeit der Bilder unterstreicht".

Ideal Model Pictures

Dietrich – the woman who broke with all the rules – also supplied the smooth transition to the project which Irene Andessner had prepared for Graz 2003: "Wanda Sacher-Masoch." With the radical performance series the artist archived for eternity "look moments" of the mother of all dominas. This extravagant work in several parts also went ahead with precisely structured organisation.

Still in her Dietrich outfit Andessner – alluding to the masochistic relationship of Dietrich and her love-director Sternberg – let fifty men tie her tie in a Viennese bar: a short cut to bondage and Leopold von Sacher-Masoch, whose novel "Venus im Pelz" [Venus in furs] counts as one of the classics of sexual literature. Masoch's first wife, Angelica Aurora Rümelin, was the model for Wanda, the key figure of the classic which was written in Graz. She represented for Sacher-Masoch that powerful woman's figure which he wanted in his fantasy, from Venus in sable to Catherine the Great with her dog whip.

From the "Confessions" of Masoch's wife and the figure of Wanda, Andessner created a directing script and during a year of preparation shaped each individual role with meticulous exactness into the living picture of a series of performances.

Ordeal Pictures

At the first staging in a Graz wedding dress shop which was fitted out according to Wanda's interior descriptions, Andessner welcomed over twenty amateur actors, most of whom were male, to humiliation rituals: "I had them recite poetry on their knees, ridiculed and whipped them and chased them away. Six hours long in high summer, in furs."

As Catherine the Great, Andessner then sat enthroned in a giant bed on an ice rink. She signed up an ice-hockey team and had them line up in their underwear to her absurd commands, just as the cruel czarina once had her soldiers brought forward before watching their execution.

Andessner reproduces the Sacher-Masoch icon in front of Titian's painting "Girl in Furs" in the Kunsthistorisches Museum. Consistently following the literary model, a contract with a painter was concluded beforehand in which he (subsequently replaced by other artists) undertook to create fetish drawings of her for weeks at the instigation of his "mistress" in the dungeon of the bell-tower of the Graz Schlossberg. The action was transmitted live by 64 monitors to the Andessner exhibition in the "Dom im Berg."

Inner Pictures

"I know how my work should look in the end, because nothing is left to chance," emphasises the perfectionist Andessner. That is why for the "Wanda SM" project a psychotherapist joined the team, to make sure the authentic game between absolute kindness and unexpected cruelty was not derailed. Franz Pomassl created the music for the masochistic role-play art, as already so often in Andessner projects. Even in this nothing was left to chance. Andessner had music produced which "heightens the intensity of the seeing for the viewers" and "emphasises the inwardness of the pictures."

Geschlechterbilder

Mit dem Projekt „Donne Illustri" hat Irene Andessner für einen „Bruch" im Blick auf sie gesorgt, in dem sie – nach jahrelanger Arbeit mit verschiedenen Fotografen – den Auslöser selbst in die Hand nahm und den Moment der Ablichtung selbst bestimmte. Eine adäquate Methode, um Frauen ins Bild zu setzen, die selbstbewusst und selbstständig lebten, die ihre Interessen und Projekte in Eigenregie – unabhängig von Männern und mit überliefertem Erfolg – verfolgten.

Für das Kunstprogramm des Caffè Florian in Venedig schlüpfte Andessner in die Rollen von zehn Venezianerinnen aus acht Jahrhunderten, die den „Saal der berühmten Männer" (Sala degli Uomini Illustri) in einen „Saal der berühmten Frauen" (Sala delle Donne Illustri) verwandeln sollten. Die Reihe der vor-bild-haften Frauen geht von der ersten Doktorin Elena L.C. Piscopia bis zur ersten Frauenrechtlerin Moderata Fonte. Von Andessner in die Gegenwart transponiert, zeigen sie sich jeweils in der Haltung ihrer männlichen Pendants, vor deren Porträts sie platziert wurden. Ein in mehrfacher Hinsicht ver-rücktes Projekt, für dessen Umsetzung trashige Styling-Utensilien wie Baumaterialien, Plastiktüten und Wandlampen zum Einsatz kamen, mit denen Andessner die historischen Kostüme und Dekorationen illusionierte.

Fremdbilder

Irene Andessner, die hinter den vielen angeeigneten Gesichtern das Private gerne zurückhält und auch im privaten Leben wie eine Kunstfigur anmutet, ist eine präzise Performerin, die ihre Arbeit mit zahlreichen entschlüsselbaren Codes versieht. Mit der Ambivalenz des modernen Blicks spielt sie dabei mindestens so raffiniert wie mit dem Wissen, dass ein Bild immer im Auge des Betrachters entsteht. An ihm liegt es, aus dem großen Angebot der Aspekte den Sinn für sich zu finden.

Gender Pictures

With the "Donne Illustri" project Irene Andessner has provided a "dislocation" in the view of these women, taking – after a year's work with various photographers – the shutter release in her own hand and deciding the moment of the photograph herself. A suitable method for putting in the picture women who lived self-confidently and self-directedly, who followed their interests and projects under their own guidance – independent of men and with a success which has come down to us.

For the art programme of the Caffè Florian in Venice Andessner has slipped into the roles of ten Venetian women from eight centuries, intending that they should transform the "Salon of Famous Men" (Sala degli Uomini Illustri) into a "Salon of Famous Women" (Sala delle Donne Illustri). The series of "ideal model" women ranges from the first woman doctor, Elena L. C. Piscopia, to the first feminist, Moderata Fonte. Transposed by Andessner into the present, they appear in the stance of their masculine opposite numbers, in front of whose portraits they are placed. A crazy project in many respects; to carry it through, trashy styling utensils such as building materials, plastic bags and wall lamps were used by Andessner to create the illusion of the historical costumes and decorations.

Unfamiliar Pictures

Irene Andessner, who likes to reserve the private behind the many faces she takes on, while appearing in private life like a fictional character, is a precise performer who provides her work with numerous decipherable codes. She plays with the ambivalence of the modern look at least as sophisticatedly as she does with the knowledge that a picture always emerges from the eye of the beholder. It is up to him or her to find the sense for themselves from the great range of aspects.

Wasserfest, 1999 – 2002

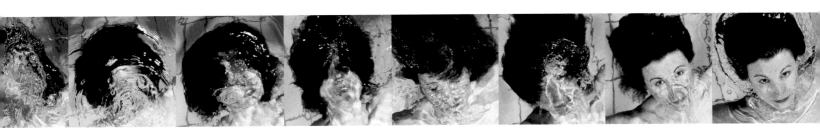

Wasserfest, Portrait 1-8, C-Print, 30 x 240 cm, 2000

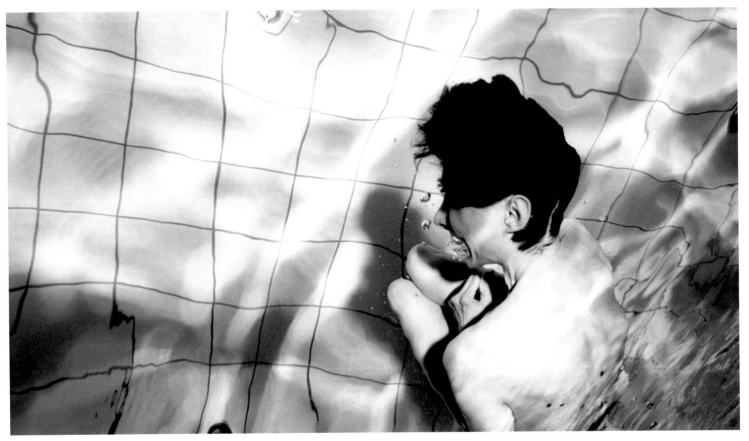

Wasserfest, #1, Lightbox, 154 x 275 cm, 1999

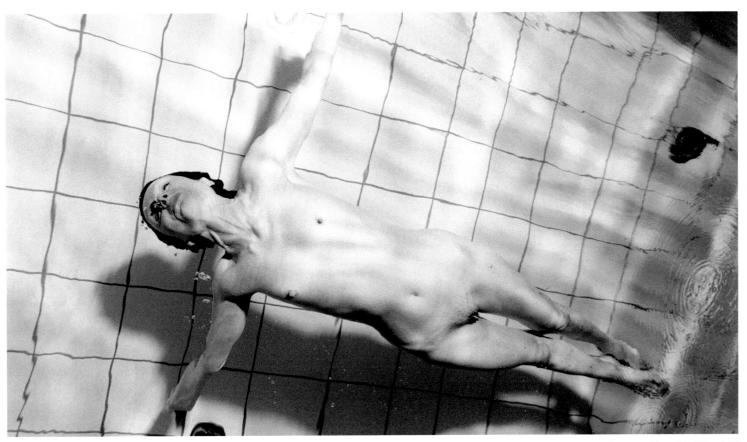

Wasserfest, #2, Lightbox, 154 x 275 cm, 1999

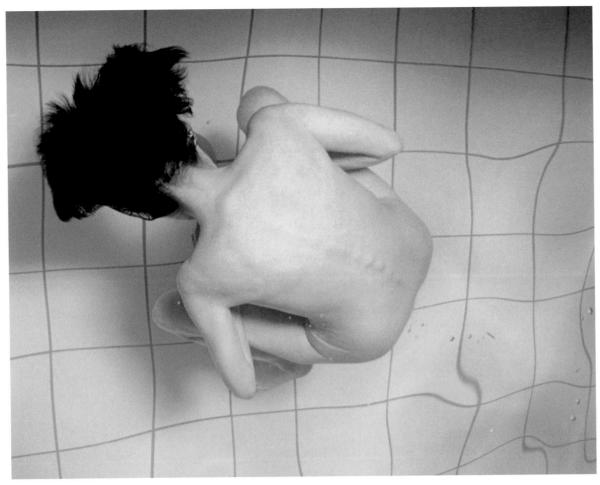

Wasserfest, #3, Lightbox, 124 x 160 cm, 1999

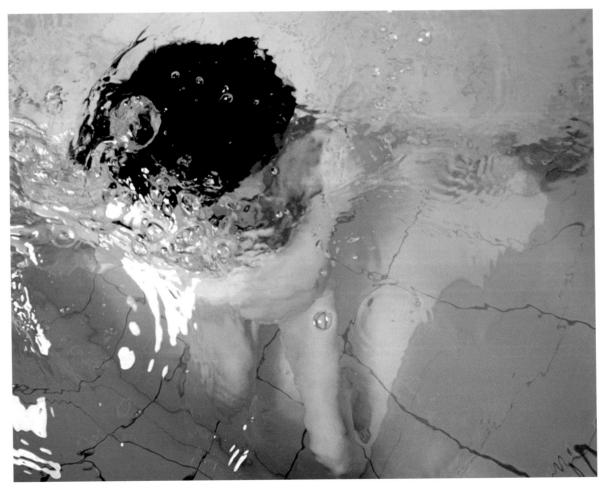

Wasserfest, #4, Lightbox, 124 x 160 cm, 1999

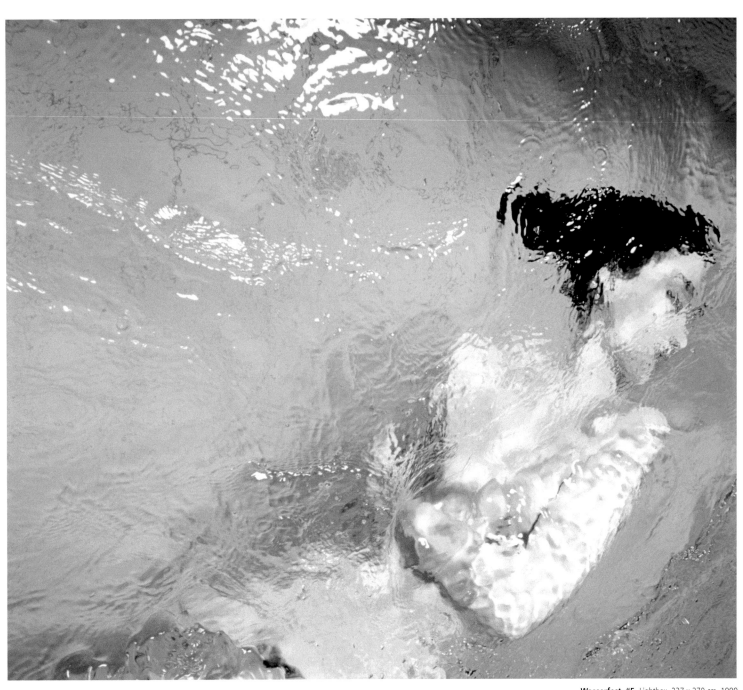

Wasserfest, #5, Lightbox, 237 x 270 cm, 1999

Cyberface, Nexus 7, Lightbox, 160 x 124 cm, 1998, S. 19

Cyberface, 1998

Cyberface, Nexus 8, Lightbox, 160 x 124 cm, 1998, S. 21

Cyberface, Nexus 9, Lightbox, 160 x 124 cm, 1998, S. 23

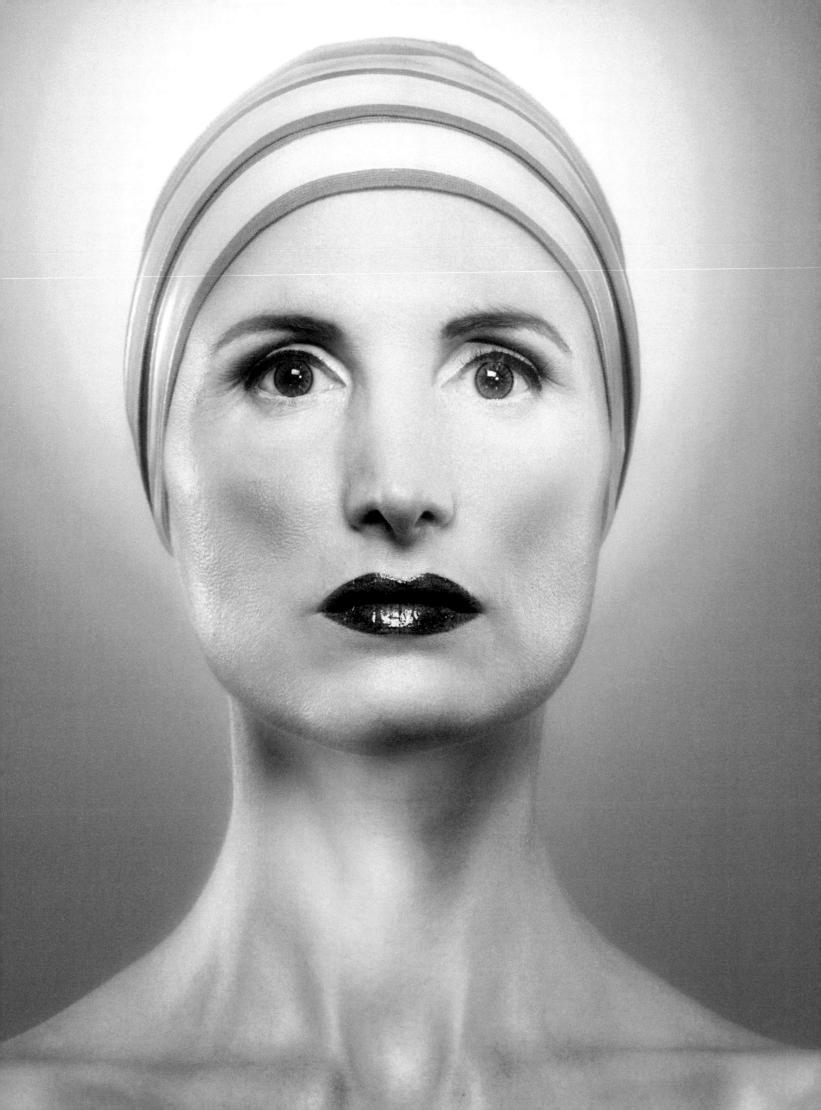

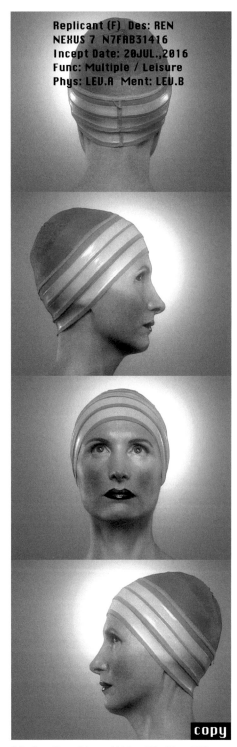

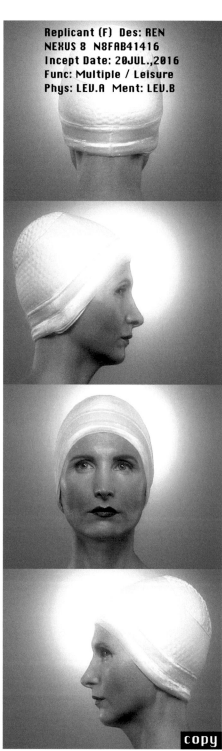

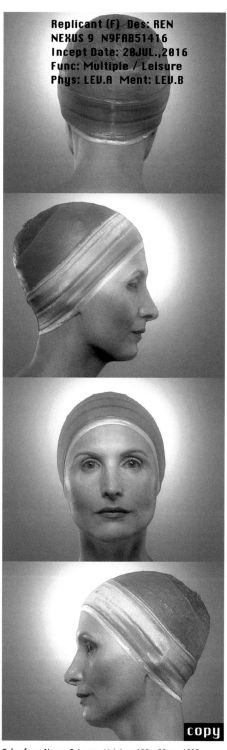

Cyberface, Nexus 7 / copy, Lightbox, 100 x 33 cm, 1998

Cyberface, Nexus 8 / copy, Lightbox, 100 x 33 cm, 1998

Cyberface, Nexus 9 / copy, Lightbox, 100 x 33 cm, 1998

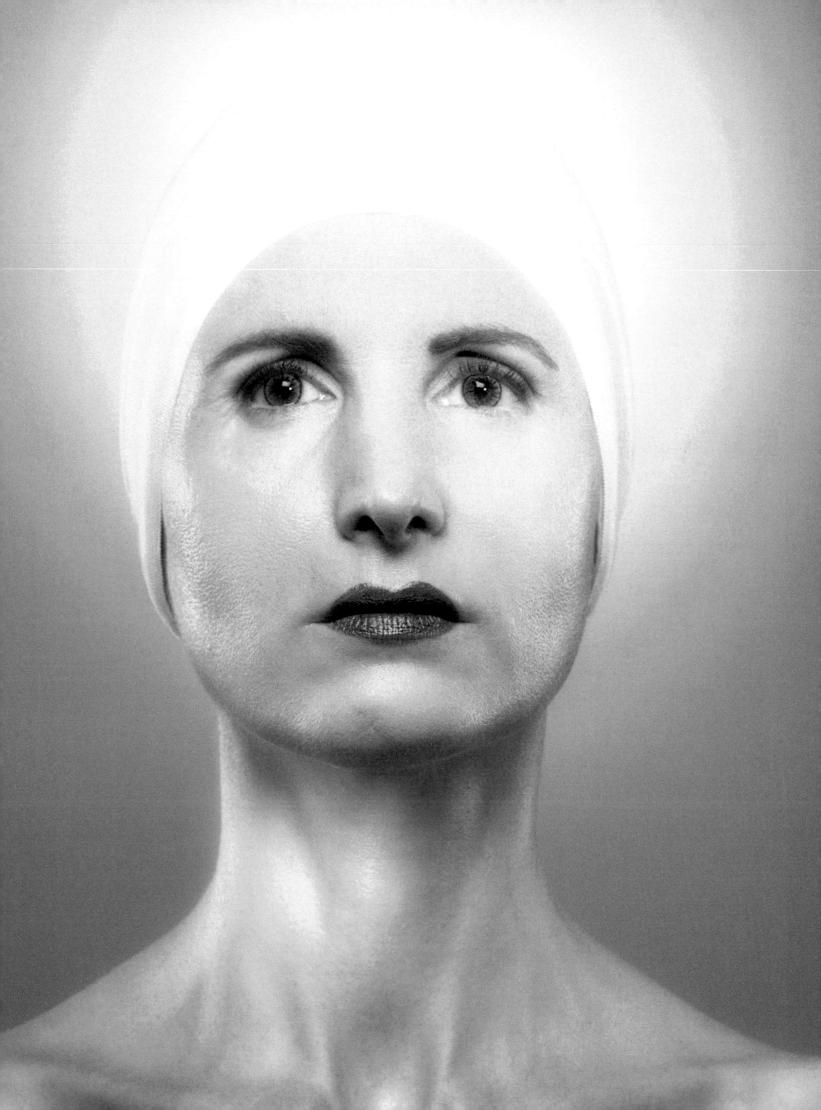

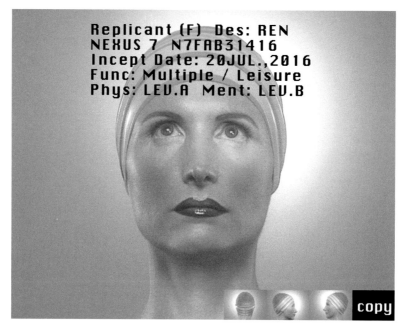

Cyberface, Nexus 7 / copy, C-Print, 80 x 100 cm, 1998

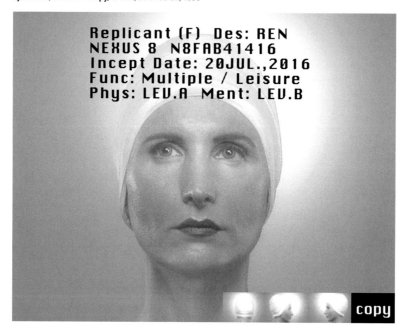

Cyberface, Nexus 8 / copy, C-Print, 80 x 100 cm, 1998

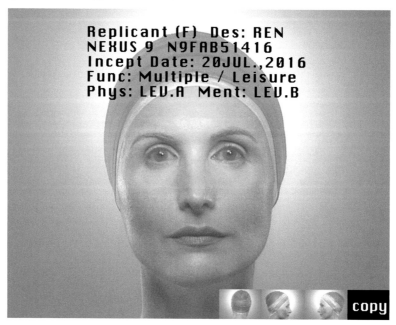

Cyberface, Nexus 9 / copy, C-Print, 80 x 100 cm, 1998

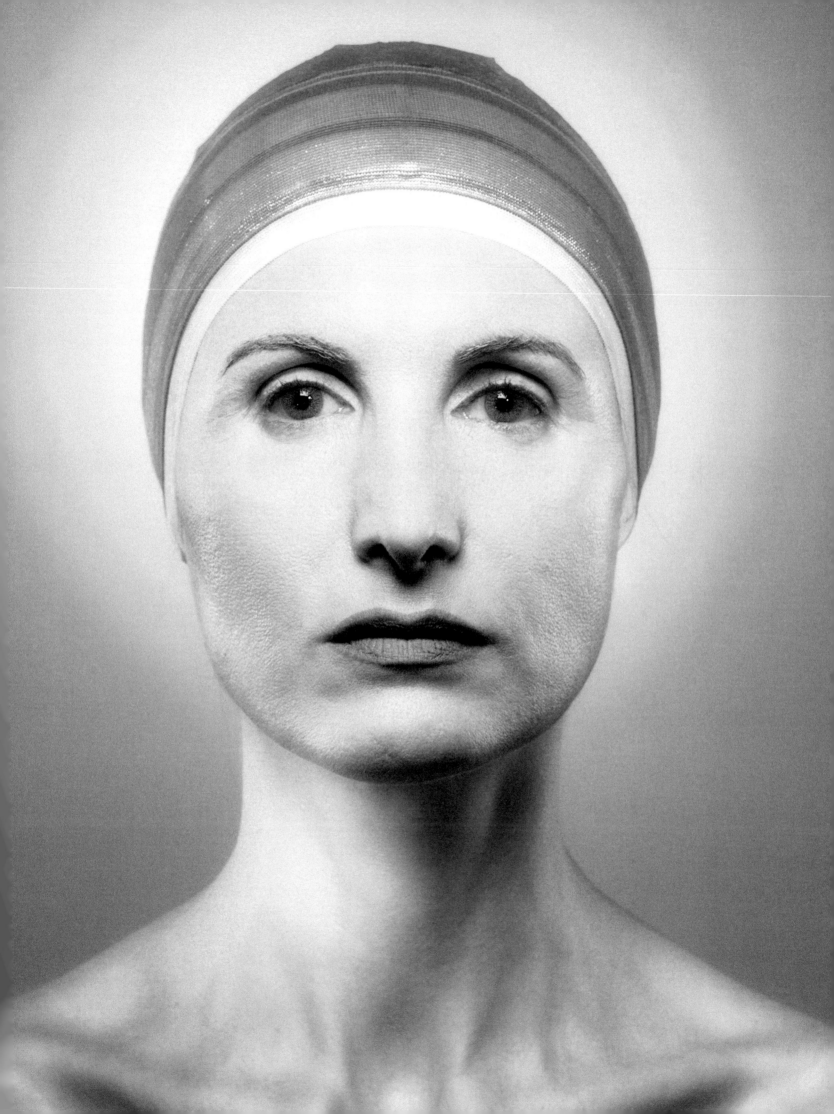

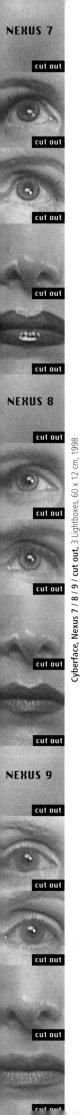

NEXUS 7

NEXUS 8

NEXUS 9

Cyberface, Nexus 7 / 8 / 9 / cut out, 3 Lightboxes, 60 x 12 cm, 1998

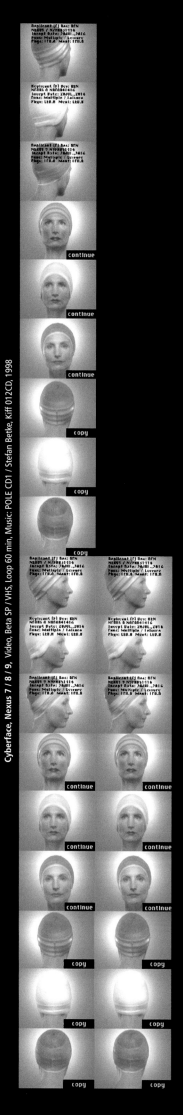

Cyberface, Nexus 7 / 8 / 9, Video, Beta SP / VHS, Loop 60 min, Music: POLE CD1 / Stefan Betke, Kiff 012CD, 1998

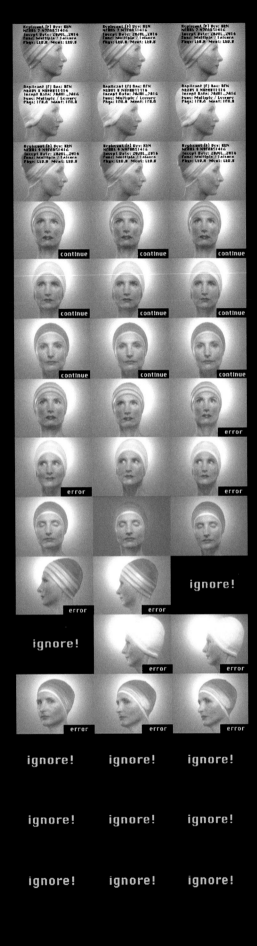

reset

Vorbilder, 1995 – 1998

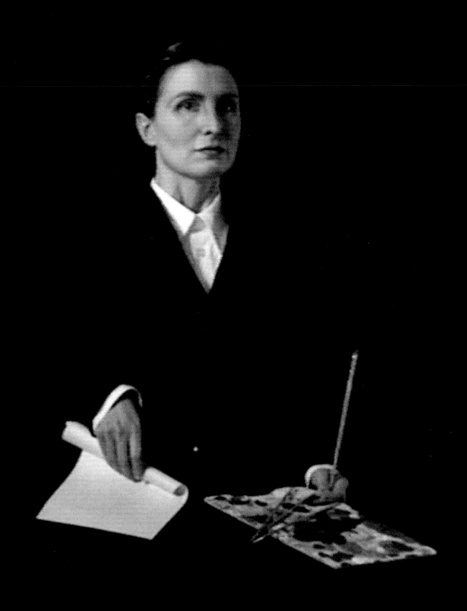

Vorbilder, Video #1 - 5, Beta SP / VHS, 5 min., 1998

#1: Sofonisba Anguissola (dat. 1552)

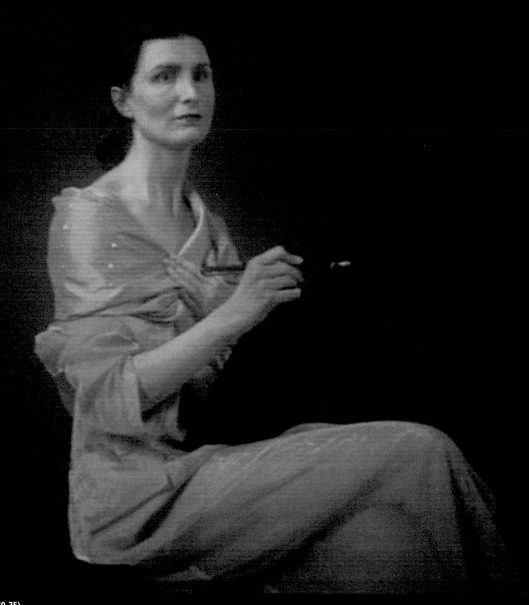

#2: Angelica Kauffmann (dat. 1770-75)

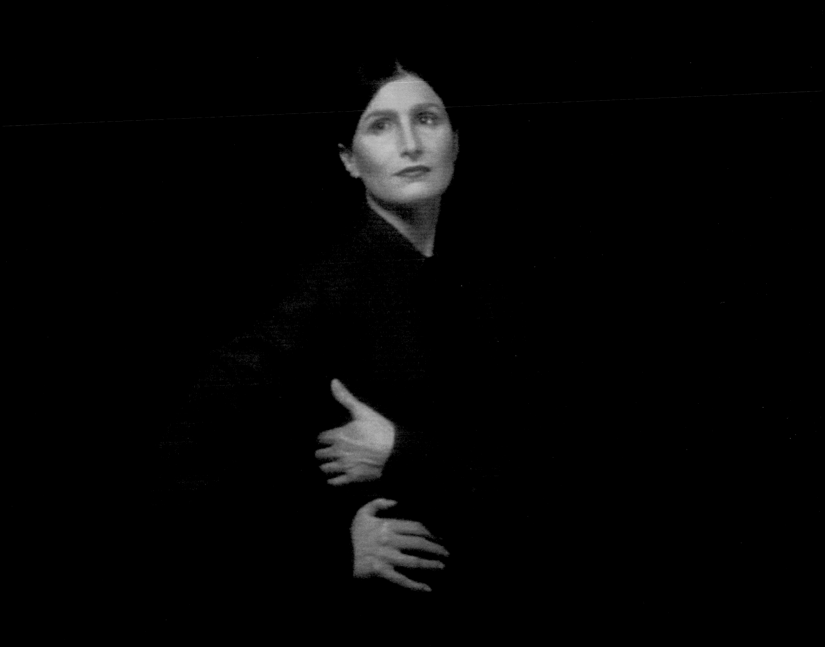

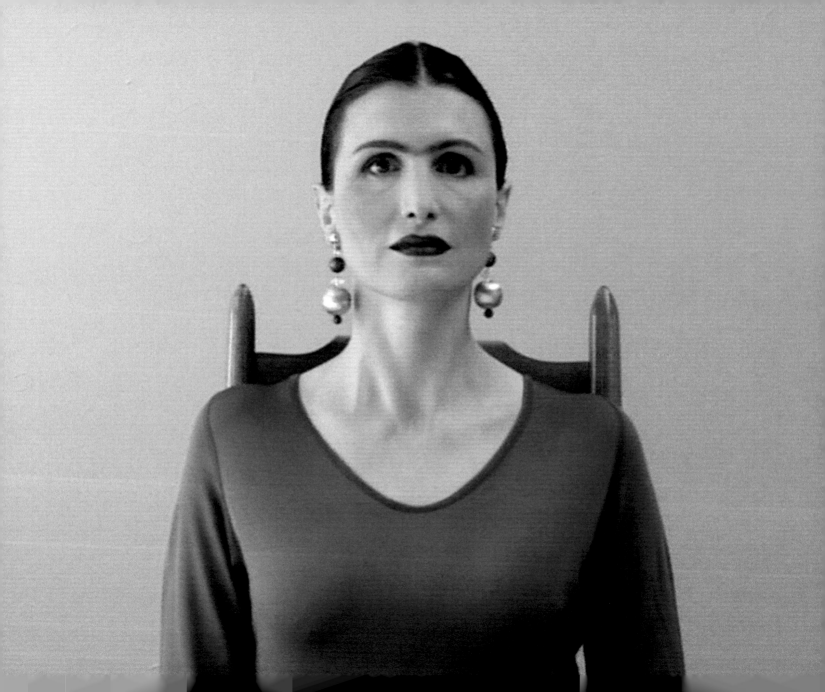

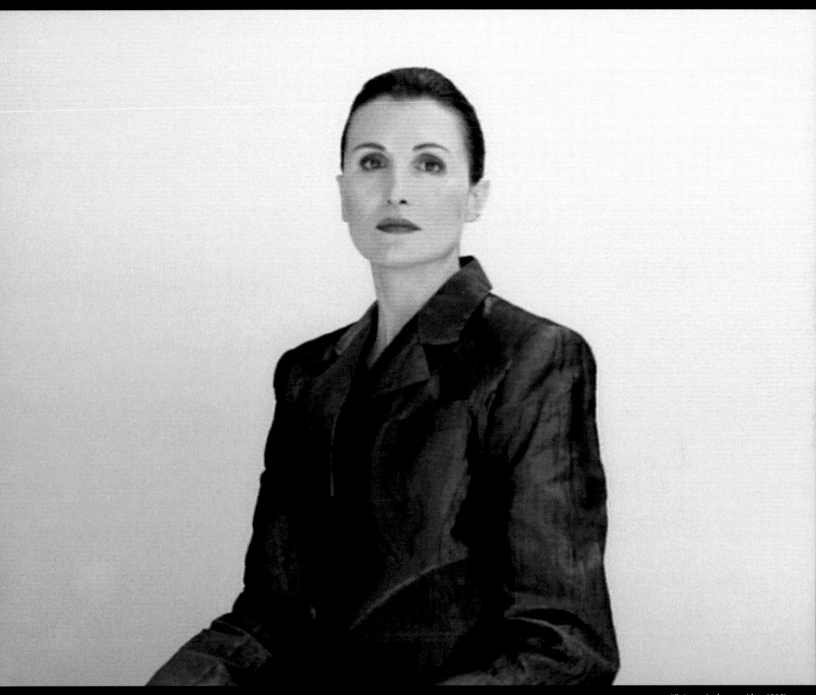

#5: Irene Andessner (dat. 1996)

Vorbilder #1, Sofonisba Anguissola, Lightbox, 160 x 124 cm, 1996

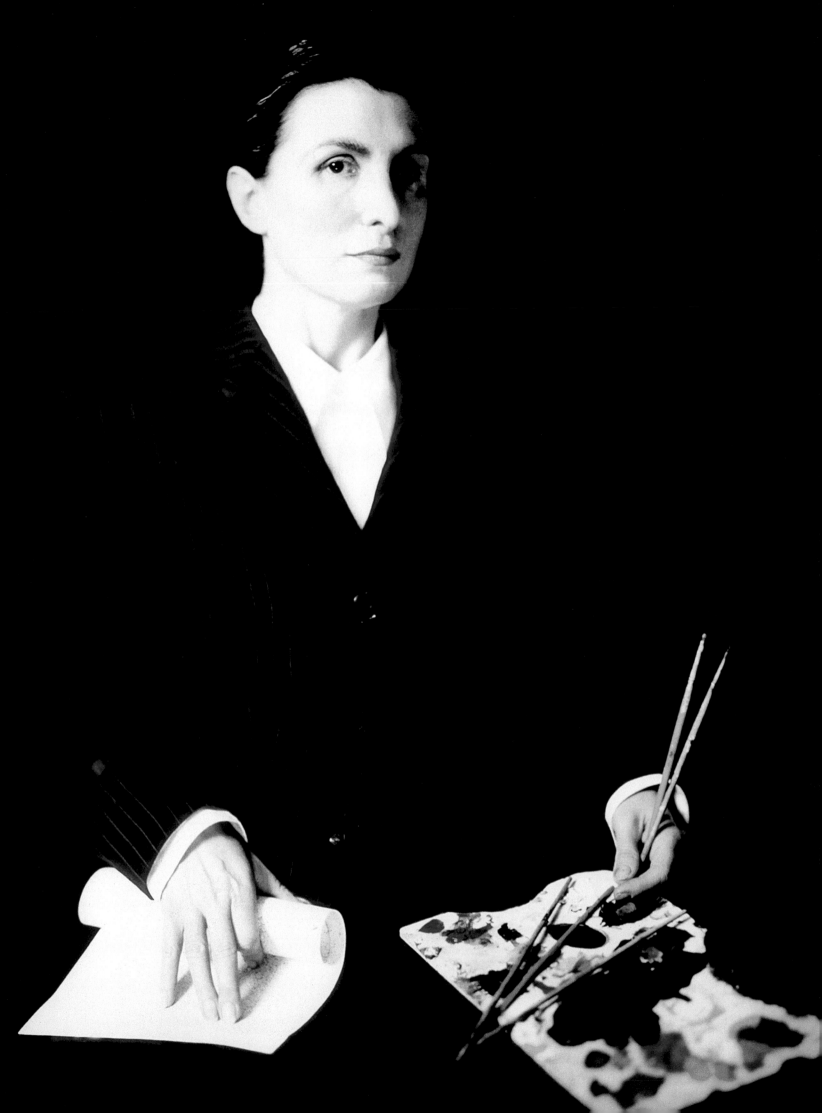

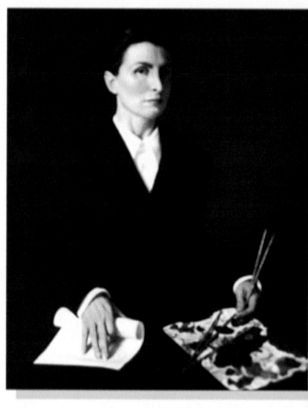

Vorbilder #1, Sofonisba Anguissola, Installation, 40 Duratrans (10 x 10 cm) / Lightbox (160 x 124 cm) / Oil on canvas, 40 x 30 cm, 1998

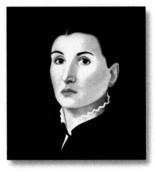

Vorbilder #1-5, Lightboxes, 120 x 100 cm, 1996

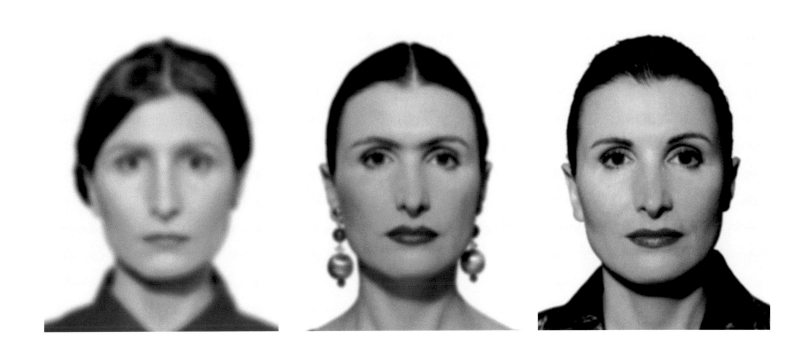

Vorbilder #1-5, Video Frames, Internegativ, 70 x 50 cm, 1997

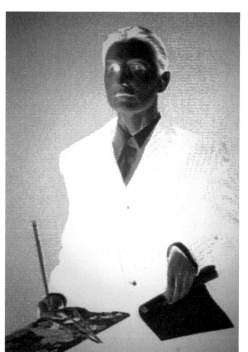 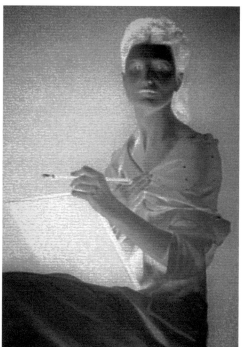

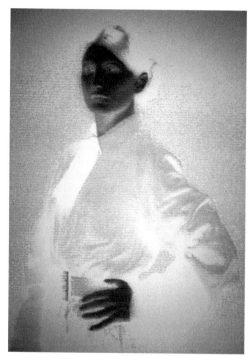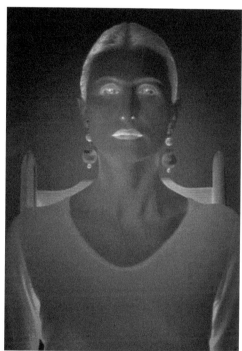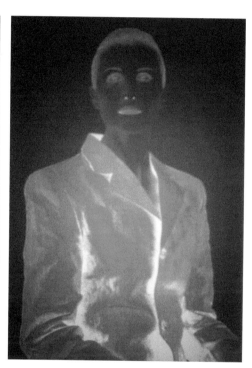

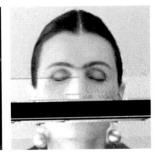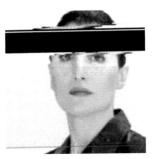

Vorbilder #1-5, Video Frames, 30 x 30 cm, 1997

Vorbilder #3, Gwen John, Lightbox / chair / ca.150 x 45 x 45 cm, 3 Duratrans, 40 x 40 cm, 1996/1997

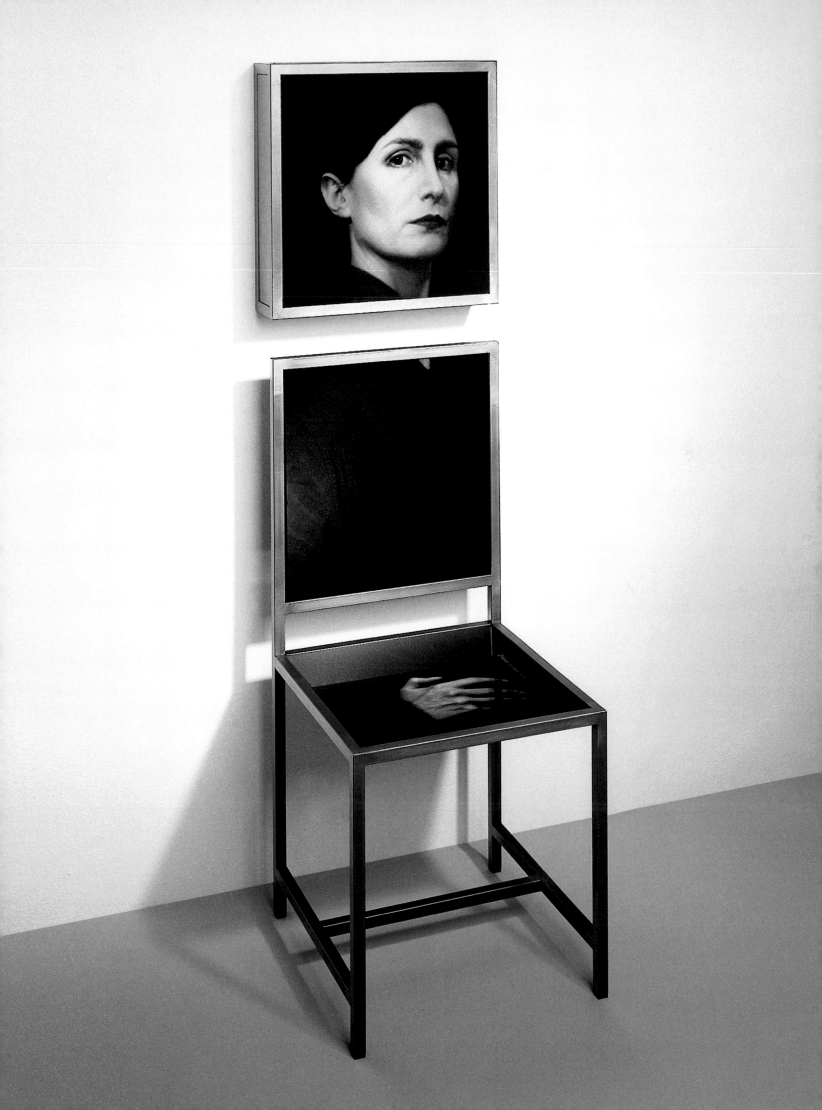

Barbara Blomberg, 1998

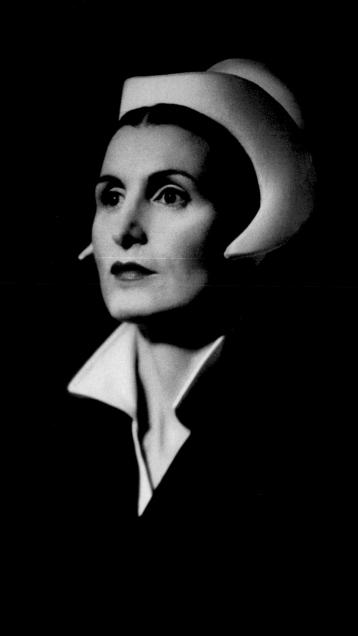

Frauen zu Salzburg, 1999

Frauen zu Salzburg, Caroline Auguste / Urania 1, Lightbox, 160 x 124 cm, 1999

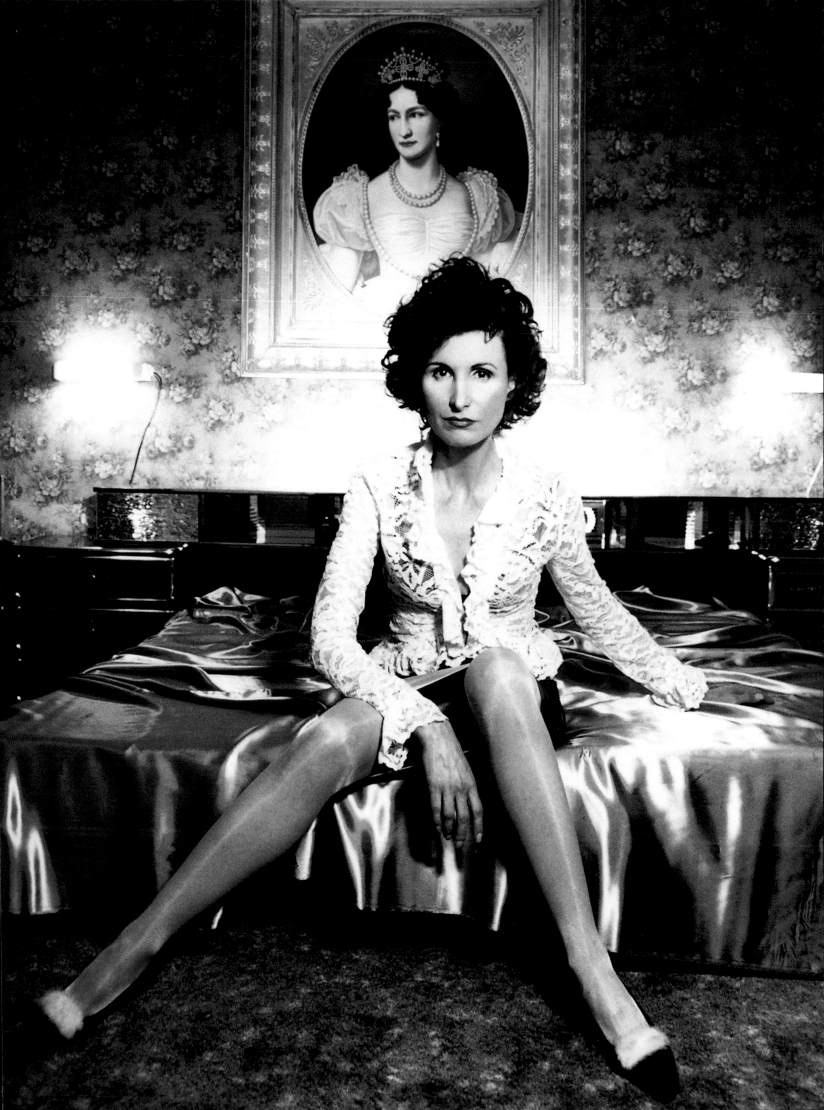

„Ich bin Caroline Auguste, 46 Jahre alt.

Ich wurde zweimal verheiratet.

Beide Ehemänner hat mein Vater im Interesse
seiner Familienpolitik für mich gewählt.

In meiner ersten Ehe habe ich mir meine Augen beinahe ausgeweint.

Meine zweite Ehe hingegen, mit Franz I., war sehr glücklich.

Leider blieben wir kinderlos.

Mein Mann lebte für seine Betriebe und ich für ihn.
Er ist vor drei Jahren gestorben.

Ich bin nach Salzburg gezogen
und es ist seither mein innigstes Anliegen,
den Bedürftigen dieser Stadt zu helfen.

Ich brauche einen repräsentativen, gebildeten,
gesellschaftlich gewandten Mann,
der bei meinen zahlreichen sozialen Aktivitäten
verläßlich an meiner Seite steht."

"I am Caroline Auguste, 46 years of age.

I was married off twice.

My father chose both husbands
on the basis of his dynastic interests.

I nearly cried my eyes out during my first marriage.

But my second marriage to Franz I was very happy.

Unfortunately, we had no children.

My husband lived for his work, and I for him.
He died three years ago.

I moved to Salzburg,
and since then,
my chief concern has been caring for the needy of this city.

I need a presentable, cultured, socially adroit husband,
whom I can rely on to stand at my side
during the performance of my many social duties."

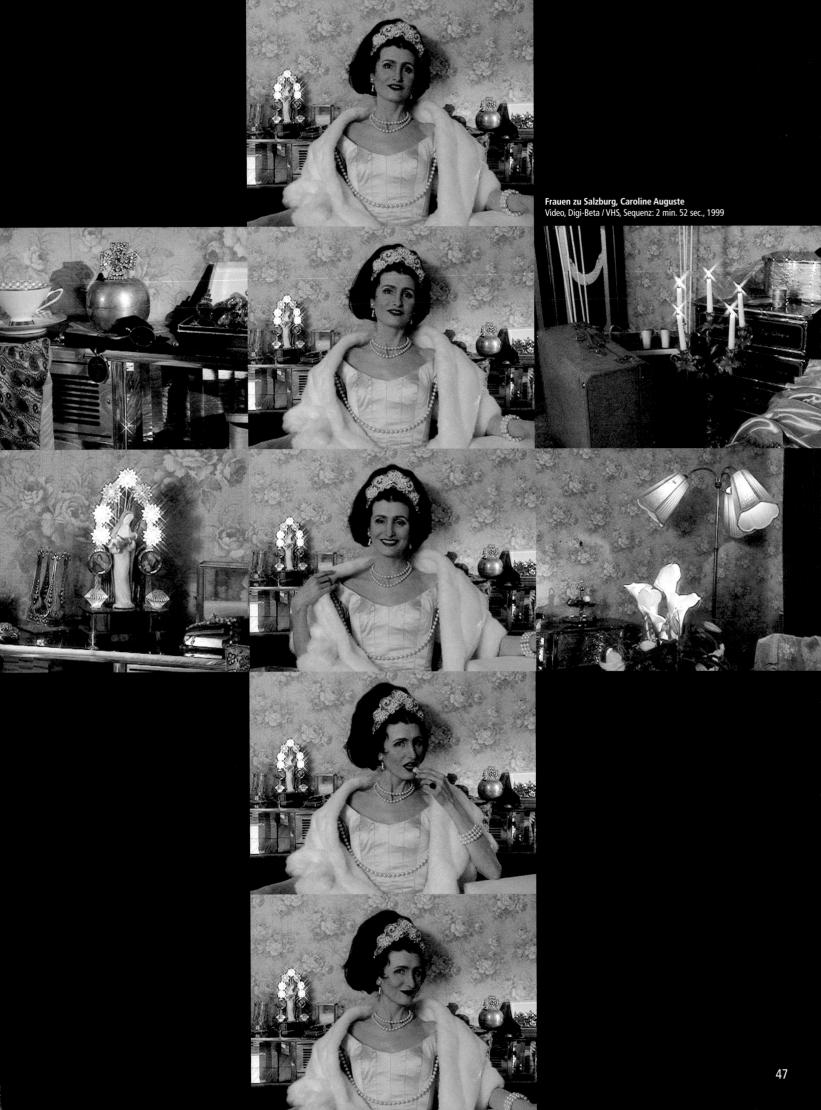

Frauen zu Salzburg, Caroline Auguste
Video, Digi-Beta / VHS, Sequenz: 2 min. 52 sec., 1999

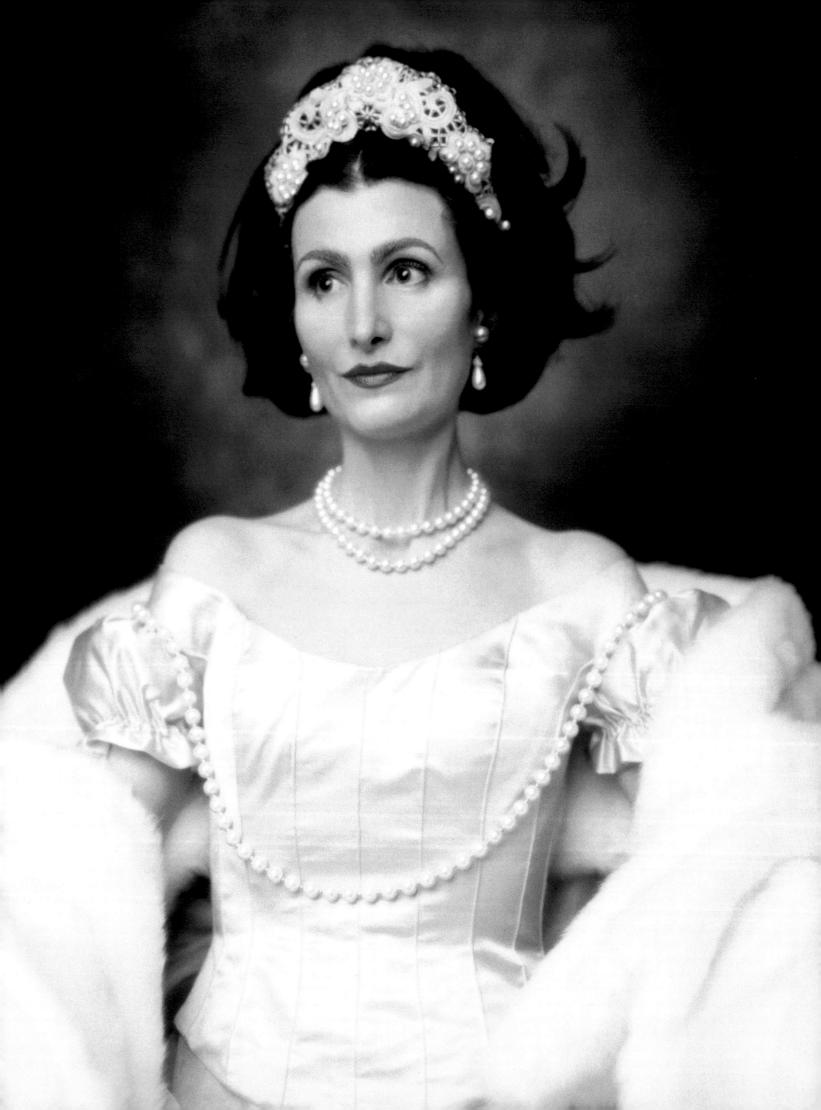

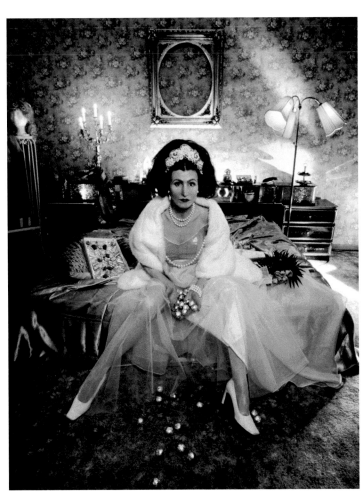

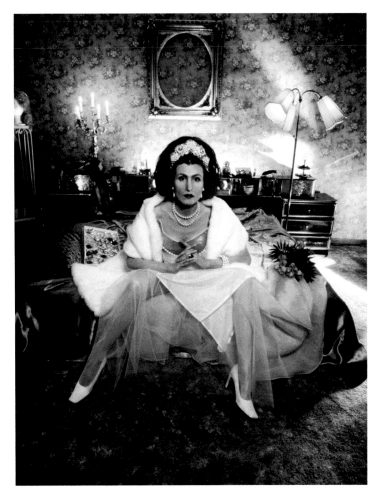

Frauen zu Salzburg, Caroline Auguste 1, C-Print, 230 x 150 cm, 1999

Frauen zu Salzburg, Caroline Auguste 2, C-Print, 230 x 150 cm, 1999

Frauen zu Salzburg, Caroline Auguste 1, Lightbox, 160 x 124 cm, 1999

„Ich heiße Constanze Mozart, und bin 39 Jahre alt.

Mein Mann Wolfgang Amadeus Mozart, war Musiker und Komponist. Er ist vor elf Jahren gestorben.

Wir hatten eine gute Zeit und viel Spass miteinander. Außer seinen Söhnen hinterließ er mir allerdings nur beträchtliche Schulden.

Deshalb war ich auch zur preisgünstigsten Bestattungsform gezwungen – was man mir bis heute vorwirft.

Eigentlich bin ich Sängerin und ich habe vor dem besten Publikum gesungen.
.

Aber jetzt bin ich hauptsächlich damit beschäftigt, den künstlerischen Nachlaß meines Mannes finanziell zu verwerten.

Mein Wolferl soll genial gewesen sein, sagen die Leute.

Ich bin jetzt oft in Salzburg
. . . und ich suche einen Mann, in herausragender gesellschaftlicher Position."

"My name is Constanze Mozart, and I am 39 years old.

My husband, Wolfgang Amadeus Mozart, was a musician and composer. He died eleven years ago.

We had good years together and a lot of fun. But aside from his sons, he left me nothing but his considerable debts.

That is why I was forced to choose a budget-priced burial – which some people still criticize me for today.

Actually, I am a singer and have appeared before the best audiences.
. . . . , . . .

But at the moment, I am mainly occupied with trying to derive some financial benefit from my husband's musical estate.

My Wolferl is supposed to have been a genius – everybody says he was.

I am often in Salzburg . . . and I am looking for a husband with a prominent social position."

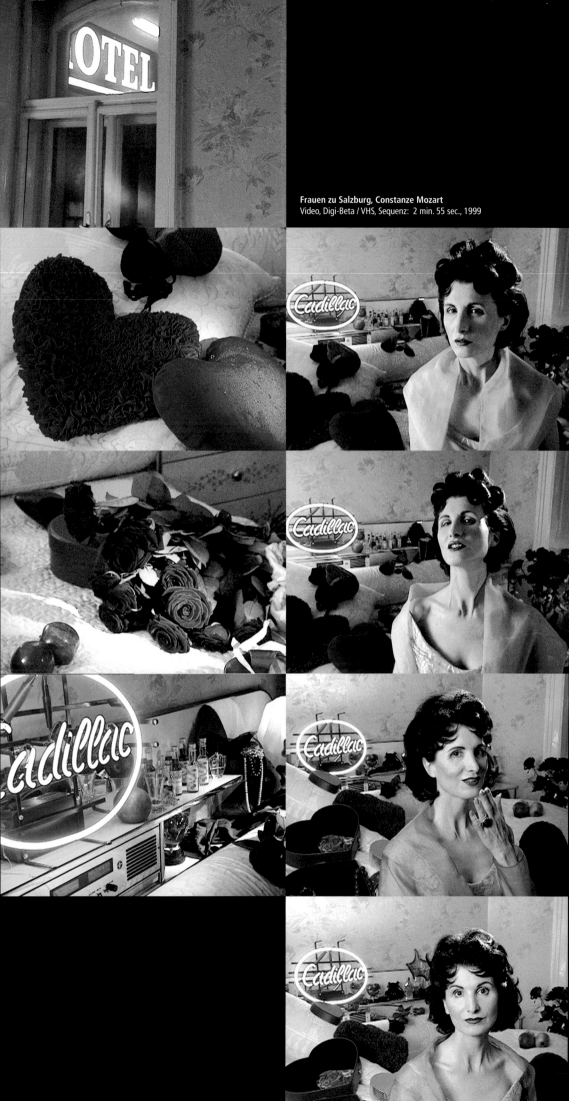

Frauen zu Salzburg, Constanze Mozart
Video, Digi-Beta / VHS, Sequenz: 2 min. 55 sec., 1999

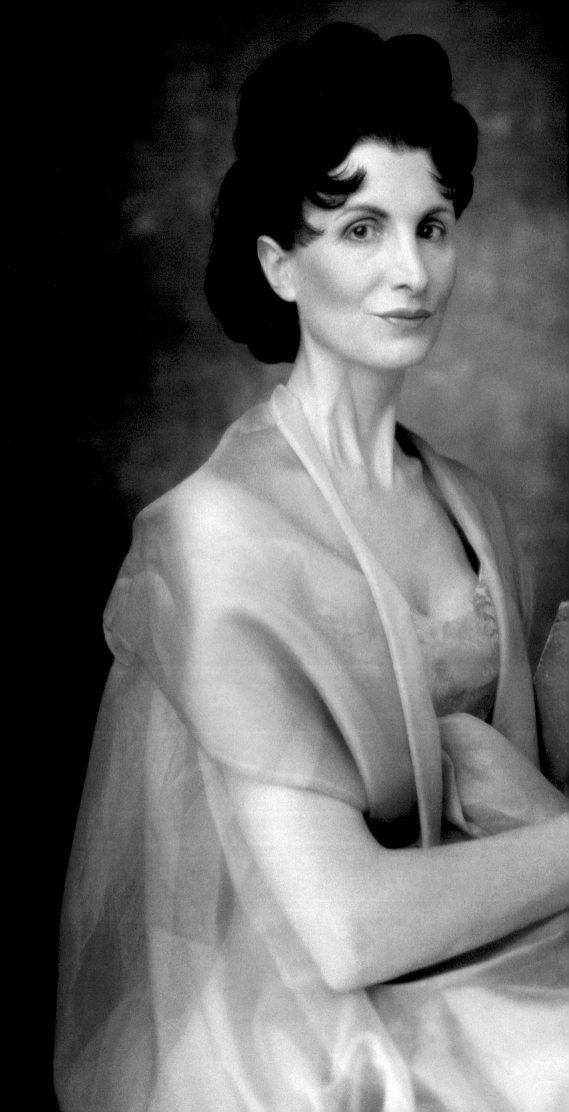

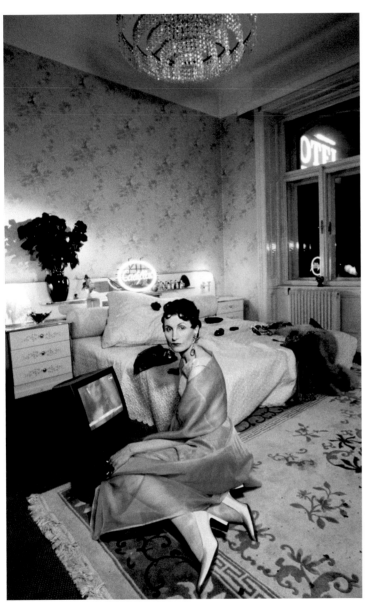

Frauen zu Salzburg, Constanze Mozart 1, C-Print, 80 x 50 cm, 1999

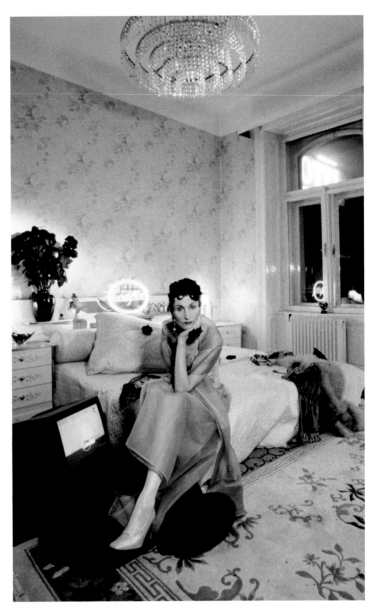

Frauen zu Salzburg, Constanze Mozart 2, C-Print, 80 x 50 cm, 1999

Frauen zu Salzburg, Constanze Mozart 2, Lightbox, 160 x 124 cm, 1999

„Ich bin Maria Anna Mozart,
32 Jahre alt.
Ich bin Pianistin.

Als Kind konzertierte ich
mit meinem Bruder Wolfgang
in vielen Städten Europas.

Eigentlich hätte ich gern
meine Karriere als Pianistin fortgesetzt,
aber meinem Vater zuliebe,
der meinen Bruder Wolfgang bevorzugte,
habe ich immer zurückgesteckt.

Hier in Salzburg führe ich jetzt
meinem Vater den Haushalt.
Nebenbei arbeite ich
noch als Klavierlehrerin.
Mein Vater möchte,
daß ein vermögender Gatte
meine Zukunft sichert.

Wo ist der Mann,
der mich auf meinen
künftigen Wegen begleitet?"

"I am called Maria Anna Mozart and am
32 years old.
I am a pianist.

As a child, I toured many European cities,
holding concerts with my
brother Wolfgang.

I would actually have liked to continue my
career as a pianist,
but to please my father,
who preferred my brother Wolfgang,
I always kept myself in the background.

I now keep house for my father
here in Salzburg.
I still work part-time
as a piano teacher.
My father would like
to see a wealthy husband provide me
with a secure future.

Where is the man
who can accompany me
on my future path?"

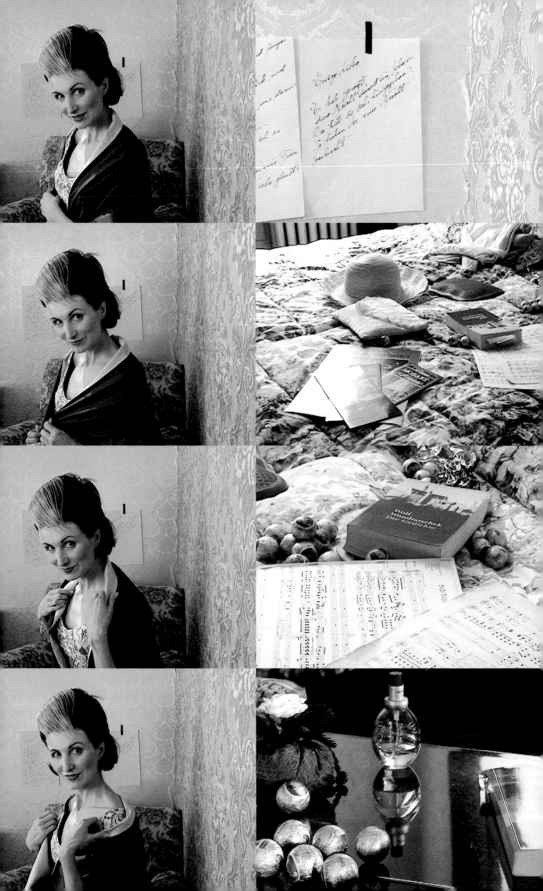

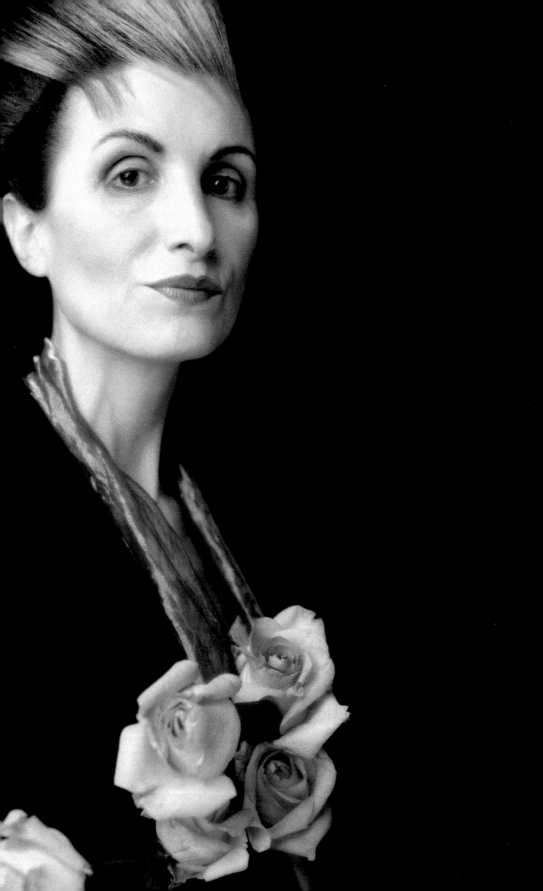

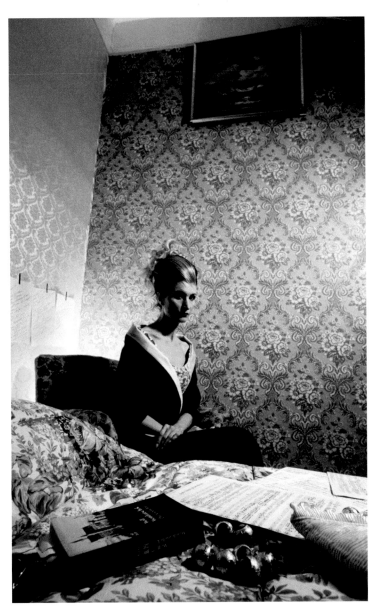

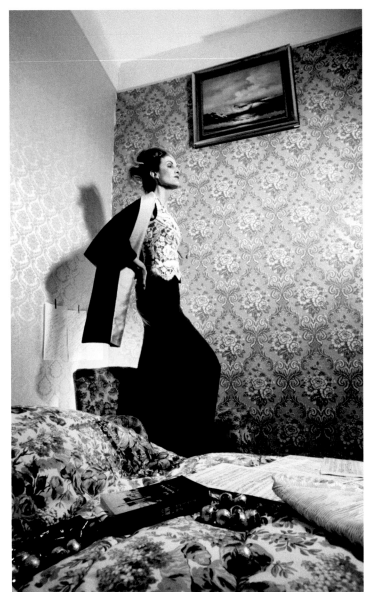

Frauen zu Salzburg, Nannerl Mozart 1, C-Print, 80 x 50 cm, 1999

Frauen zu Salzburg, Nannerl Mozart 2, C-Print, 80 x 50 cm, 1999

Frauen zu Salzburg, Nannerl Mozart 1, Lightbox, 160 x 124 cm, 1999

„Ich bin Barbara Krafft. 43 Jahre alt.

Seit drei Jahren lebe ich
mit meinen beiden Kindern in Salzburg.

Ich bin verheiratet; mein Mann ist in Wien geblieben –
und ich werde ihn nie wieder sehen.

Meinen Unterhalt verdiene ich mit Porträtieren.
Meine Kunden kommen aus den besten Familien der Stadt;
die Tomasellis z.B.

Schon mein Vater war Maler
und da er keinen Sohn hatte, der seine Karriere fortsetzen konnte,
hat er mich zur Malerin ausgebildet.

Ich hätte eine dreiste Manier beim Malen, sagt man.

Meine knappe Freizeit würde ich gerne mit einem Mann verbringen,
der mich bewundert, der mich begehrt, mich unendlich liebt
und der mich immer wieder anruft
und mich mit seiner Stimme zum Schmelzen bringt . . .

Ich warte auf deinen Anruf."

"I am Barbara Krafft. 43 years old.

I have been living with my two children
in Salzburg for three years now.

I am married; my husband remained in Vienna –
and I will never see him again

I earn my living by painting portraits.
My clients come from the best families in the city;
the Tomasellis, for example.

My father was also a painter,
and as he had no son to carry on his career,
he trained me to paint.

I have a bold manner in my painting, people say.

I would like to spend what little spare time I have with a husband
who admires me, desires me, loves me infinitely,
and who calls me again and again,
his voice making my heart melt. . .

I await your call."

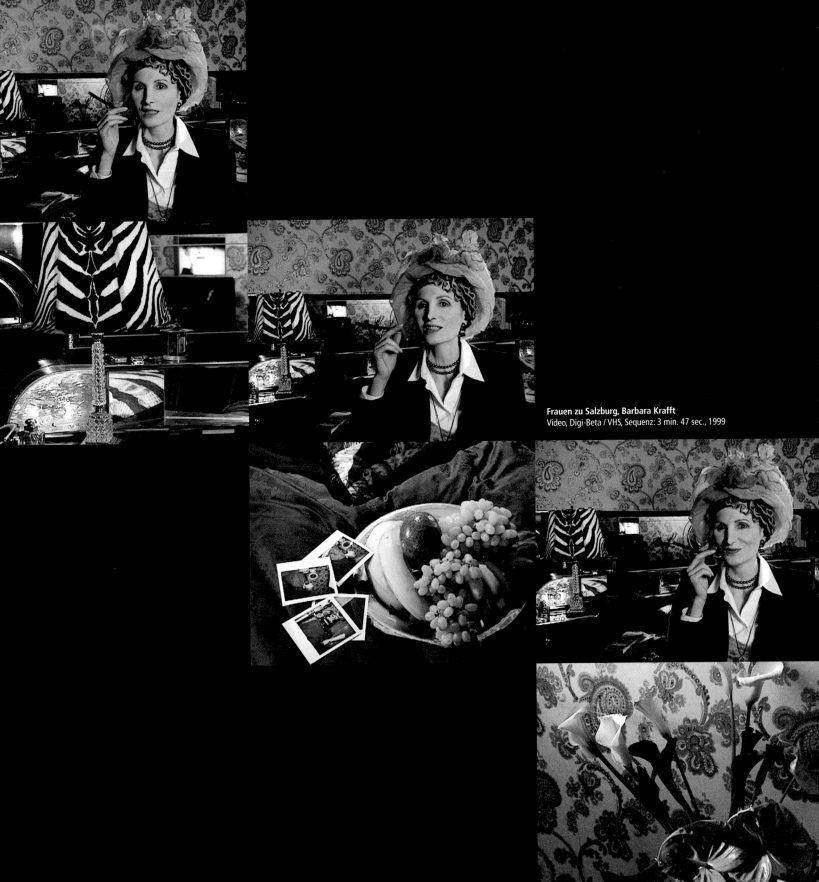

Frauen zu Salzburg, Barbara Krafft
Video, Digi-Beta / VHS, Sequenz: 3 min. 47 sec., 1999

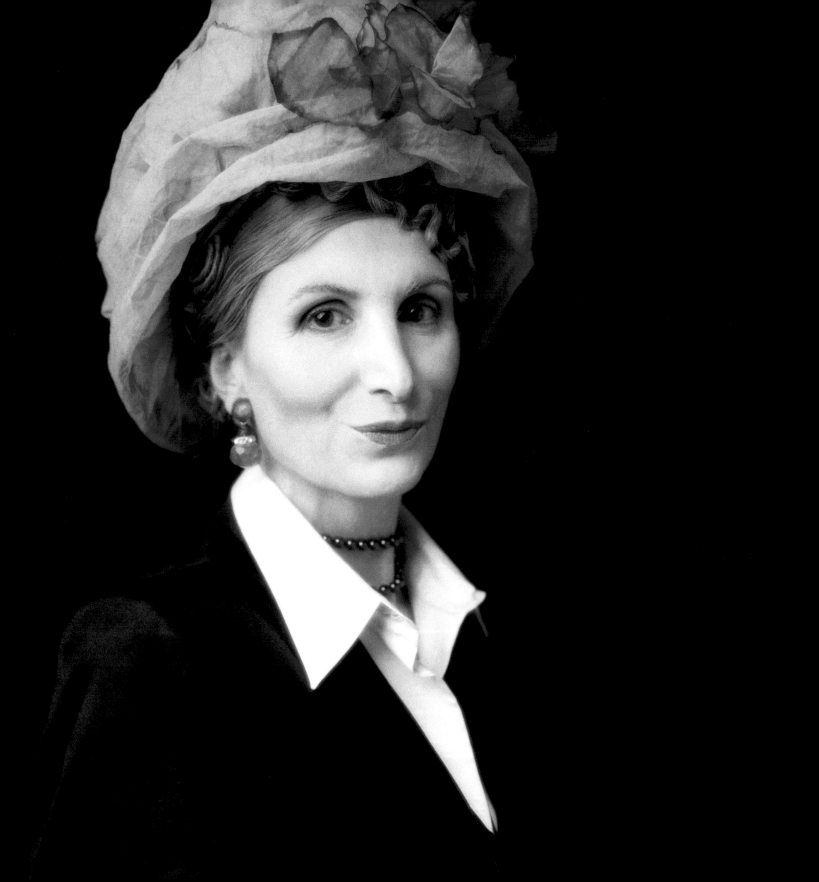

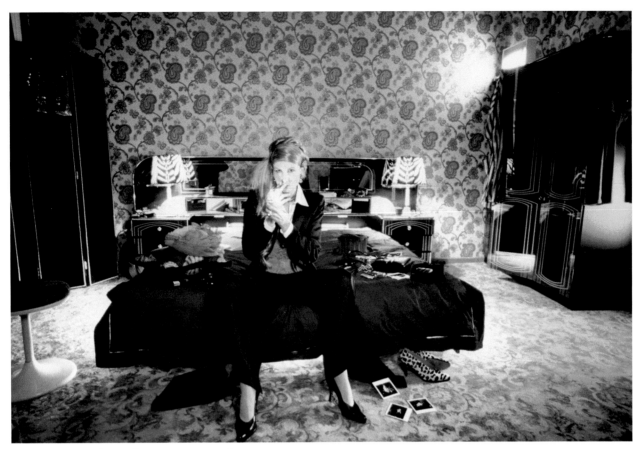

Frauen zu Salzburg, Barbara Krafft 1, C-Print, 50 x 80 cm, 1999

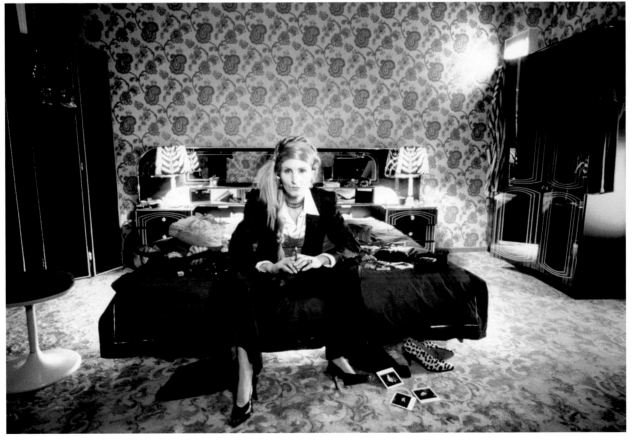

Frauen zu Salzburg, Barbara Krafft 2, C-Print, 50 x 80 cm, 1999

Frauen zu Salzburg, Barbara Krafft 2, Lightbox, 160 x 124 cm, 1999

„Mein Name ist Eva Lucia Cäcilia Emilia, Freiin von Wolfsberg, geborene Kraus. Ich bin 45 Jahre alt; jedenfalls sehe ich keinen Tag älter aus. Das sagen alle. Schon als Kind war ich sehr schön – mein Gott war ich ein schönes Kind . . . Ein Wiener Offizier hat mich meiner Mutter abgekauft – um viel Geld. In Wien lernte ich den so berühmten wie gefürchteten Bonaparte kennen und ich folgte ihm als seine Gefährtin – diskret in Männerkleidern als sein Sekretär „Felix". Er schenkte mir einen Ring mit der Inschrift: „Diese Antwort tröstet, aber sie genügt nicht." Mehr als acht Jahre blieb ich bei ihm, bis zum Höhepunkt seiner Macht. Dann heiratete ich einen meiner vielen Verehrer, einen Rechtsanwalt aus Wien. Er war nicht der Richtige, ich ließ mich scheiden und heiratete wieder. Diesesmal einen Arzt, jünger als ich, mit dem ich nach Salzburg ging. Leider ist er gestorben. Mein Stiefvater hat indessen nahezu meinen gesamten Besitz veruntreut. Ich habe fast alles verloren. Nur meine Tiere halten noch zu mir – und ich halte zu ihnen. 32 Hunde, 2 Affen, 40 Katzen, dazu Pfauen, Papageien und zwei Pferde. Von ihnen werde ich mich niemals trennen . . . das ist mein Fidele. Wo ist der Retter, der uns liebt und beschützt?"

"My name is Eva Lucia Cäcilia Emilia, Baroness von Wolfsberg, née Kraus. I am 45 years old – at least I don't look a day older. Everyone says so. I was very beautiful even as a child – my God was I a beautiful child . . . A Viennese officer bought me from my mother – for a large sum. In Vienna, I met the famous and feared Bonaparte and accompanied him on his travels – discretely dressed in men's clothes – as his secretary, "Felix." He gave me a ring with the inscription: "This answer consoles, but it is not enough." I stayed with him for more than eight years, until the high point of his power. Then I married one of my many admirers, a lawyer from Vienna. He was not the right one. I divorced him and married again. This time it was a doctor, younger than I, with whom I moved to Salzburg. He died, unfortunately. In the meantime, my father-in-law has misappropriated almost all my property. I have lost nearly everything. Only my animals have remained loyal to me – and I to them. Thirty-two dogs, two monkeys, forty cats, peacocks, parrots, and two horses. I will never leave them . . . this is my Fidele. Where is the saviour who will love and protect us?"

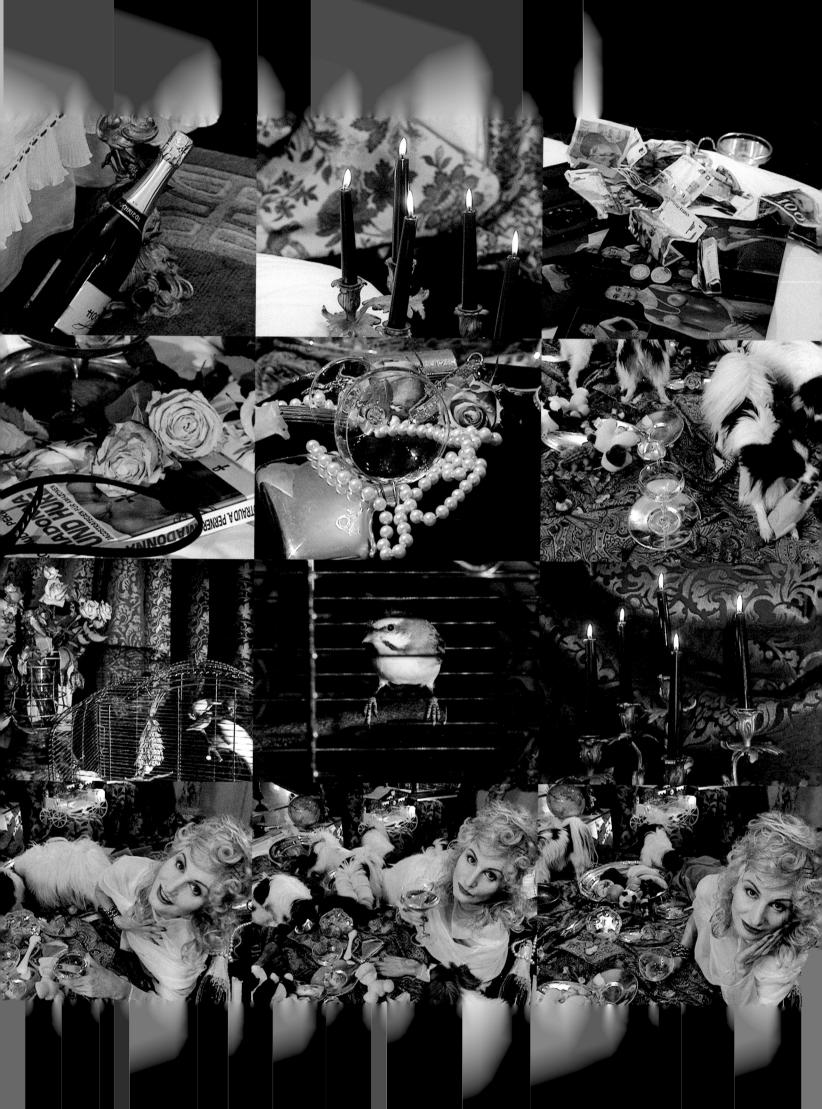

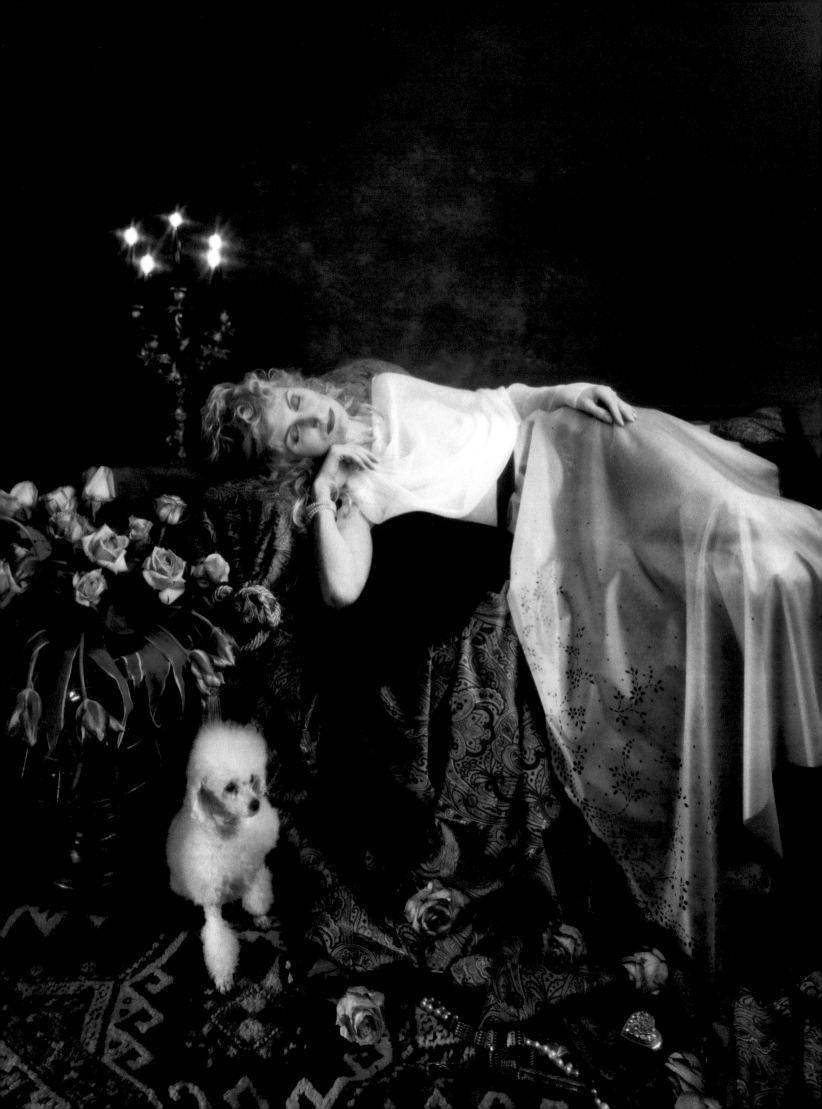

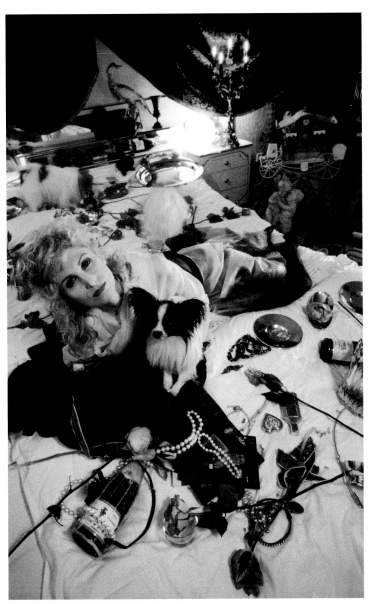

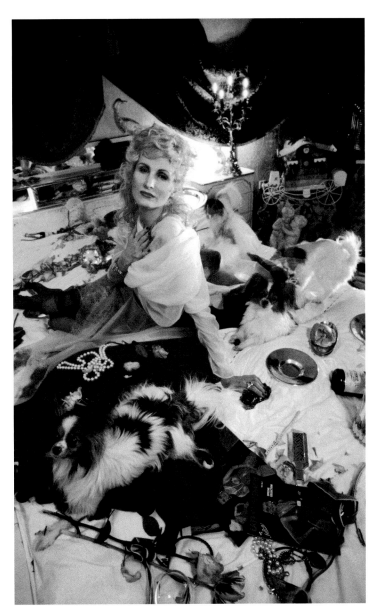

Frauen zu Salzburg, Emilia Viktoria Kraus "Hundsgräfin" 1, C-Print, 80 x 50 cm, 1999

Frauen zu Salzburg, Emilia Viktoria Kraus "Hundsgräfin" 2, C-Print, 80 x 50 cm, 1999

Frauen zu Salzburg, Emilia Viktoria Kraus "Hundsgräfin" 1, Lightbox, 160 x 124 cm, 1999

Irrlichter, **#1.1,** Lightbox, 80 x 62 cm, 2000, S. 67

Irrlichter, **#1,** Lightbox, 150 x 190 cm, 2000, S. 68/69

Irrlichter, **#2,** Lightbox, 160 x 124 cm, 2000, S. 71

Irrlichter, **#3,** C-Print, 80 x 62 cm, 2000, S. 75

Irrlichter, 2000

Irrlichter, **#3.1,** C-Print, 40 x 30 cm, 2000, S. 76

Irrlichter, **#4,** Lightbox, 80 x 62 cm, 2000, S. 78

Irrlichter, **#4.1,** Lightbox, 80 x 62 cm, 2000, S. 79

Irrlichter, **#4.2,** Lightbox, 80 x 62 cm, 2000, S. 80

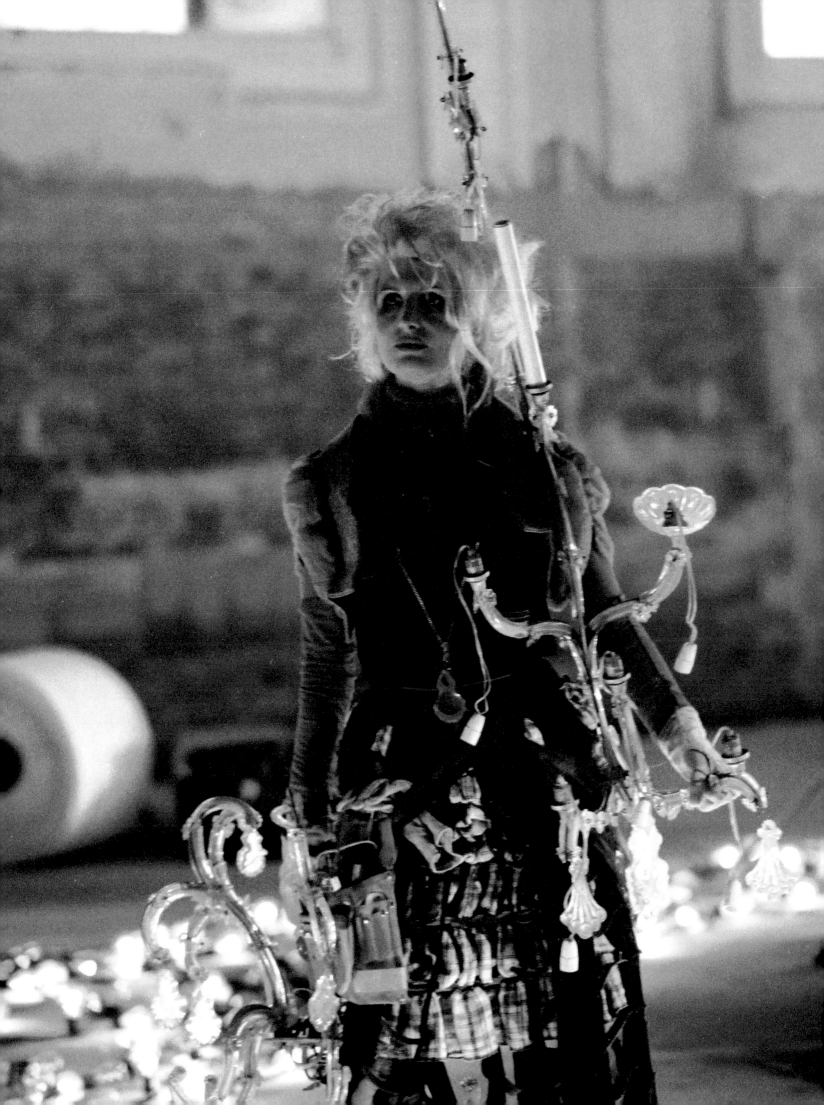

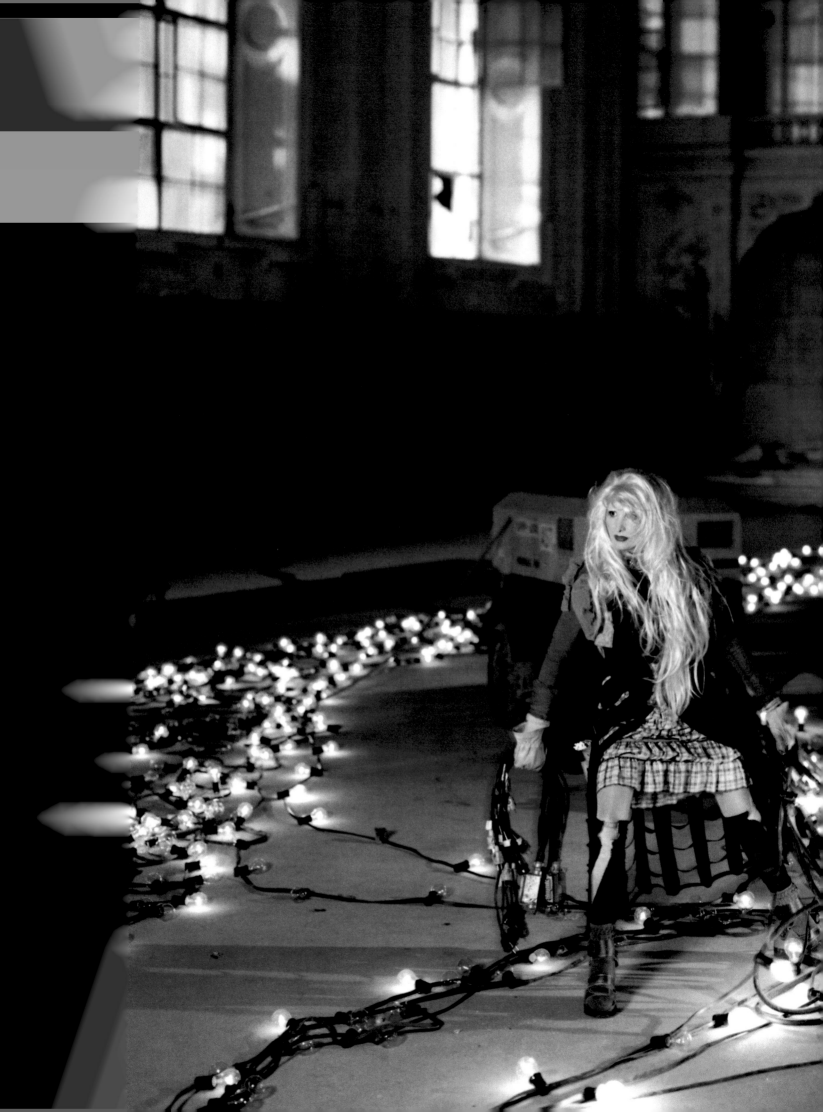

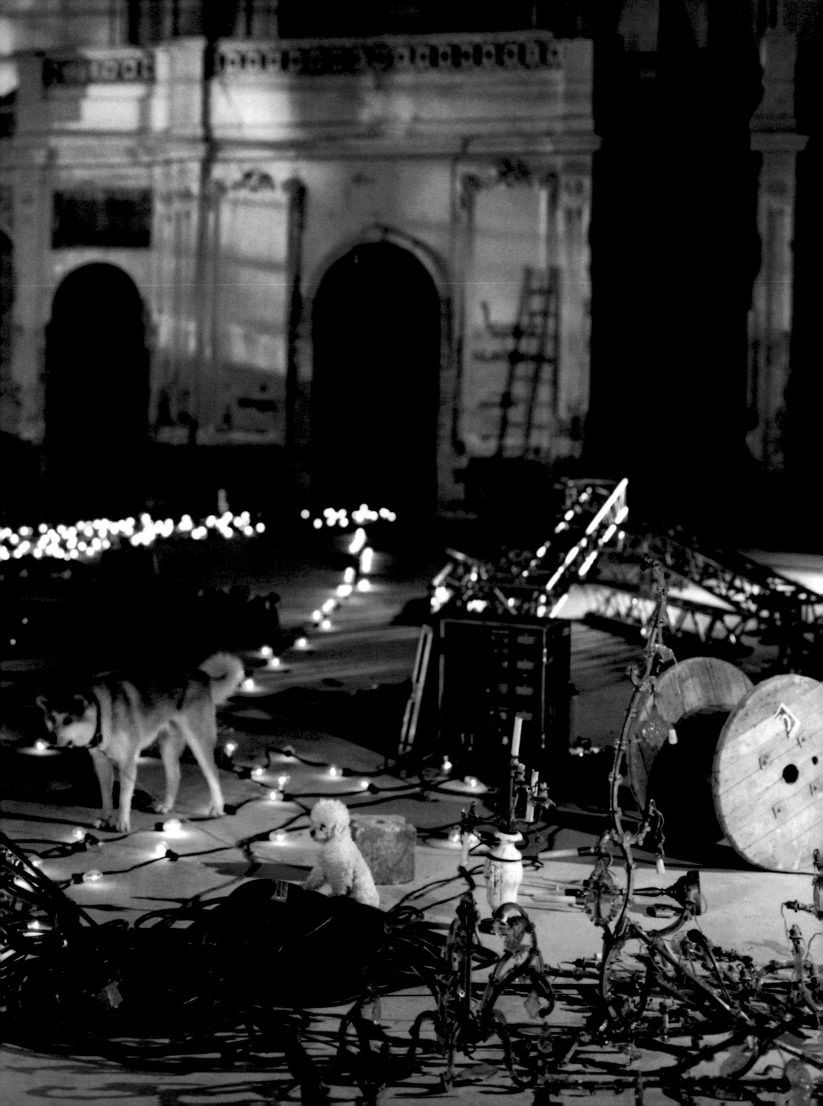

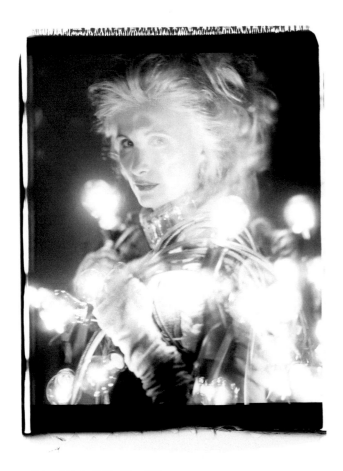

Irrlichter, #1, Polaroid, 88 x 56 cm, 2000

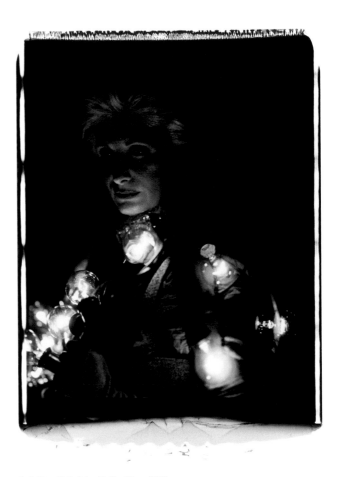

Irrlichter, #1.1, Polaroid, 88 x 56 cm, 2000

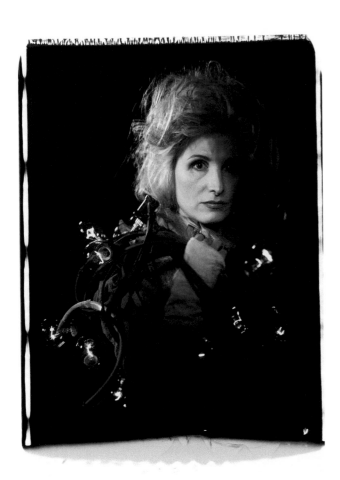

Irrlichter, #1.2, Polaroid, 88 x 56 cm, 2000

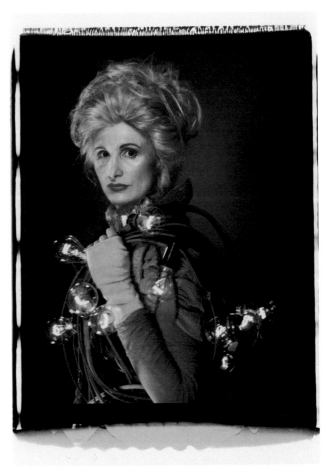

Irrlichter, #1.3, Polaroid, 88 x 56 cm, 2000

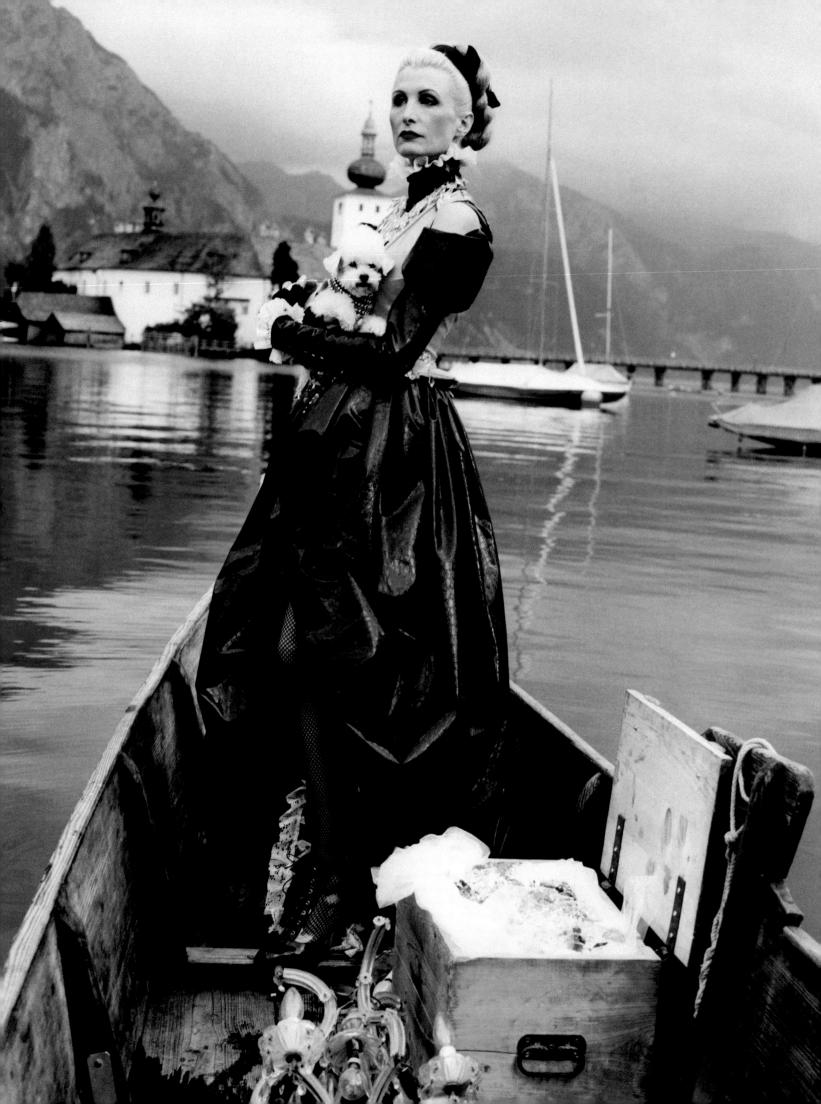

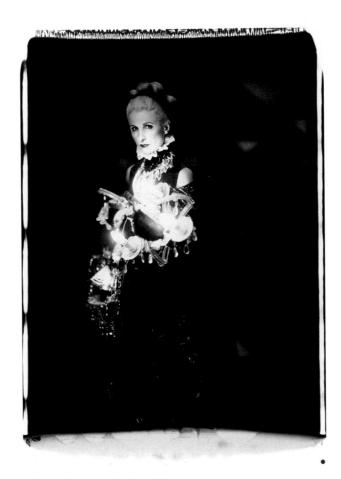

Irrlichter, #2, Polaroid, 88 x 56 cm, 2000

Irrlichter, #2.1, Polaroid, 88 x 56 cm, 2000

Irrlichter, #2.2, Polaroid, 88 x 56 cm, 2000

Irrlichter, #2.3, Polaroid, 88 x 56 cm, 2000

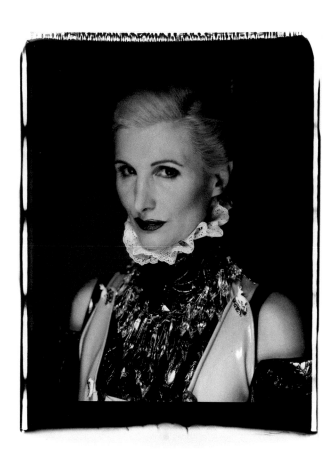

Irrlichter, #2.4, Polaroid, 88 x 56 cm, 2000

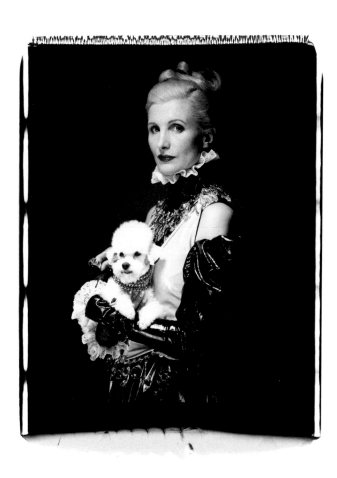

Irrlichter, #2.5, Polaroid, 88 x 56 cm, 2000

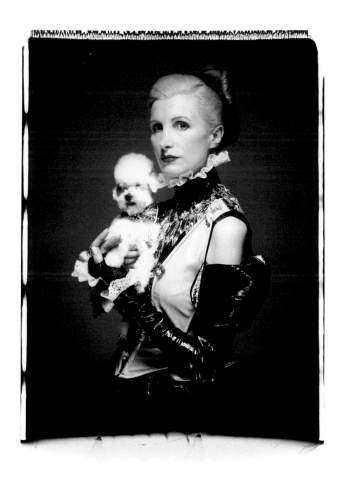

Irrlichter, #2.6, Polaroid, 88 x 56 cm, 2000

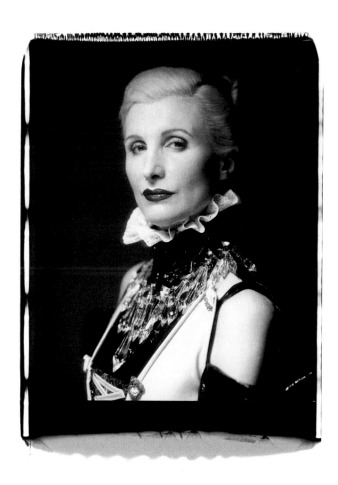

Irrlichter, #2.7, Polaroid, 88 x 56 cm, 2000

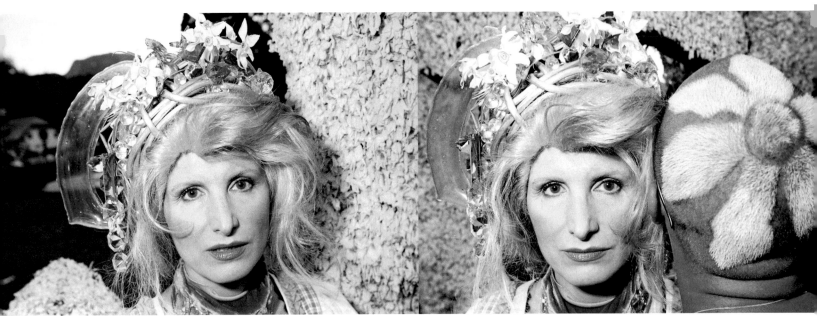

Irrlichter, #3.2, C-Print, 30 x 450 cm, 2000

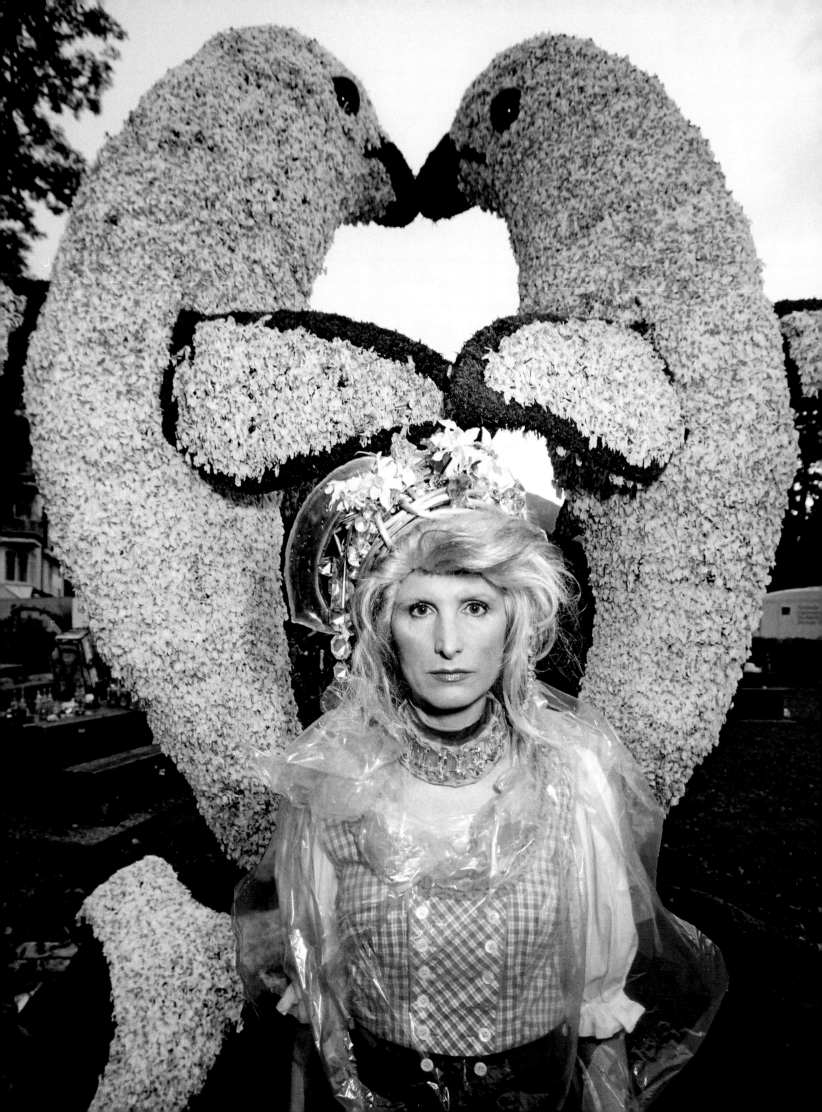

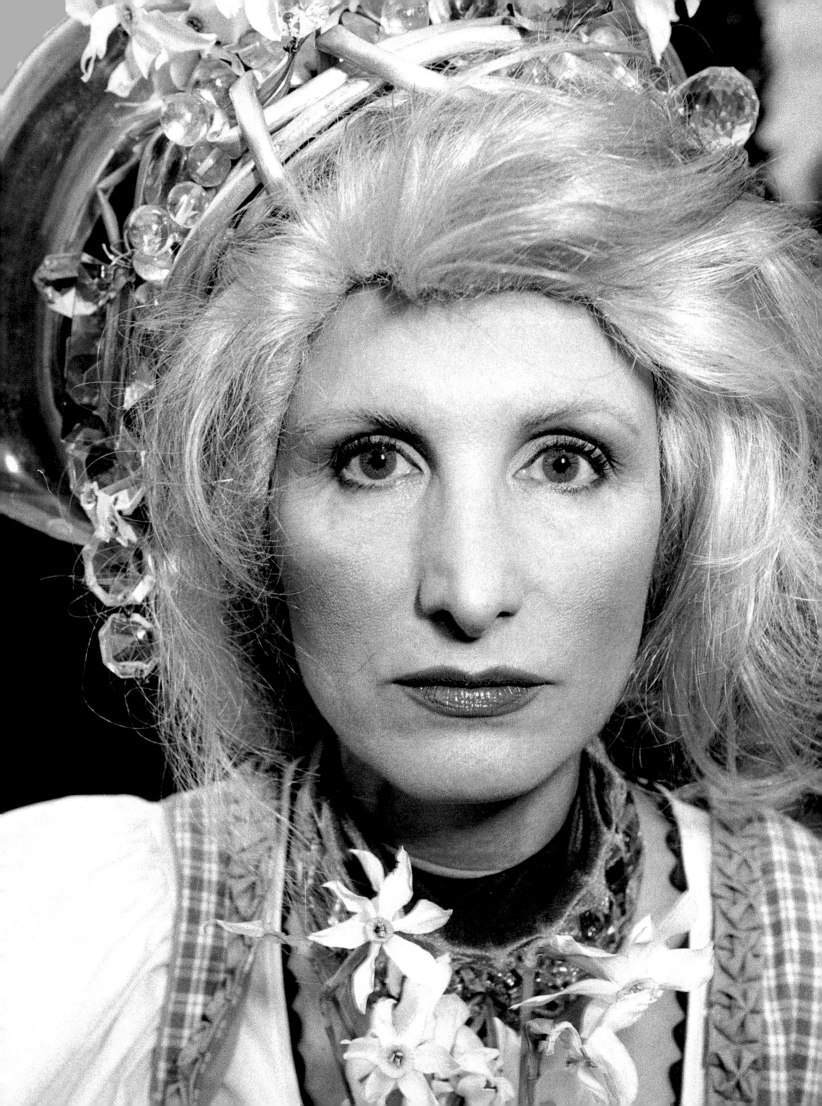

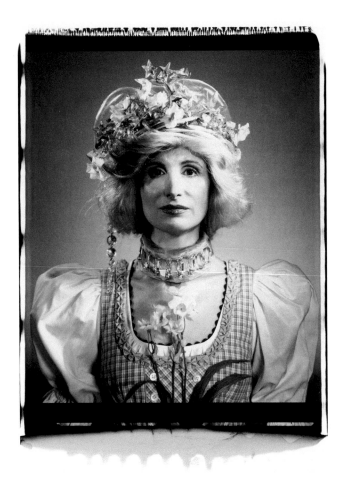

Irrlichter, #3, Polaroid, 88 x 56 cm, 2000

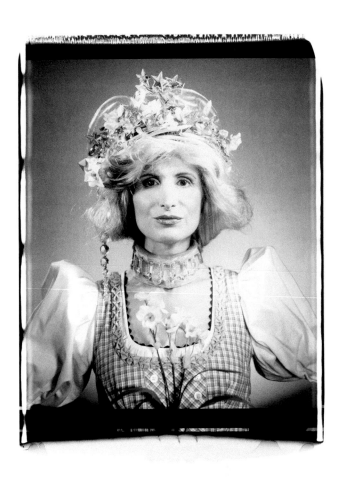

Irrlichter, #3.1, Polaroid, 88 x 56 cm, 2000

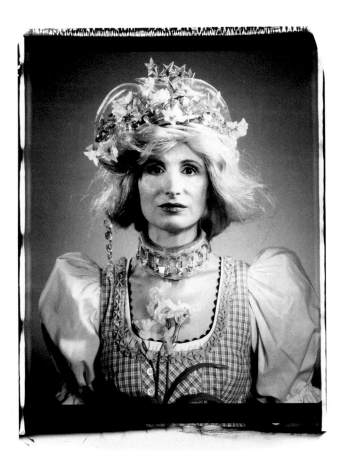

Irrlichter, #3.2, Polaroid, 88 x 56 cm, 2000

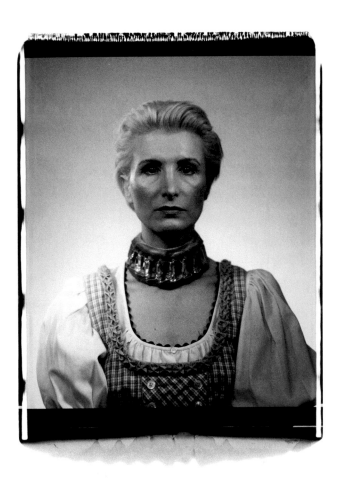

Irrlichter, #3.3, Polaroid, 88 x 56 cm, 2000

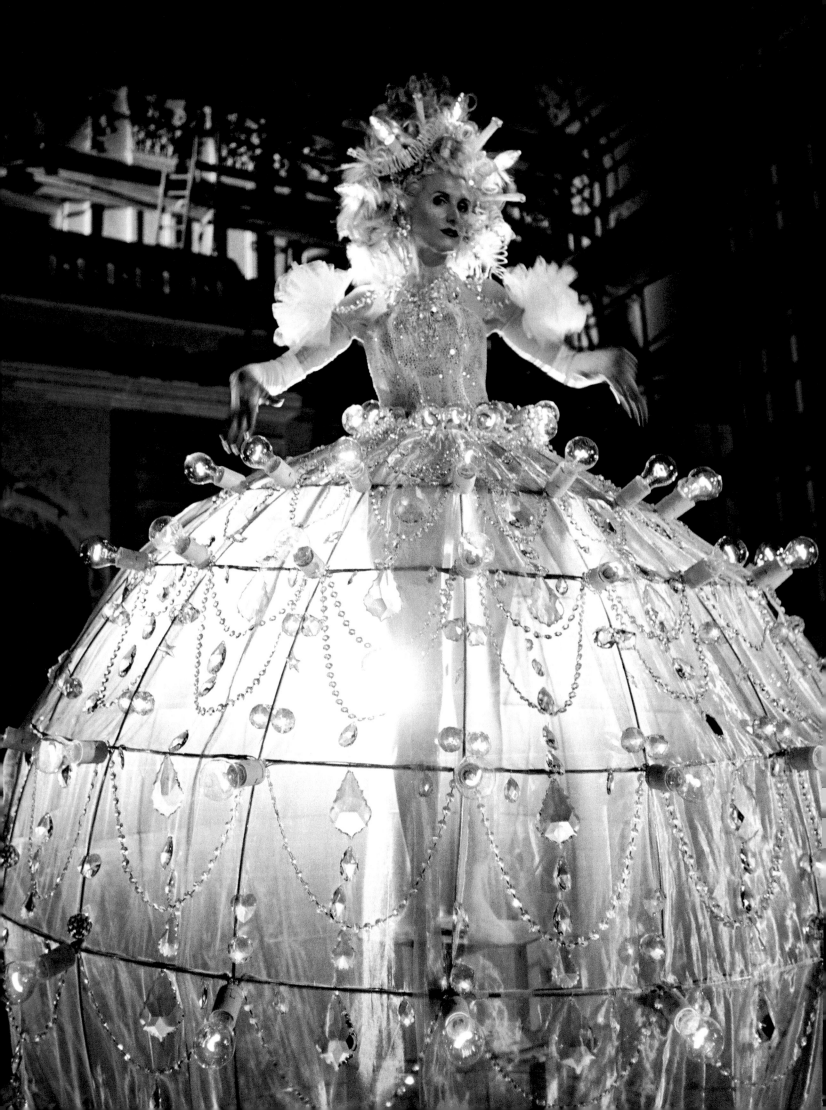

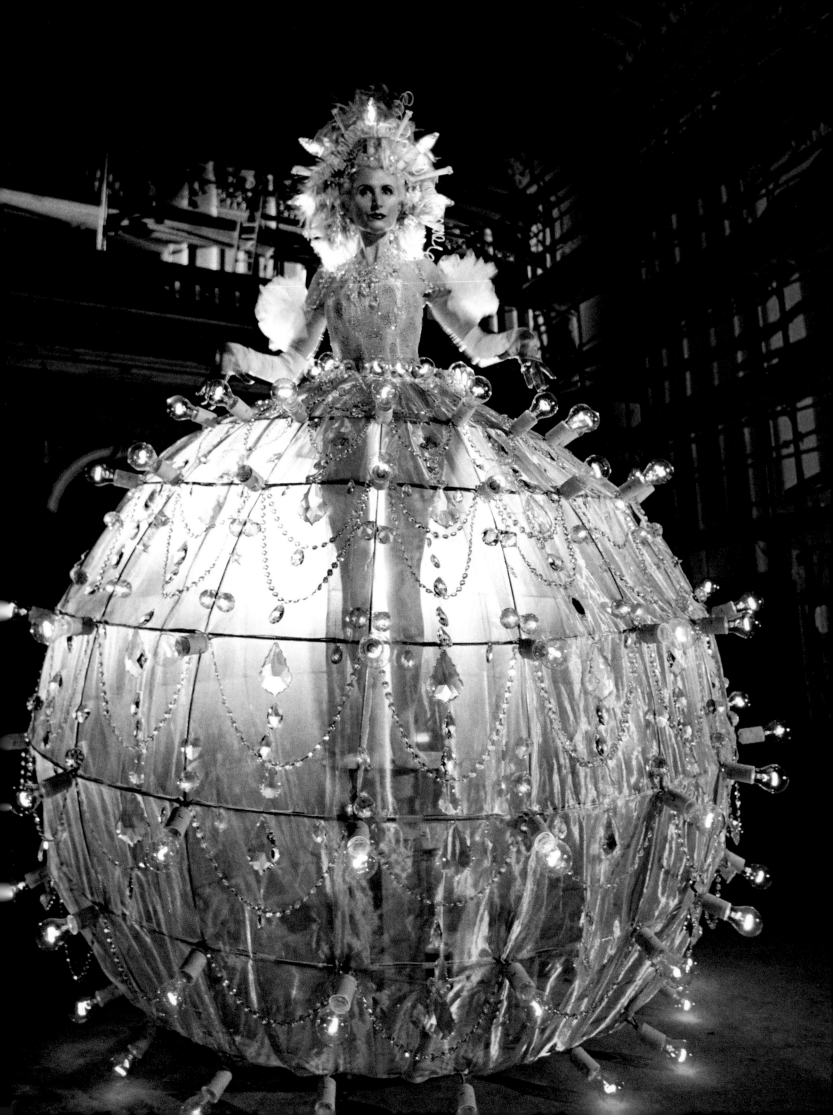

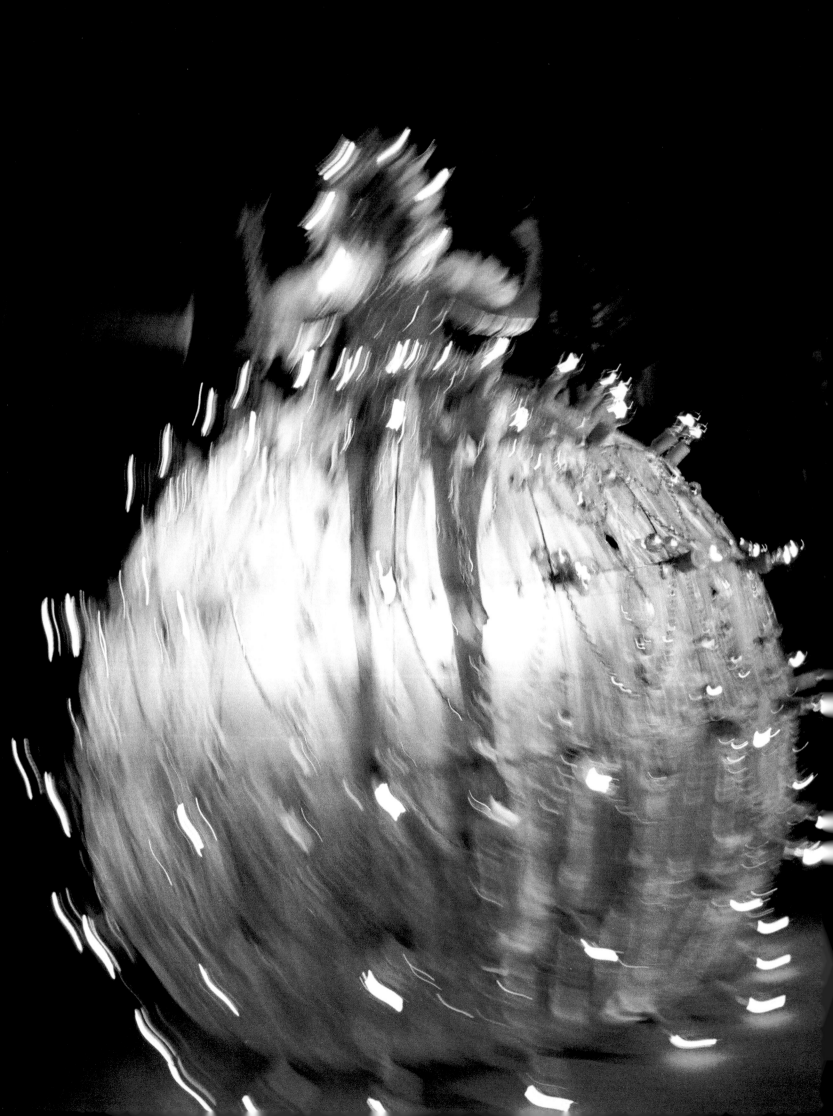

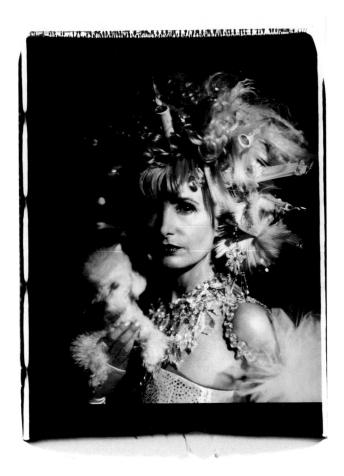

Irrlichter, **#4,** Polaroid, 88 x 56 cm, 2000

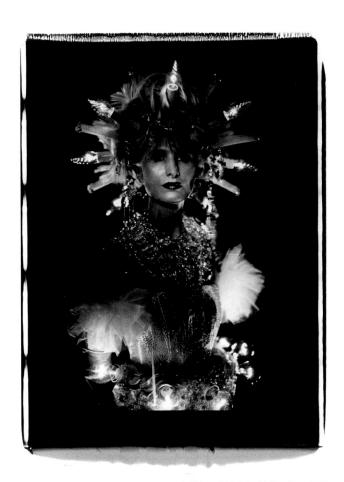

Irrlichter, **#4.1,** Polaroid, 88 x 56 cm, 2000

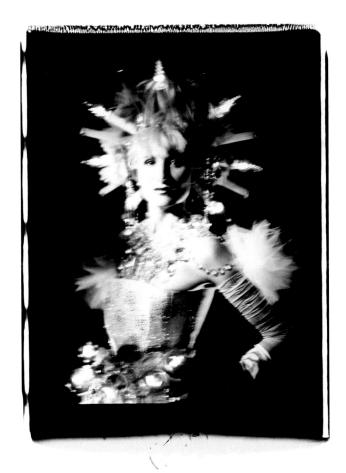

Irrlichter, **#4.2,** Polaroid, 88 x 56 cm,2000

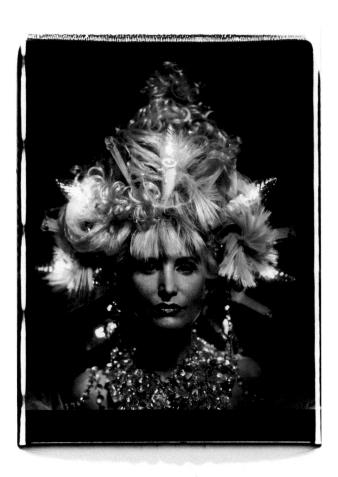

Irrlichter, **#4.3,** Polaroid, 88 x 56 cm, 2000

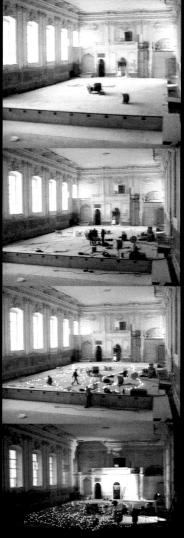
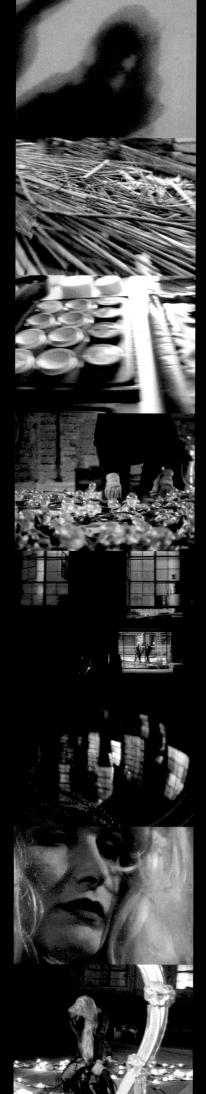

Irrlichter, Milli Stubel-Orth
Two Screen-Video, Digi-Beta / VHS, 23 min. 30 sec., 2000

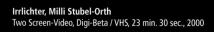
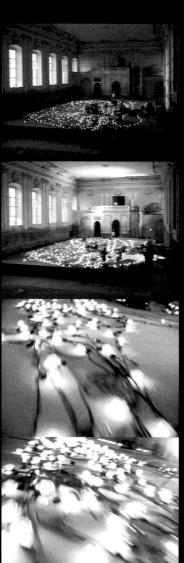

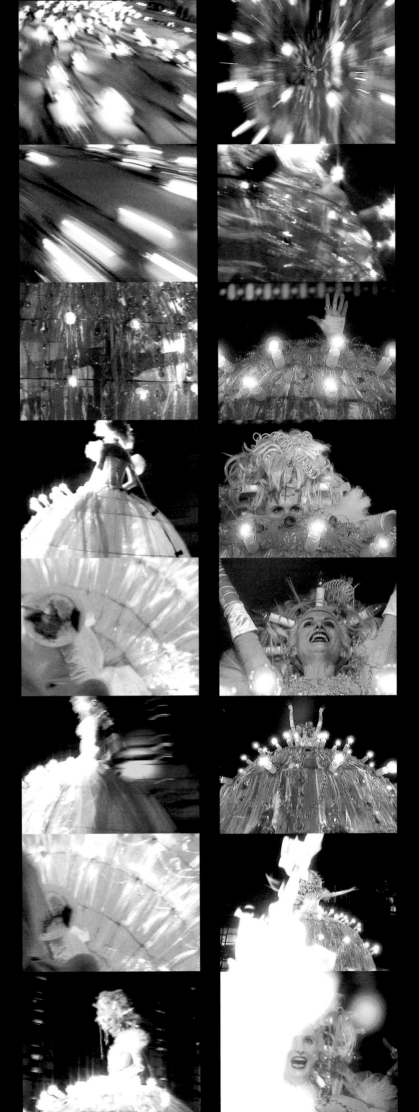

I.M. Dietrich, 2001

I.M. Dietrich #1, Lightbox, 160 x 124 cm, 2001

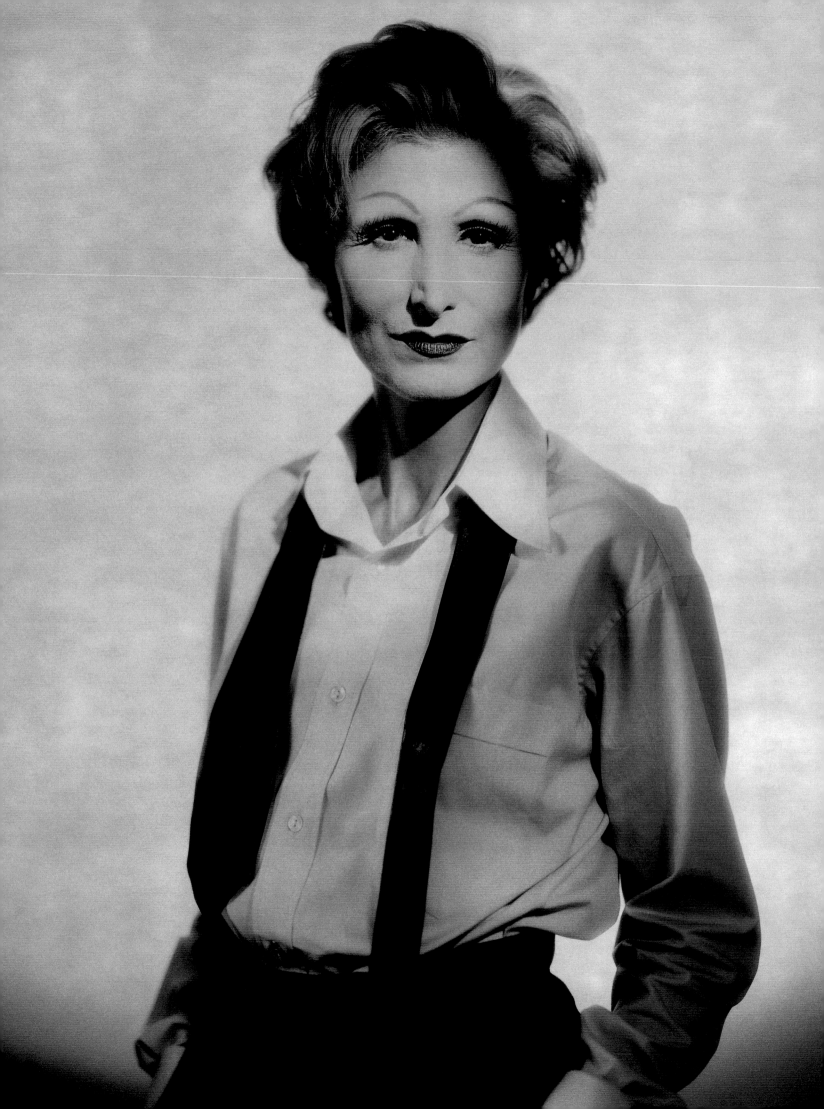

VERSUCHE ZUR KRAWATTE
ODER EINE HOMMAGE AN I. M. DIETRICH

Von Gerald Matt

„A well tied tie is the first serious step in life."
Oscar Wilde, aus „The Picture of Dorian Gray"

"The world is a stage"
Elvis Presley nach William Shakespeare

Eine gut gebundene Krawatte –
der immerwährende Sonnenuntergang

Bevor Balzac 1830 in seinem „Traité de la vie élégante" den Theorien Galls und Lavaters folgend einen Bezug zwischen Kleidung und Charakter feststellte, widmete er sich in „Seize leçons (...)" „L'art de mettre sa cravatte". Lord Byron gar soll schlaflose Nächte damit verbracht haben, sein Halstuch so perfekt und faltenlos zu binden wie der von ihm so bewunderte Beau Brummell.

Brummell, der Dandy der Dandys, bestimmte als unangefochtener „arbiter elegantiarum" den Kleidungs- und Lebensstil einer ganzen Epoche. Die Dandys Europas verfielen der von ihm geprägten „necklothiania", und die Blasiertesten schickten ihre Wäsche nach England im Wissen der Unvergleichlichkeit der englischen Rasenbleiche.
Der Dandy Baudelaire pflegte seine Haare den Farbnuancen seiner Krawatten entsprechend zu färben.

Arnold Hauser vergleicht in seiner „Sozialgeschichte der Kunst" das Phänomen des Dandy mit jenem des Bohemien. „Sie verkörpern den gleichen Protest gegen die Trivialität und Routine des bürgerlichen Lebens, nur dass sich die Engländer mit der Sonnenblume im Knopfloch leichter abfinden als mit dem offenen Kragenknopf." Der Dandy fordert mit seinem Ich heraus, im Kult seiner Selbst formuliert er ein Programm gegen alles Utilitaristische und Kollektive.

Oscar Wilde lässt in „An Ideal Husband" den Dandy Lord Goring diese Haltung im berühmten Dialog mit seinem Butler Phipps räsonieren: „To love oneself is the beginning of a livelong romance." Gleichwohl stellt er klar: „Fashion is what one wears oneself, unfashionable is what other people are wearing."

Indem der Dandy Moral durch Stil ersetzt, den Arbeitszwängen den Müßiggang gegenübersetzt und die Pflicht durch den Genuss ersetzt, brüskiert er die bürgerliche Welt mit ihrem Puritanismus und Nützlichkeitsdenken.

Die Verweigerung des Dandy gipfelt in der „Metaphysik der Provokation", wie sie Walter Benjamin an Baudelaires „Strategie des Chaos" aufzeigt.

Wenn etwa der Dandy Baron de Montesquieu, Vorbild von Marcel Proust für seinen Baron Charlus, andachtsvolle Stunden mit der seelischen Stimmungen folgenden Auswahl seiner Krawatten zubrachte, dann verbirgt sich hinter dieser Ankleidungspraxis dieselbe verachtende Herausforderung für eine immer leistungs- und zweckorientiertere Zeit wie in der Haltung Oscar Wildes, der auf Befragen nach seiner Tagesbeschäftigung einmal erklärte, er habe den gesamten Morgen mit der Durch-

TRY TO TIE
OR A HOMAGE TO I. M. DIETRICH

by Gerald Matt

"A well-tied tie is the first serious step in life"
Oscar Wilde, in "The Picture of Dorian Gray"

"The world is a stage"
Elvis Presley after William Shakespeare

A Well-Tied Tie –
The Perpetual Sunset

Before Balzac, in his "Traité de la vie élégante" of 1830, established the theories of Gall and Lavater concerning a connection between apparel and character, he devoted himself to "Seize leçons"... on "L'art de mettre sa cravatte." Lord Byron was even said to have had sleepless nights about tying his cravat as perfectly and faultlessly as Beau Brummell, whom he so admired.

Brummell, the dandy of dandies, unchallenged "arbiter elegantiarum," defined the style of clothing and living of an entire epoch. The dandies of Europe were seized by "necklothiania," as he expressed it, and the blasénistas sent their laundry to England, secure in the knowledge of the incomparable quality of English lawn bleaching.

The dandy Baudelaire took care that the colour nuances of his hair matched his ties.

Arnold Hauser in his "Social History of Art" compared the phenomenon of the dandy to that of the bohemian. "They embody the same protest against the triviality and routine of bourgeois life, except that Englishmen put up with a sunflower in the buttonhole more easily than with an open collar button." The dandy challenges with his "I," formulating in the cult of his self a programme against all utilitarianism and collectivism.

Oscar Wilde had the dandy Lord Goring in "An Ideal Husband" muse on this stance in the famous dialogue with his butler Phipps: "To love oneself is the beginning of a lifelong romance." Nevertheless he makes it clear: "Fashion is what one wears oneself, unfashionable is what other people are wearing."

By having style take the place of morality, indolence replace the constraints of work and duty replaced by pleasure, the dandy brushes off the bourgeois world with its Puritanism and utilitarian thinking.

The denial of the dandy peaks in the "metaphysics of provocation," as Walter Benjamin demonstrates using Baudelaire's "strategie of chaos."

When for instance the dandy Baron de Montesquieu, Marcel Proust's model for his Baron Charlus, spent rapt hours with the emotional moods following selection of his ties, he concealed, behind this dressing practice, the same despising challenge to a time which was always oriented on achievement and purpose as in that stance of Oscar Wilde who, questioned about his day's occupation, once declared that he spent the entire morning in the inspection of his poem and finally discovered a comma too many; around evening he put it back again.

sicht seiner Gedichte zugebracht und schließlich ein Komma herausgenommen; gegen Abend habe er es wieder eingesetzt.

Das Leben gilt dem Dandy als unerträglicher Fehlschlag, von naturgemäßer Stillosigkeit und Banalität. Von Effizienz und Funktionalität dominiert, dient es allein dem Fortkommen und der Erhaltung der Gesellschaft. So beklagt Oscar Wilde, dass das Leben, was die Form angeht, schrecklich ungenügend sei. Kunst und Künstlichkeit wird hier im Sinne Gautiers mit Tugend gleichgesetzt.

So unnatürlich die Krawatte den Hals zwischen Körper und Kopf einschnürt, so sehr spiegelt sie die Haltung des Ästheten wider.

Wo die Schönheit absolut gesetzt wird, wird die Welt nur als ästhetischer Gegenstand auf Kosten der Wirklichkeit zugelassen.

Die Natur ist wieder das geworden, was sie immer war, nämlich schmutzig und unbequem. Wenn Wilde hierzu meint: „Was Kunst wirklich für uns enthüllt, ist ihr Mangel an Design, ihre seltsame Grobheit, ihre außergewöhnliche Monotonie und ihr absolut unvollendeter Zustand", dann hat sentimentale Rousseau'sche Naturduselei ausgespielt. So wenig die Natur den Ansprüchen des Ästheten genügt, so sehr gilt sie diesem nun als Auftrag und Chance für die Inszenierung seiner Selbst.

Die programmatische Distanz des Dandy allem Natürlichen gegenüber findet in der modischen Stilisierung und im kultivierten Aperçu seine äußere Entsprechung.

Der Kult um die Krawatte spiegelt jene Haltung wider, die das Leben zum Kunstwerk und die Funktionslosigkeit zu dessen Sinn erklärt. Hinter der Liebe zur Krawatte, zum Detail, steht, wie Walter Pater es formuliert: „The power of being deeply moved by the presence of beautiful objects."

Voller Hingabe für den schönen Gegenstand, voller Verehrung für den Fetisch führen Ästheten wie Huysmans, Pater oder D'Annunzio ihren aussichtslosen Kampf gegen die Vergänglichkeit des Seins und gegen die unerbittliche Macht des Schicksals. Die Krawatte wird so zum Code für die Vergeblichkeit des Bemühens um Autonomie und Selbstbestimmung. So bleibt eines der letzten Accessoires männlicher Schönheit und Raffinements in Zeiten totalitärer Bequemlichkeits- und Freizeitfanatiker „ein letzter Akt des Heroismus in Zeiten des Verfalls", „ein immerwährender Sonnenuntergang", wie Baudelaire das Schicksal des Dandy melancholisch bedauerte.

Resigniert hält auch Camus fest: „Wenn die Dandys sich nicht umbringen oder verrückt werden, machen sie Karriere." Die Krawatte freilich bleibt ein für beiderlei Zwecke vortrefflich geeignetes Mittel.

"Ich probiere Geschichte wie Kleider"
Max Frisch

Life for the dandy was an intolerable failure, of natural lack of style and banality. He alone served the advancement and maintenance of a society dominated by considerations of efficiency and functionality. So Oscar Wilde lamented that life in the form it took was dreadfully inadequate. Art and artificiality here become, in Gautier's sense, equated with virtue.

To the extent that the tie unnaturally constricts the neck between body and head, to that extent it mirrors this posture of the aesthetes.

Where beauty is made absolute, the world is only allowed as an aesthetic subject at the expense of reality.

Nature again becomes what it always was, namely dirty and uncomfortable. When Wilde gave as his opinion on this matter that, "What art really reveals for us is its design flaws, its peculiar roughness, its extraordinary monotony and its absolutely unfinished state," sentimental soft-focus nature à la Rousseau was played out. Little as nature satisfied the demands of the aesthetes, it now served them as a project and an opportunity for self-staging.

This programmatic distance of the dandy from all things natural found its external expression in modish stylisation and cultivated aperçu.

The cult of the tie mirrored that posture which understands life as a work of art and the lack of functionality as the sense of it. Behind the love of ties, of detail, stands, as Walter Pater put it, "The power of being deeply moved by the presence of beautiful objects."

With complete passion for the beautiful object and complete admiration for the fetish, leading aesthetes such as Huysmans, Pater or D'Annunzio prosecuted their hopeless war against the transitoriness of being and the unrelenting power of destiny. The tie thus becomes a code for the futility of efforts towards autonomy and self-determination. What remains is one of the last accessories of manly beauty and refinement in a time of totalitarian fanatics of comfort and leisure; "a last act of heroism in times of decline," "a perpetual sunset," as Baudelaire melancholically regretted the fate of the dandy.

Camus, too, observed with resignation that, "When the dandies do not kill themselves or go mad, they make careers." But for both purposes the tie remains a splendidly suitable medium.

"I try on stories like clothes"
Max Frisch

Corbata feminina – der weibliche Dandy

Von Kopf bis Fuß auf Gender Trouble eingestellt: Marlene, die Göttliche. Blassblauer Engel, der mit einem Schmetterlingszucken der Lider und mit einer wie achtlos scheinenden und doch perfide konzipierten Verschränkung der Schenkel Professor Unrat in den Abyssus, ja den Jünger'schen Blechsturz eines existenziellen Kataklysmus peitscht. Aber auch: Marlene, der weibliche Dandy. Beau Brummell, über die Geschlechterachse gehüpft, der Angel azul als „Blue Boy" wiedererstanden. Ein Gemälde von Gainsborough, von Marlene Dietrich bei einem Kostümfest zum lebenden Bild geadelt. Die Frauen waren oft wütend über sie, doch die Herrenwelt applaudierte, wenn sie mit Seglermütze, marineblauem Blazer und weiten, weißen Hosen erschien oder ihre Gäste bei der Gartenparty in kurzen bayerischen Lederhosen überraschte. See what the boys in the backroom will have, and tell them I'm having the same!

Schnappschuss von 1953: Marlene, die schönste Zirkusdirektorin der Welt, die unschlagbaren Beine den gierigen Blicken feilgeboten. Schwarze, halbhohe Stiefeletten, schwarzer Zylinder, weiße Nelke, die Chambrière, wie die Dresseure sie für Pferdenummern verwenden, vorschriftsmäßig in Gebrauch. Am Hals: eine weiße Fliege. Bübisch freches Grinsen. Ein Wesen, das sich immer wieder selbst und neu erschafft, mit der Eleganz einer Soubrette zwischen den Polen Mann und Frau fluktuierend. Go see what the boys in the backroom will have, and give them the poison they name. Dietrich in Rio: ein weißer Engel im Frack, auf die Lehne des verkehrt herum platzierten Sessels gestützt. Leere Champagnergläser erzählen von welken Exzessen verschwendeter Nächte. Ein Prosit der Ungemütlichkeit. Angel exterminator: ein Würgeengel, selbst gewürgt von jenem eng geschnürten Binder, der nach der Art einer Schanz'schen Krawatte den schlanken, hungrigen Hals ruhigstellt. Marlene als emblematische Tortikollis-Patientin, vom Erfolg stranguliert, vom allzu schnellen Leben in Atemnot gebracht. Gala-Vorstellung im Théâtre de l'Etoile in Paris: Makin' Whoopee. Die Arme triumphal nach oben gestreckt, die Gesichtszüge aus der strengen Façon entgleist und einem befreiten Lächeln anheim gegeben. Trommelwirbel, Frack und Zylinder: Meine Damen und Herren, Biologie ist Schicksal. Zer-schmettern wir die Grenzen zwischen Mann und Frau, sodass Geschlecht, Charakter und Begehren flexibel, frei fließend und deterritorial werden. I.M. Dietrich. Irene Andessner auf dem Weg zu Marlene Dietrich. Metamorphose in Berlin. Herr Dietrich ist Herr Dietrich ist Herr Dietrich. Frau Andessner ist Frau Dietrich ist Frau Andessner. „Wohin?", „Hin und Retour". Aus San Fransisco de Paula, Kuba, Ernest Hemingway am 26. September 1951: "She is brave, beautiful, loyal, kind and generous. She is never boring and is as lovely looking in the morning in a GI shirt, pants and combat boots as she is at night or on the screen. ... I know that every time I have ever seen Marlene Dietrich it has done something to my heart and made me happy. If this makes her misterious then it is a fine mystery." Ein Herr wirft vor Begeisterung sein Smoking-Jackett auf die Bühne. Marlene fängt es auf und singt einfach weiter. Und dann ist die Show vorbei. Die Leute im Publikum stehen auf, um ihre Sitze zu verlassen. Es ist Zeit, die Mäntel zu holen und nach Hause zu gehen. Sie drehen sich um ... da sind keine Mäntel mehr und auch kein Zuhause.

„Du tust so viele wunderbare Dinge"
Orson Welles an Marlene Dietrich

Corbata Feminina – The Female Dandy

Falling in gender trouble again: Marlene the divine. Pale blue angel, who with a butterfly's flutter of the eyelids and a seemingly thoughtless yet perfidiously conceived crossing of the thighs hurtles Professor Unrat into the abyss, even the Jüngerish Blechsturz of an existential cataclysm. But also: Marlene the female dandy. Beau Brummell frolicking along the gender axis, the ángel azul rising again as "Blue Boy." A painting by Gainsborough of Marlene Dietrich at a fancy-dress ball, ennobled to the rank of a living picture. Women were often furious about her, though the male world applauded when she appeared in sailor's cap, marine blue blazer and wide, white trousers, or surprised her guests at a garden party in short Bavarian lederhosen. See what the boys in the backroom will have, and tell them I'm having the same!

Snapshot from 1953: Marlene, the most beautiful circus director in the world, the matchless legs offered for sale to greedy eyes. Black, half-length ankle boots, black topper, white carnation, the chambrière, like the animal trainers use for horse numbers, used according to the regulations. At the neck, a white bow tie. Mischievous cheeky grin. A being that re-creates itself again and again, with the elegance of a soubrette fluctuating between the poles of man and woman. Go see what the boys in the backroom will have, and give them the poison they name. Dietrich in Rio: a white angel in tails, supported on the armrest of the sofa transported and placed there. Empty champagne glasses tell of the wilted excesses of wasted nights. Cheers to discomfort. Angel exterminator: an Angel of Death, a strangled angel, herself strangled by that tight-tied tie which immobilises the slender, hungry neck in the manner of a neck support collar. Marlene as emblematic torticollis patient, strangled by success, brought to shortness of breath by an all too quick life. Gala performance at the Théâtre de l'Etoile in Paris: makin' whoopee. The poor little girl triumphantly raised up, the features released from the strict façon and given over to unbound laughter. Drum roll, topper and tails: Ladies and gentlemen, biology is fate. We shatter the boundaries between man and woman so that gender, character and desire become flexible, free flowing and displaced. I.M. Dietrich. Irene Andessner on the way to Marlene Dietrich. Metamorphosis in Berlin. Herr Dietrich is Herr Dietrich is Herr Dietrich. Frau Andessner is Frau Dietrich is Frau Andessner. "Where to?" "There and back." Ernest Hemingway on 26 September 1951 from San Fransisco de Paula, Cuba: "She is brave, beautiful, loyal, kind and generous. She is never boring and is as lovely looking in the morning in a GI shirt, pants and combat boots as she is at night or on the screen. ... I know that every time I have ever seen Marlene Dietrich it has done something to my heart and made me happy. If this makes her mysterious then it is a fine mystery." A gentleman throws his smoking jacket on the stage for the fun of it. Marlene catches it and simply goes on singing. And then the show is over. The people in the audience stand up to leave their seats. It is time to put on coats and go home. They turn around ... there are no more coats and no home to go to.

"You do such wonderful things"
Orson Welles to Marlene Dietrich

„Morocco" – „binde mich"

Knotenform der DNA bei der Rekombination durch so genanntes crossing-over, Knoten in zehn Dimensionen, nicht mehr anschaulich vorstellbar in der String-Theorie, die sich um eine Vereinigung der allgemeinen Relativitätstheorie und der Quantenmechanik bemüht. Die meisten Krawattenknoten gehören zu den so genannten Elementarknoten. Dabei werden die älteren Halstücher als Spitzen zu einem halben Schlag oder Schleifenknoten gebunden. Schwarze Stocks und Frackschleifen zu Kreuzknoten und die Langbinder ausschließlich zu einem Gordingknoten, bekannt als Four in Hand.

Eine Stimme aus dem Off: „Ein Krawattenknoten ist jede geschlossene Krawattenkontur, wobei gilt, dass zwei Knoten äquivalent sind, wenn sie durch Verformung ineinander übergeführt werden können, anderenfalls sind sie nicht äquivalent."

Vorhang auf: Wir sehen Bagwig und Solitaire in einer Szene aus William Hogarth´s Stichfolge „Das Leben eines Wüstlings". Man trägt Stock, ein längliches weißes Musselintuch, das zu einem schmalen Band gefaltet, ein oder zweimal um den Hals gewickelt wird und im Genick mit einer Nadel befestigt wird, versteift mit Fischbein, Pappe, Leder oder gar Holz, das es in einen eisenharten Kragen verwandelt. Eleganz und Tortur.

Im Rampenlicht: Lola – Lola, Lieder, die erklingen und verwehen: „Männer umschwirren mich wie Motten das Licht." Und Professor Unrat, steif und ernst, der Selbstbinder tadellos, geschnürt, gebunden, verknotet, die Welt, die ist noch heil. Dann dräut die Liebe am Horizont, und die Krawatte, die wird lose und formt sich so und wieder anders. Und da stellt sich die Frage, wie ein Stück Tuch von bestimmter Form und Länge um den Hals – oder sonstwo gebunden wird. Cravatte à l´américaine, cravatte à l´orientale, cravatte collier de chavale, cravatte à la Byron. Die cravatte mathématique erfordert Übereinkunft von Symmetrie und Regelmäßigkeit, würdevoll und klar ihr Knoten, jede noch so winzige Falte ist ihr verboten. Die Enden sind geometrisch korrekt und halten jeder Prüfung, selbst der mit einem Kompass stand, wie uns Balzac in seiner „L´art de mettre sa cravatte" 1827 wissen ließ.

Es geht um den Knoten. Fesseln und gefesselt werden. 1930. Wieder Marlene, Marlene im weiten offenen Hemd, von Sternberg fotografiert, verwegener Blick, Konturen ihrer Weiblichkeit, Marlene mit umgebundener Krawatte. „Binde mir die Krawatte", scheint sie dem Mann hinter der Kamera zu befehlen, scheint sie allen Männern zu befehlen. 2002 I.M. Dietrich in Aktion. Tableau vivant in der Eden Bar.

Szenenwechsel: Dreharbeiten zu „Morocco", Frack, Zylinder, Sternbergs Licht, schwarzweiß, ein explosives Spiel von Licht und Schatten, die eisige Kühle der Nacht und der glühende Sog des Dämons, eine Ahnung von Lust und Schmerz, der Knoten schmerzt, der Knoten ist zu eng, das Blut steigt zu Kopf, der Kopf wird rot, und da ist die Angst, der Mut, die Lust, der Schmerz und Schluss.

„Wer die Schönheit angeschaut mit Augen, ist dem Tod bereits anheim gegeben"
August Graf von Platen

"Morocco" – "Tie Me"

DNA knot formation recombined through so-called crossing-over, knots in ten dimensions, no longer possible to picture in String Theory, which comes close to a unification of the General Theory of Relativity and of Quantum Mechanics. Most tie knots belong to the so-called elementary knots. Thus the older neckerchief tied as points into a half hitch or bow knot. Black stock and dress bow tie into a cross knot and the long tie only into a "four-in-hand."

A voice off: "A tie knot is any closed tie shape of which it is true that two knots are equivalent when they can be transferred through distortion into one another, otherwise they are not equivalent."

Curtain up: we see Bagwig and Solitaire in a scene from William Hogarth's series of engravings "A Rake's Progress." One wears a stock, a longish white muslim scarf which folds into a narrow band, is wrapped once or twice around the neck and fastened at the neck with a pin, stiffened with fish bone, cardboard, leather or even wood, which turns it into a iron-hard collar. Elegance and torture.

In the footlights: Lola, Lola, songs that sound and die away: "Men cluster to me like moths around a flame." And Professor Unrat, stiff and serious, the tie of the self perfect, tied, bound, knotted, the world – which is still sacred. Then love looms on the horizon and the tie, it becomes loose and forms itself so and then again another way. And there the question poses itself, like a piece of cloth of definite form and length around the neck – or wherever else. Cravatte à l'américaine, cravatte à l'orientale, cravatte collier de chavale, cravatte à la Byron. The cravatte mathématique requires an understanding of symmetry and regularity, its knot dignified and clear; every wrinkle, however tiny, is forbidden it. The ends are geometrically correct and hold up to every test, even one with a compass, as Balzac let us know in his "L'art de mettre sa cravatte" of 1827.

It's about the knot. Tying and being tied. 1930. Marlene again, Marlene in the wide open dress, photographed by Sternberg, bold gaze, contours of her femininity, Marlene with tie untied. "Tie my tie," she seems to command the man behind the camera, seems to command all men. 2002. I.M. Dietrich in action. Tableau vivant in the Eden Bar.

Change of scene. Film shoot for "Morocco," tails, topper, Sternberg's light, black and white, an explosive play of light and shadow, the icy cold of the nights and the glowing slipstream of the demons, a premonition of longing and pain, the knot hurts, the knot is too tight, the blood rises to the head, the head becomes red, and there is fear, courage, lust, pain. The end.

"Anyone who looks at beauty with the eyes is already Death's victim"
August Graf von Platen

Erotik und Tod –
die Krawatte als terminales Instrument

Von den unzähligen Höflingen des Königs stach die Figur des Signor di Miramond, „Cravatier" seiner Majestät, hervor. Sobald der Herrscher seine Krawatte festgeknotet hatte, war es seine Aufgabe, diese auszurichten und zu stilisieren. Ein scheinbar unbedeutendes Accessoire als jenes Kleidungsdetail, das den Liebreiz vollkommen machte. Die erotische Anmutung lag in der vorgeblichen Achtlosigkeit des Arrangements, die mit einem Höchstmaß an Präzision und Zeitaufwand erzielt wurde. „Meine erste Sorge gilt meiner Krawatte. Ich arbeite Stunden in der Hoffnung, dass sie wie hastig gebunden wirken mag."

Sinnlichkeit des Beiläufigen, Magnetismus der Désinvolture.

Später dann: Die obszöne Kleiderpracht der „Incroyables" im 18. Jahrhundert: überproportionaler Halsschmuck mit einer großen Anzahl von Schleifen, die das Kinn und die Unterlippe überdeckten. Lüsterne Hände, die im autoseduktiven Massagerubato über die knisternden Stoffe huschen. Im Allgemeinen gesehen gilt die Krawatte unumstritten als Symbol des Penis, dekretiert das Lexikon der Erotik. Wenig später endete so manche Halszierde blutig an einem kopflosen Rumpf unter der Guillotine.

„Das Schrecklichste ist der Tod, und das Werk des Todes aufrechterhalten, verlangt die größte Kraft" (Hegel).

Das weiche Gewebe umschmeichelt den Hals. Zartgliedrige Frauenfinger mit Nikotinflecken überprüfen den Sitz des Knotens, lassen den Stoff mit einem pfeifenden Geräusch herausschnellen. Zuziehen, Dichtmachen, Kehle abschnüren – die Krawatte als terminales Instrument – das wäre eine Option. Die Erotik siedelt sich an der Grenze zwischen Leben und Tod an, sagt Georges Bataille. In der Überschreitung wächst das Erleben über sich hinaus, im finalen Akt ereignet sich die Transgression. Wir erreichen die Ekstase nicht, wenn wir nicht den Tod, die Vernichtung vor uns sehen, und wären sie noch so fern. Eine Frauenleiche treibt in der Themse – nackt bis auf den Schlips, mit dem sie erwürgt wurde. „Frenzy" von Hitchcock. Der Regisseur mit dem Blähhals, der den Binder unter Fettwülsten beerdigte, wusste um den geheimen Code der vier Reiter der Apokalypse: Grüne Krawatte – Pest. Gelbe Krawatte – Hungersnot. Schwarze Krawatte – Tod. Rote Krawatte – Krieg. Das Artefakt der bürgerlichen Selbststilisierung als McGuffin – das war der vorletzte Trick des Meisters. Danach kam bald das Familiengrab. Während der Dreharbeiten zu „Frenzy" erlitt Alma Hitchcock einen Schlaganfall – eine zugeschnürte Krawatte soll nicht im Spiel gewesen sein. Wir empfangen das Sein nur in einem unerträglichen Hinausgehen über das Dasein, spuckt der Necktie-Murderer zwischen den Zähnen hervor. Und da es uns im Tod zur gleichen Zeit, wo es uns geschenkt auch wieder genommen wird, müssen wir es in dem Gefühl des Todes suchen, in den unerträglichen Momenten, in denen uns scheint, dass wir sterben, weil das Sein in uns nur mehr Exzess ist.

„Man ist entweder ein Teil des Problems, ein Teil der Lösung
 oder ein Teil der Landschaft"
Robert De Niro

Eroticism and Death –
The Tie as Terminal Instrument

The figure of Signor di Miramond, "cravatier" to his majesty, stood out from the innumerable courtiers of the king. As soon as the monarch had knotted his tie it was his job to line it up and style it. It was such an apparently insignificant accessory as that detail of dress that made the charm complete. The erotic presentation lay in the seeming carelessness of the arrangement which was achieved with maximum precision and expenditure of time. "My first care was for my tie. I worked hours in the hope that it would give the effect of having being tied in a rush."

Sensuality of the fleeting, magnetism of the désinvolture.

Later… The obscene dress code of the "Incredibles" in the 18th century: huge, out of proportion neck jewels, multi-faceted, that cover up the chin and upper lip. Lascivious hands that flicker over the rustling material in the auto-seductive massage rubato. In general, the lexicon of the erotic decrees that the tie is to be seen indisputably as a symbol of the penis. A little later some of these decorated necks ended up bloody on a headless torso under the guillotine. "The most terrible is death, and sustaining the work of death requires the greatest strength." (Hegel)

The soft fabric caresses the neck. Tenderly gliding woman's fingers with nicotine marks check the placing of the knot, let the material fall with a whistling sound. Tighten, close, block off the throat: the tie as terminal instrument – that would be an option. The erotic takes up its position at the boundary between life and, says Georges Bataille. In the crossing over, experience surpasses itself; in the final act, transgression occurs. We do not attain ecstasy when we do not see before us death, annihilation, be they still ever so far off. A woman's body drifts in the Thames, naked except for the tie with which she was strangled. "Frenzy" by Hitchcock. The director with the swollen neck which buries the tie under bulging fat knew about the secret code of the four horsemen of the apocalypse. Green tie – pestilence. Yellow tie – famine. Black tie – death. Red tie – war. The artefact of the bourgeois self-styling as McGuffin – that was the master's penultimate trick. Soon after came the family grave. During the shooting of "Frenzy" Alma Hitchcock suffered a stroke – a too-tight tie was not, apparently, involved. We receive being only in an unbearable going beyond of being-there, the necktie murderer spits out between his teeth. And because in death it will be taken away from us again at the same time as it is given to us, we have to seek it in the sense of death, in the intolerable moments in which it appears to us that we die because being in us is nothing more than excess.

"You're either part of the problem, part of the solution, or part of the landscape"
Robert De Niro

Von Cary Grant bis Robert De Niro – Virtute et armis

„Les Incroyables", Männer, deren exzentrische Halstücher mehrere Meter Stoff erforderten, da sie bis zu zehn Mal um den Hals gewickelt wurden. Erscheinungen, die auf den Boulevards Wolken aus Essenzen und Parfums zurückließen.

Kreaturen, die dem gemeinen Passanten das Rätsel aufgaben, welchem Geschlecht sie wohl zuzuordnen seien, empörte sich das „Town and Country Magazine" im Jahre 1772. Später der glänzende, der silberne Prinz, Prinz of Wales, Trendsetter der Moden und Affären, Prinz Edward, der Wallis Simpson dem Thron und den großen Knoten und gespreizten Kragen der Krawattenkonvention vorzog. Breit und üppig, seiden und bunt, Geschichten, Materialien, Muster, Schnitte, Charaktere: Vintage Ties der 40er und 50er Jahre mit ihren geometrisch und floralen Dekorationen. Da sieht man urbane bunte Gittermuster à la Mondrian und vulvaschlundige O´Keeffe´sche Blumenarrangements. Hawaii-Palmen, Bikinifrauen und Atombomben-Explosionen bilden die narrativen Muster jener Tage. Üppige Zeiten, Jane Russells Brüste, von denen Nicholas Ray sagte, dass sie die einzigen Torpedos waren, die er je liebte, Robert Mitchums viriles Grinsen, seine Fäuste in „The Night of the Hunter": Love and Hate. Ein Überfluss an Gefühlen, Stoff und American Way of Live. Später Jim Dines orange Necktie aus dem Jahr 1962, (mixed media collage, Öl und Krawatte auf Leinwand), dann Cary Grant in Hitchcocks Film „North by Northwest", auf einem Getreidefeld, nowhere land, unter Beschuss durch ein Flugzeug, laufen, fallen lassen, Deckung, Staub und Dreck, doch das Tenue und die Krawatte sitzen tadellos, Gefahr und Eleganz, Cary Grant – ein Held, dann 1960: schmal, windschlüpfig, effizient, eilig, zwischen Tür, Angel und Mondlandung, auf dem Sprung zum Weltfrieden und zum ewigen Leben, „Reader's Digest" und Bikiniatoll, Sean Connery, der Mann im Aston Martin, die Krawatte, der Bottle und Body Opener, später Casino, die Las-Vegas-Hymne des Krawattenfetischisten, Martin Scorsese, der gerne jene Geschichte erzählt, in der er den Krawattenfetischisten Robert De Niro bei den Dreharbeiten fragt, wie er denn den Charakter eines Menschen beurteile. Robert De Niro antwortete lakonisch: „Nach der Krawatte, die er trägt." Als Scorsese weiter wissen wollte, was denn wäre, wenn einer keine Krawatte trage, schloss De Niro: „Dann hat er keinen Charakter."

„Weiß war sie, genäht aus einem groß strukturierten, rauen, seltenen Stoff und besetzt mit blauen Punkten, hellblau wie Vergissmeinnicht, und die Pünktchen waren eingewebt, obwohl sie wie aufgeklebt wirkten, sie schimmerten wie Eisenspäne … eine solche Krawatte, wie ich sie hatte, die besaß keiner hier, und so ging ich in ein Herrenwäschegeschäft, und kaum war ich eingetreten, stand ich im Zentrum aller Blicke, der Mittelpunkt war die Krawatte, denn ich wusste, wie man eine solche Krawatte zu knüpfen hatte, und so war ich Mittelpunkt des Interesses."

Bohumil Hrabal, aus „Ich habe den englischen König bedient"

From Cary Grant to Robert De Niro – Virtute et Armis

The "Incredibles," men whose eccentric cravats need several meters of material because they have to wrap them up to ten times around the neck. Apparitions trailing clouds of essence and perfume along the boulevards.

"Town and Country Magazine" in 1772 was outraged by creatures who posed to the vulgar passers-by the puzzle of their true gender attribution. Later the shining, the silvery prince, Prince of Wales, trend-setter of fashion and affairs, Prince Edward, who preferred Wallis Simpson to the throne and the great knots and spreading collars of tie orthodoxy. Broad and voluptuous, silky and colourful, appearances, materials, design, cut, character: vintage ties of the 40s and 50s with their geometrical and floral decorations. There one sees urbane, colourful grid patterns à la Mondrian and O'Keeffe-like vulva-mawed flower arrangements. Hawaii palms, bikini girls and atom bomb explosions form the narrative pattern of those days. Voluptuous times, Jane Russell's breasts, of which Nicholas Ray said that they were absolute torpedoes which he would love forever, Robert Mitchum's virile sneers, his fists in "The Night of the Hunter": Love and Hate. A surplus of feelings, material and American way of life. Later came Jim Dine's orange necktie of 1962 (mixed media collage, oil and tie on canvas), then Cary Grant in Hitchcock's film "North by Northwest," in a cornfield, nowhere land, under fire from a plane, running, dropping, cover, dust and dirt, yet the attire and the tie stay perfect, danger and elegance, Cary Grant – a hero, then 1960: slim, streamlined, efficient, urgent, passing through en route to a moon landing, world peace and eternal life on the way, "Reader's Digest" and Bikini Atoll, Sean Connery, the man in the Aston Martin, the tie, the bottle and body opener, later Casino, the Las Vegas hymn of the tie fetishists, Martin Scorsese, who liked to tell the story of how tie fetishist Robert De Niro asks during a shoot how to judge the character of a man. Robert De Niro replied laconically, "By the tie he's wearing." When Scorsese wants to know more, how it would be if a character was not wearing a tie, De Niro closes with, "Then he has no character."

"White it was, sewn from large, structured, rough, scarce material and covered with blue points, light blue like forget-me-not, and the little points were worked in, although they gave the appearance of being stuck on, they shimmered like iron filings … such a tie I had, that no one here owned, and so I went into a men's drapery shop and had hardly come through the door than all eyes were on me, the tie at the centre of attention, because I knew how to knot such a tie and so I was the centre of attention."

Bohumil Hrabal, from "I Served the King of England"

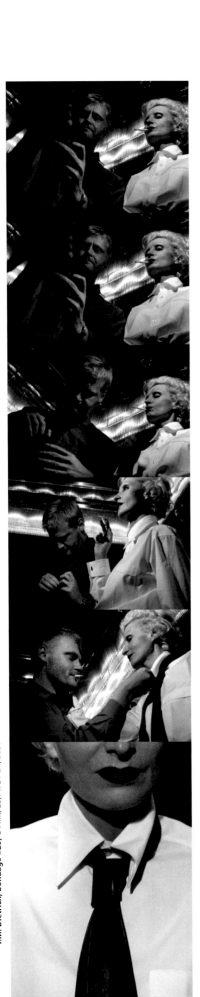

I.M. Dietrich, Bondage #29, C-Print, 29,7 x 21 cm, 2001

I.M. Dietrich, Bondage #16, C-Print, 40 x 30 cm, 2001

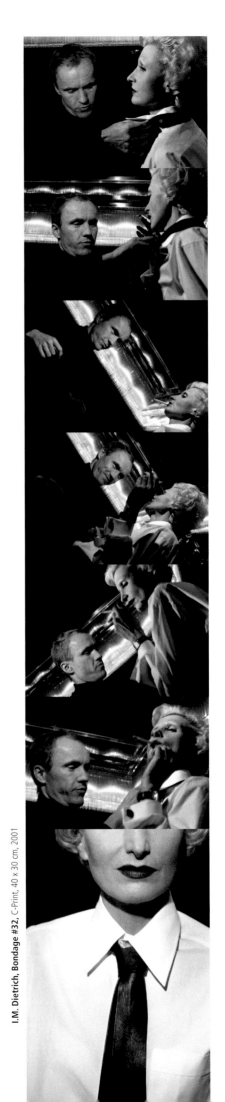

I.M. Dietrich, Bondage #32, C-Print, 40 x 30 cm, 2001

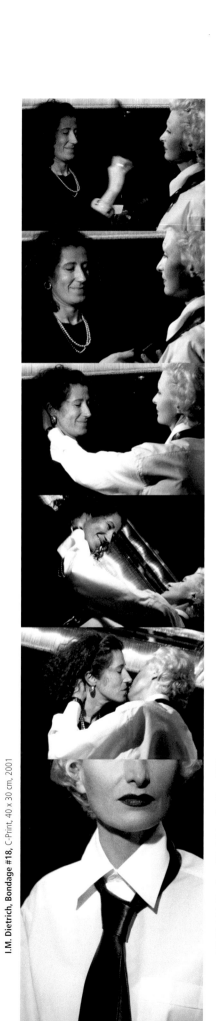

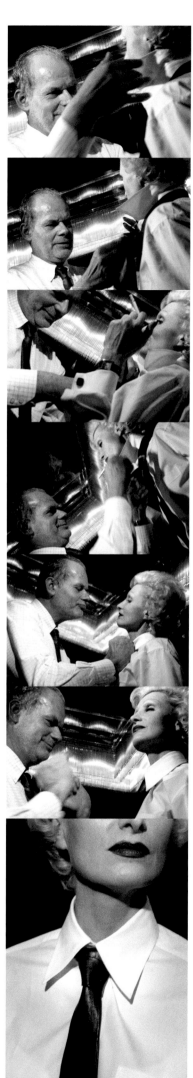

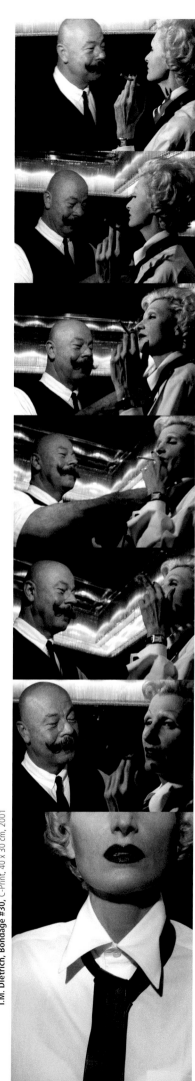

I.M. Dietrich, Bondage #18, C-Print, 40 x 30 cm, 2001

I.M. Dietrich, Bondage #21, C-Print, 40 x 30 cm, 2001

I.M. Dietrich, Bondage #30, C-Print, 40 x 30 cm, 2001

93

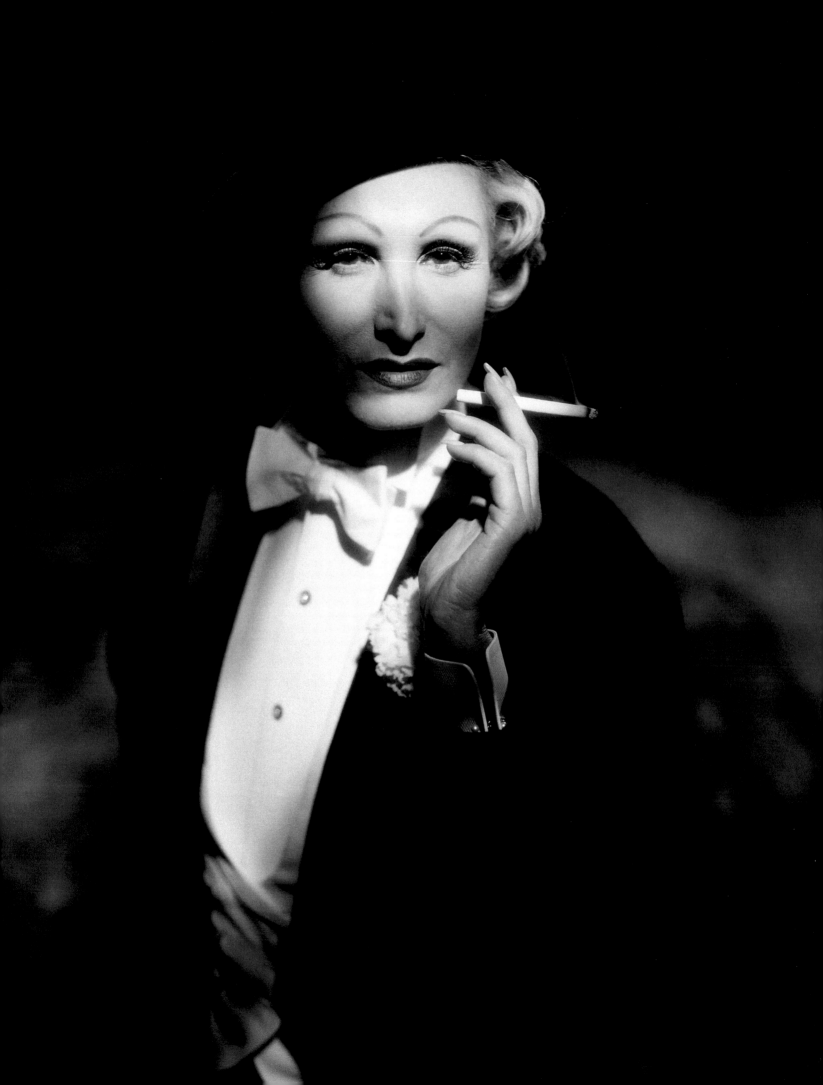

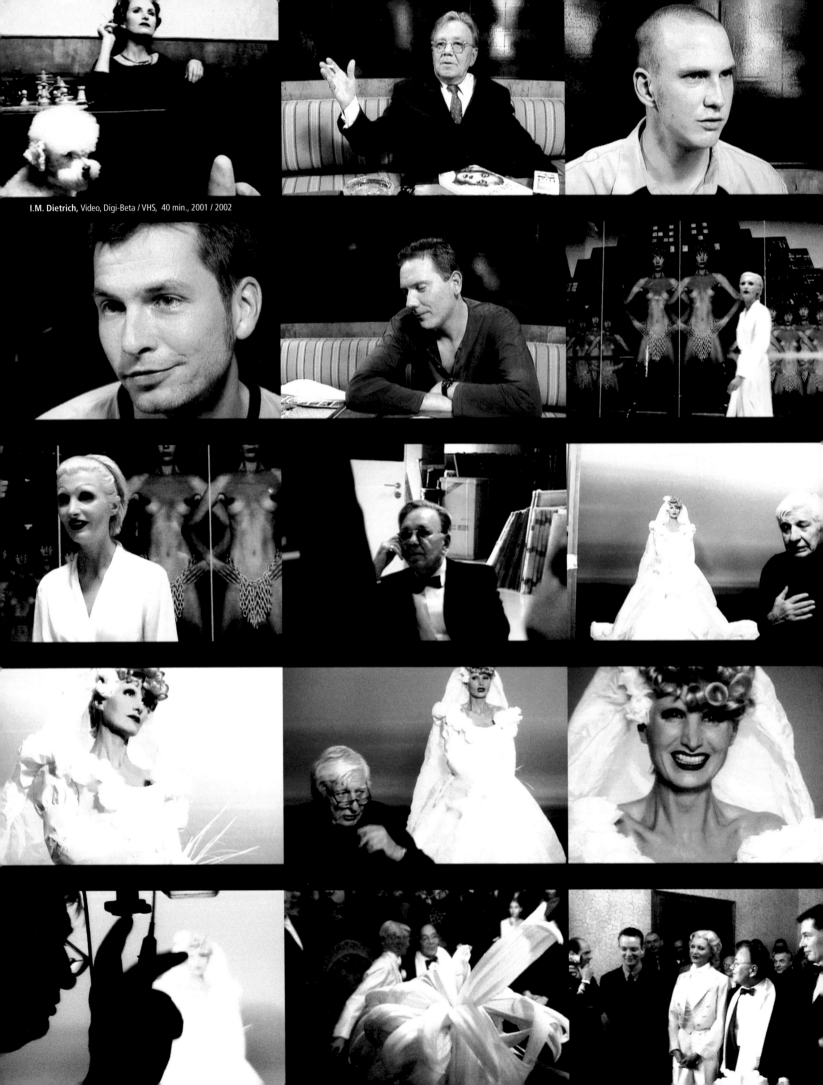

I.M. Dietrich, Video, Digi-Beta / VHS, 40 min., 2001 / 2002

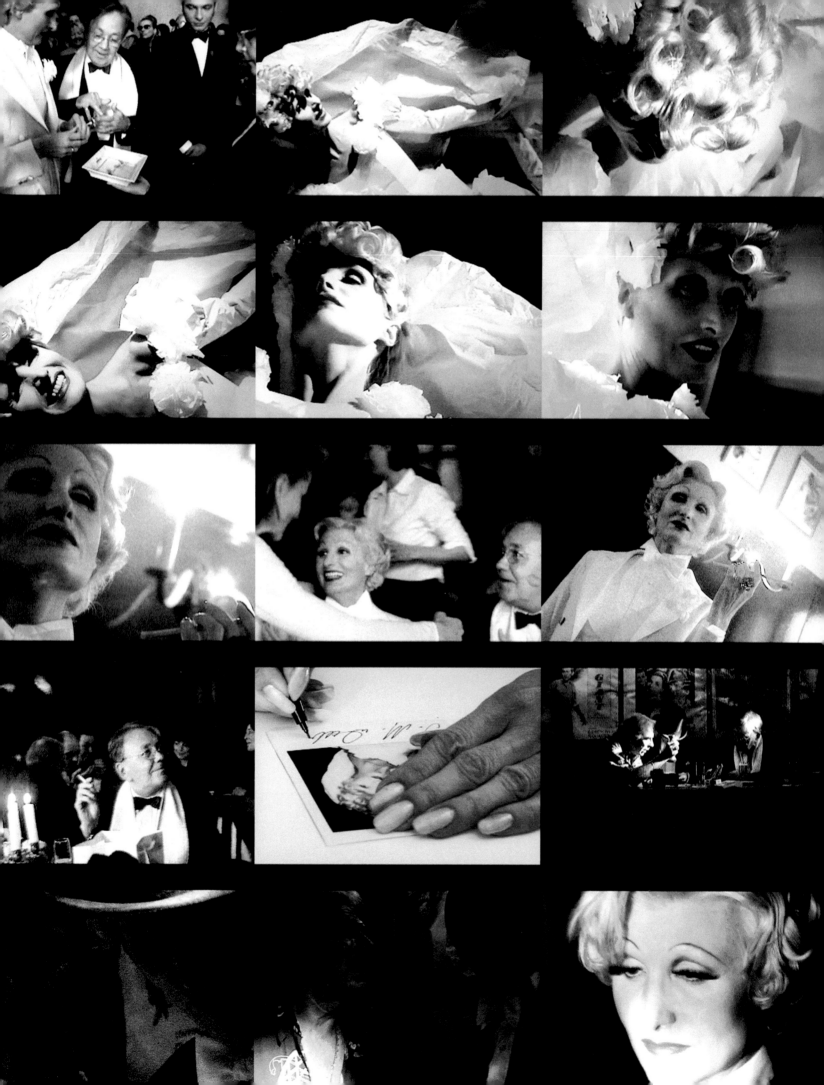

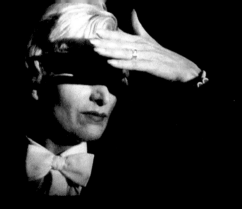

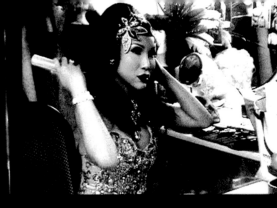

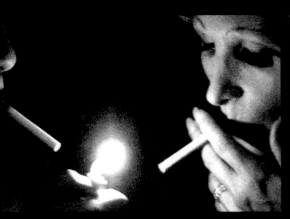
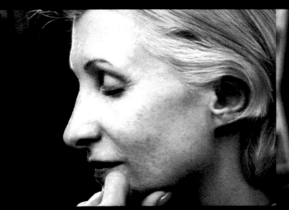
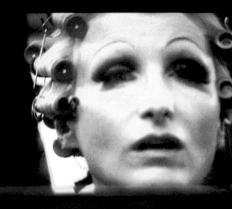
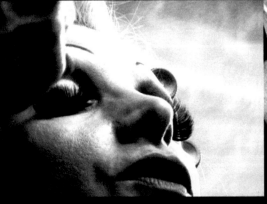
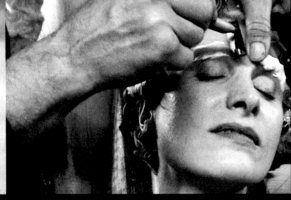
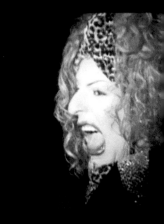
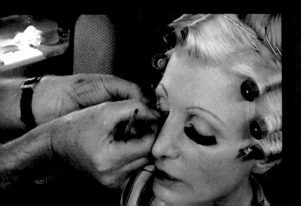
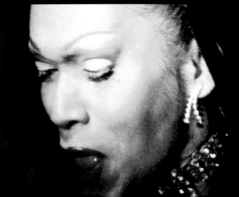
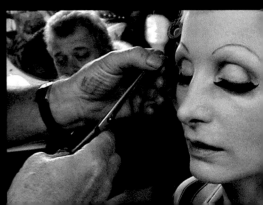

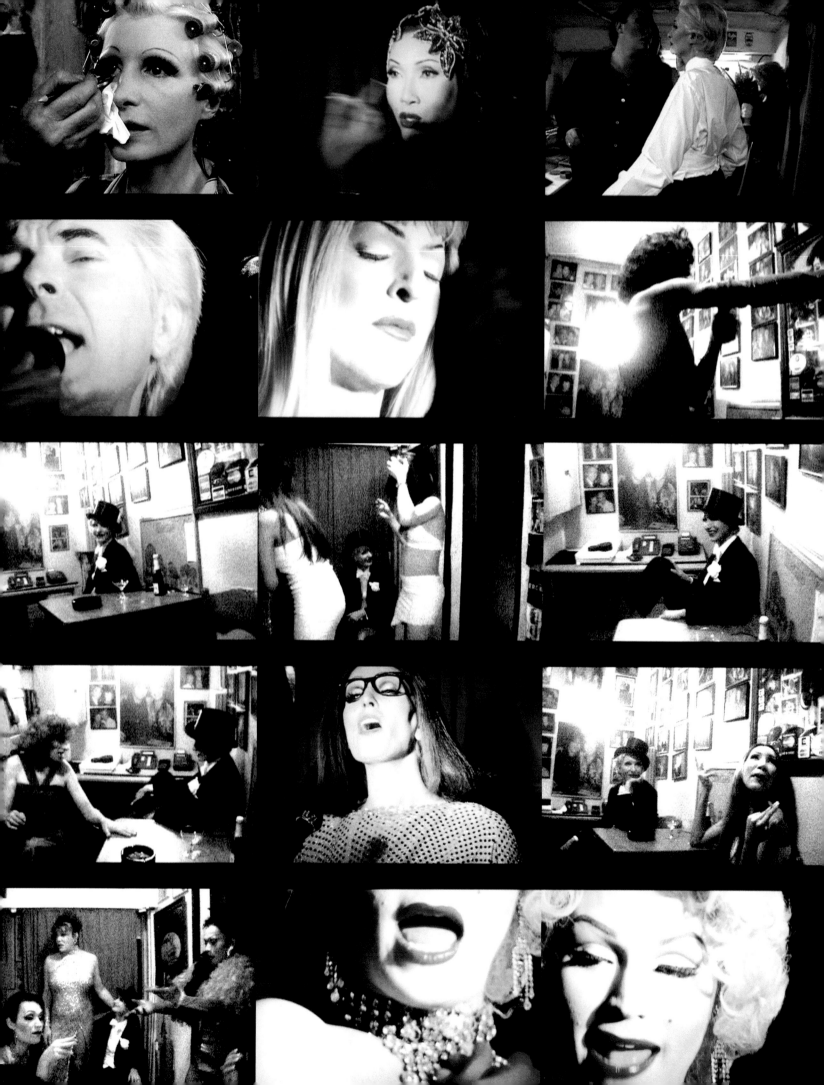

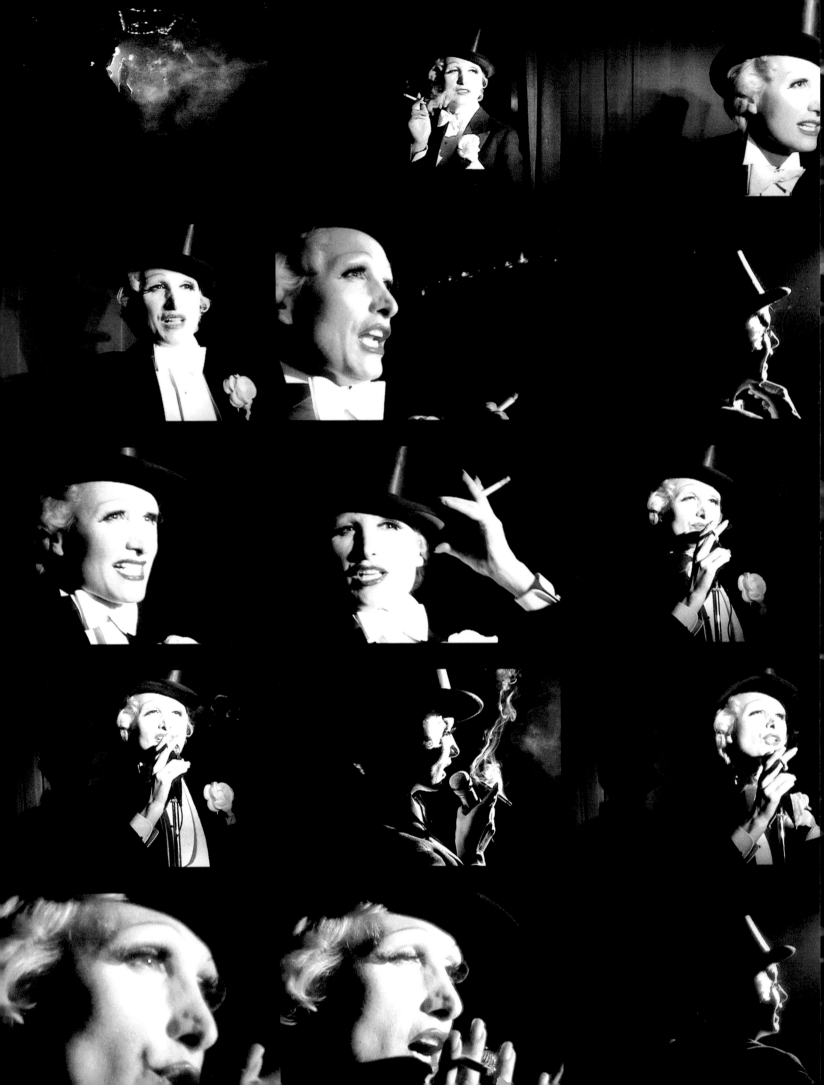

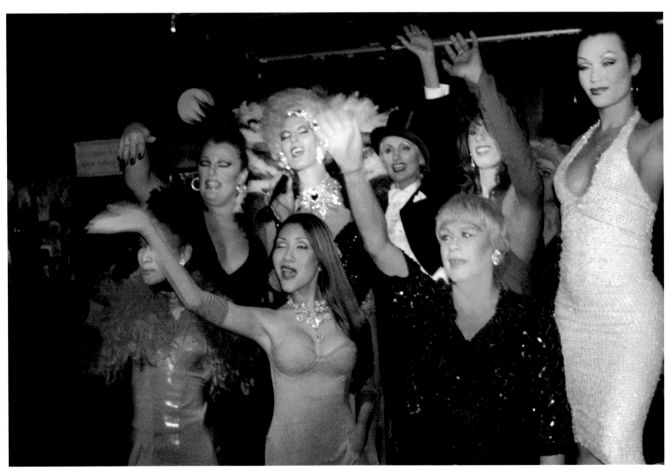

I.M. Dietrich, **TIMP,** C-Print, 60 x 90 cm, 2001

Wanda SM #1, Lightbox, 86 x 54 cm, 2002, S. 103

Wanda SM #2, Lightbox, 124 x 160 cm, 2002, S. 108/109

Wanda SM #2.1, Lightbox, 80 x 62 cm, 2002, S. 111

Wanda SM #3, Lightbox, 124 x 160 cm, 2002, S. 112/113

Wanda SM, 2001 – 2003

Wanda SM #3.1, Lightbox, 80 x 62 cm, 2002, S. 114

Wanda SM #4, Lightbox, 124 x 160 cm, 2002, S. 116/117

Wanda SM #4.1, Lightbox, 160 x 124 cm, 2002, S. 118/119

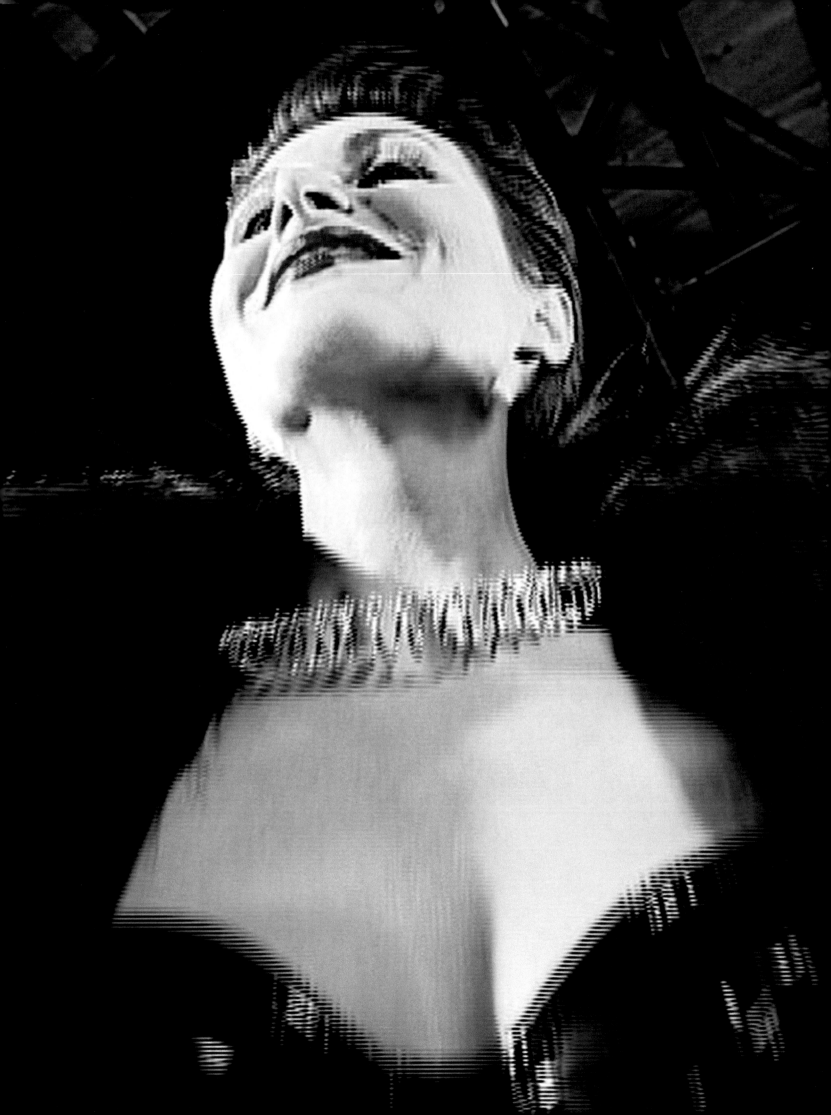

Wanda SM, I. Der Vertrag, Video, Digi-Beta / DVD / VHS, 9 min. 12 sec., 2001 / 2002

Vertrag zwischen Irene Andessner und Pjotr Dluzniewski

Deine Wünsche habe ich angehört; die Bedingungen, unter denen ich den Kontakt mit Dir für eine begrenzte Zeit erdulde, sind folgende:

1

Du bist nichts als ein Werkzeug meiner Kunst; eine willige und bequeme Figur in meiner Inszenierung. Du führst Werke nach meinen Anweisungen und unter meiner Kontrolle aus und du signierst diese Werke deshalb auch mit dem Zusatz "i.V. Irene Andessner".
Wenn Du in Bezug auf diese Werke auch nur ein Mal "mein" sagst, hast Du mit einer Strafe zu rechnen.

2

Deinen Arbeitsplatz, vorzugsweise ein Kellerraum, werde ich Dir zuweisen. Du hast die Arbeit täglich nach meinen Anweisungen zu beginnen und darfst sie nur mit meiner ausdrücklichen Erlaubnis zu beenden. (Sollte ich einmal darauf vergessen, hast Du bis zu meiner Rückkehr durchzuarbeiten.)

3

Ich kann Dich jederzeit entlassen, ich kann Deine Arbeit jederzeit auch durch einen anderen Mann, den ich für den besseren Künstler halten mag, fortsetzen lassen.

4

Du hast darüberhinaus die Pflicht, jederzeit auch den Anweisungen eines anderen Künstlers, den ich vorziehe, zu folgen.

5

Du hast keinerlei Rechte als Mann mir gegenüber geltend zu machen und Du nimmst zur Kenntnis, dass ich Dich nur als Arbeitskraft sehe, die meine künstlerische Produktion erhöht.

6

Ich verspreche dafür nichts, als Dich gelegentlich vielleicht auszupeitschen oder auspeitschen zu lassen und dich zu demütigen solange ich mich dazu überwinden kann.

7

Fotos von mir und Videos die ich dir gnadenhalber gelegentlich zur Verfügung stelle, darfst Du als Vorlage für deine Phantasien verwenden. Um Deinen Output zu erhöhen, werde ich Dir auch vielleicht eins meiner Kleidungsstücke oder sonst einen persönlichen Gegenstand überlassen - die Du aber nach Beendigung unseres Kontakts – gereinigt – zurückzustellen hast.

8

Ich habe das Recht, diesen Vertrag und alle damit verbundenen bzw. sich daraus ergebenden Bild- und Tondokumente bzw. Werke in jeder Form und auf unbegrenzte Zeit, vor allem auch in den Medien zu verwenden.

9

Dieser Vertrag gilt für die Dauer von 3 Wochen, vom 25. April bis 15. Mai, kann von mir aber nach Belieben verlängert oder verkürzt werden.

Wien am 21 Juni 2002

Irene Andessner Pjotr Dluzniewski

Contract between Irene Andessner and Pjotr Dluzniewski

I have heard your wishes. The conditions under which I can endure contact with you for a limited time are as follows:

1

You are nothing but an instrument of my art; a willing and convenient figure in the production I am staging. You shall produce works according to my instructions and under my supervision, and you shall also sign these works with the addition "on behalf of Irene Andessner." If you refer to these works on even one occasion as "mine," you can expect punishment.

2

I shall assign you your place of work, preferably a cellar room. You must begin work there every day according to my instructions, and you may never stop without my express permission. (Should I ever forget to give this permission, you must work without interruption until I return.)

3

I can dismiss you at any time. I can, at any time, charge another man, whom I might consider to be a better artist, to continue your work.

4

In addition, you shall be obliged, at any time, to follow the instructions of any other artist that I might consider superior.

5

As a man, you can claim no rights whatsoever over me, and you acknowledge that I see you only as a worker whose efforts heighten my artistic production.

6

In return, I promise nothing, except that I may occasionally whip you – or have you whipped – and that I will humiliate you, as long as I can overcome my disgust enough to do so.

7

You may use any photos of me, or videos that I might occasionally deign to give you, as models for your fantasies. In order to increase your output, I might also lend you an article of my clothing or some other personal possession – which you must return to me – after cleaning – when contact between us has been terminated.

8

I have the right to use this contract and any visual or audio documents or other works that might result from it, for an unlimited period and in any form I choose, particularly in the media.

9

This contract shall remain in force for a period of three weeks, from 25 April to 15 May, but it can be extended or abridged at my discretion.

Vienna, 21 June 2002

Irene Andessner

Pjotr Dluzniewski

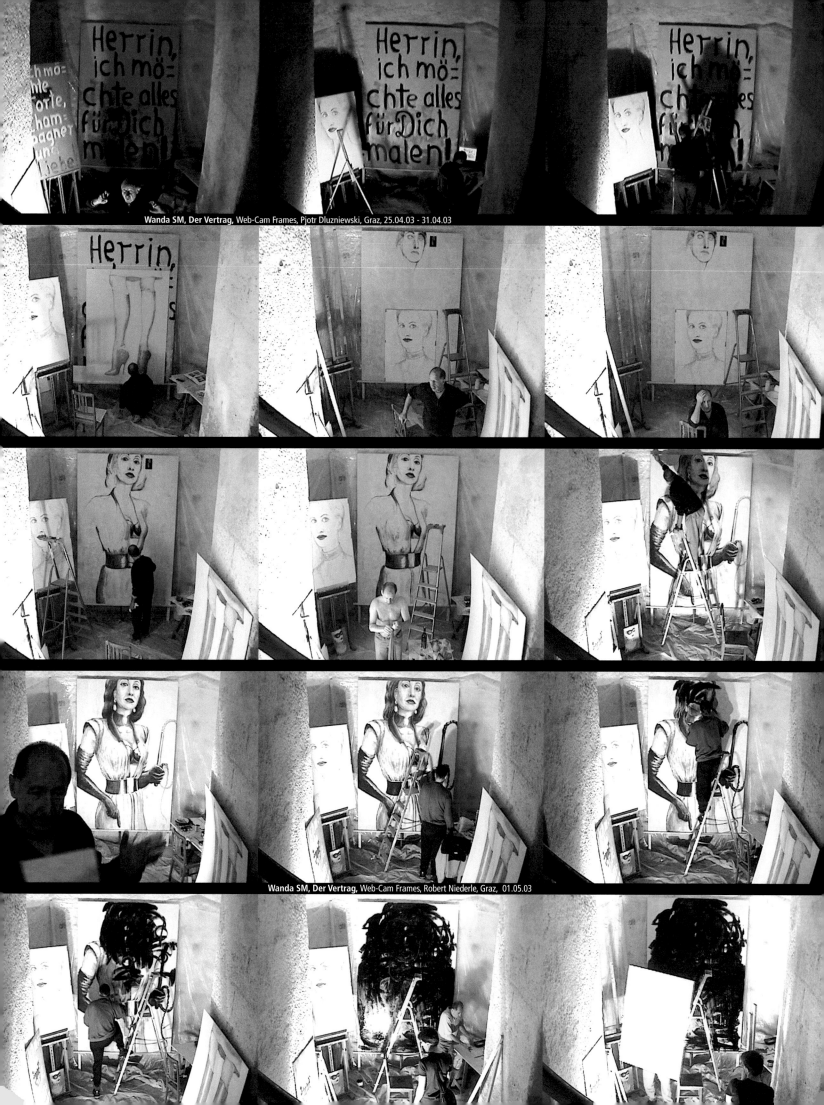

Wanda SM, **Der Vertrag**, Web-Cam Frames, Pjotr Dluzniewski, Graz, 25.04.03 - 31.04.03

Wanda SM, **Der Vertrag**, Web-Cam Frames, Robert Niederle, Graz, 01.05.03

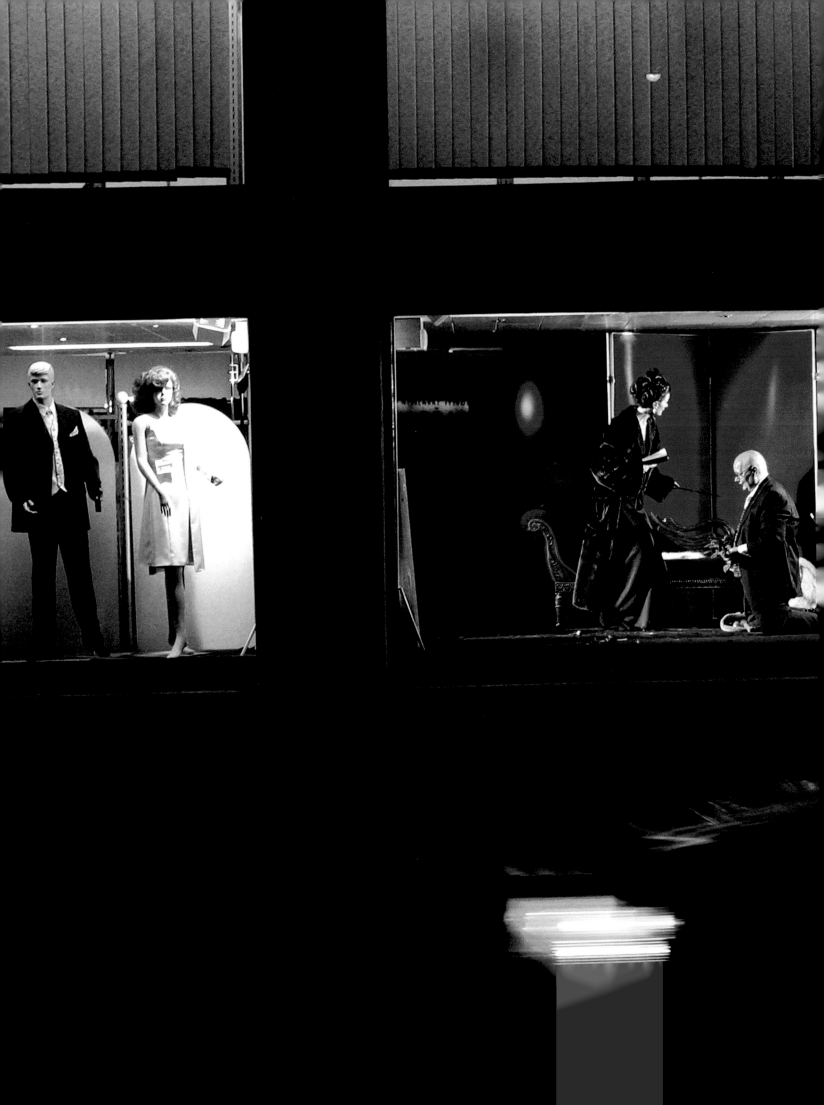

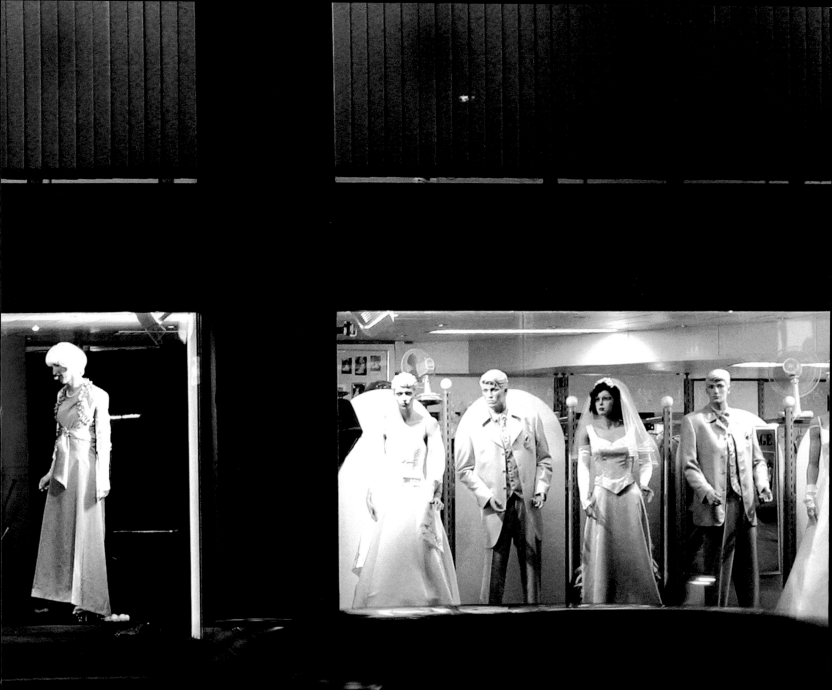

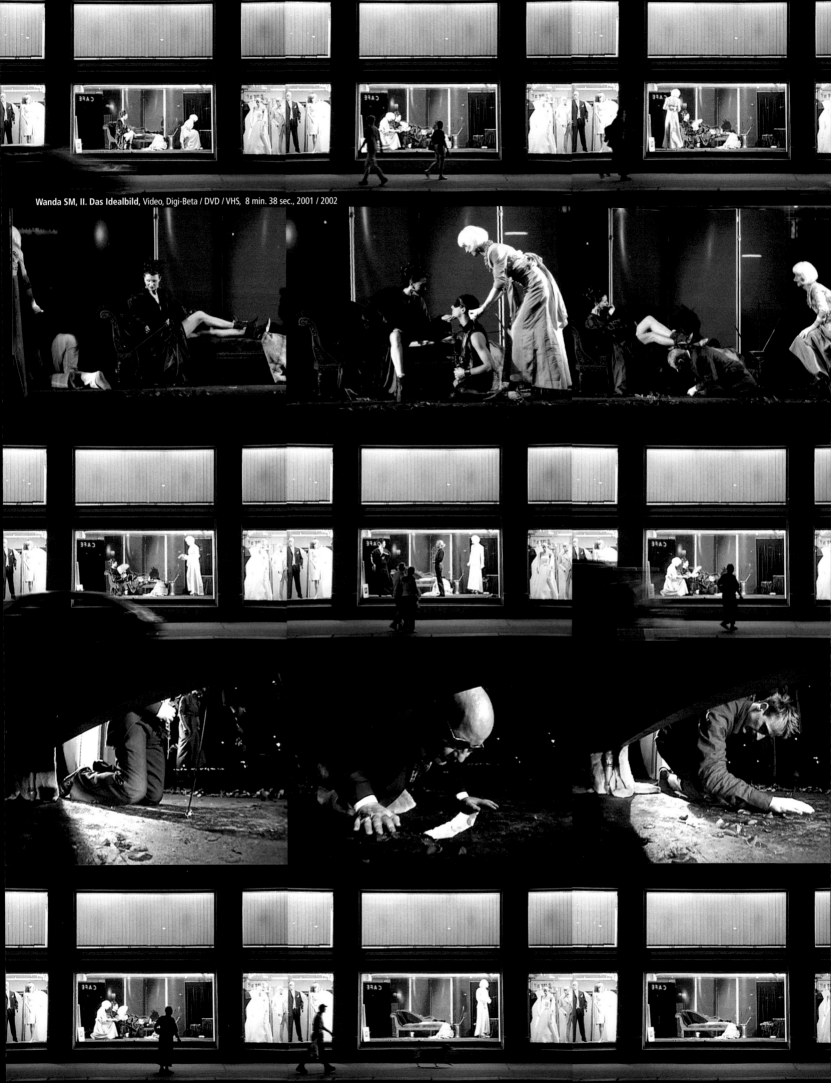

Wanda SM, II. Das Idealbild, Video, Digi-Beta / DVD / VHS, 8 min. 38 sec., 2001 / 2002

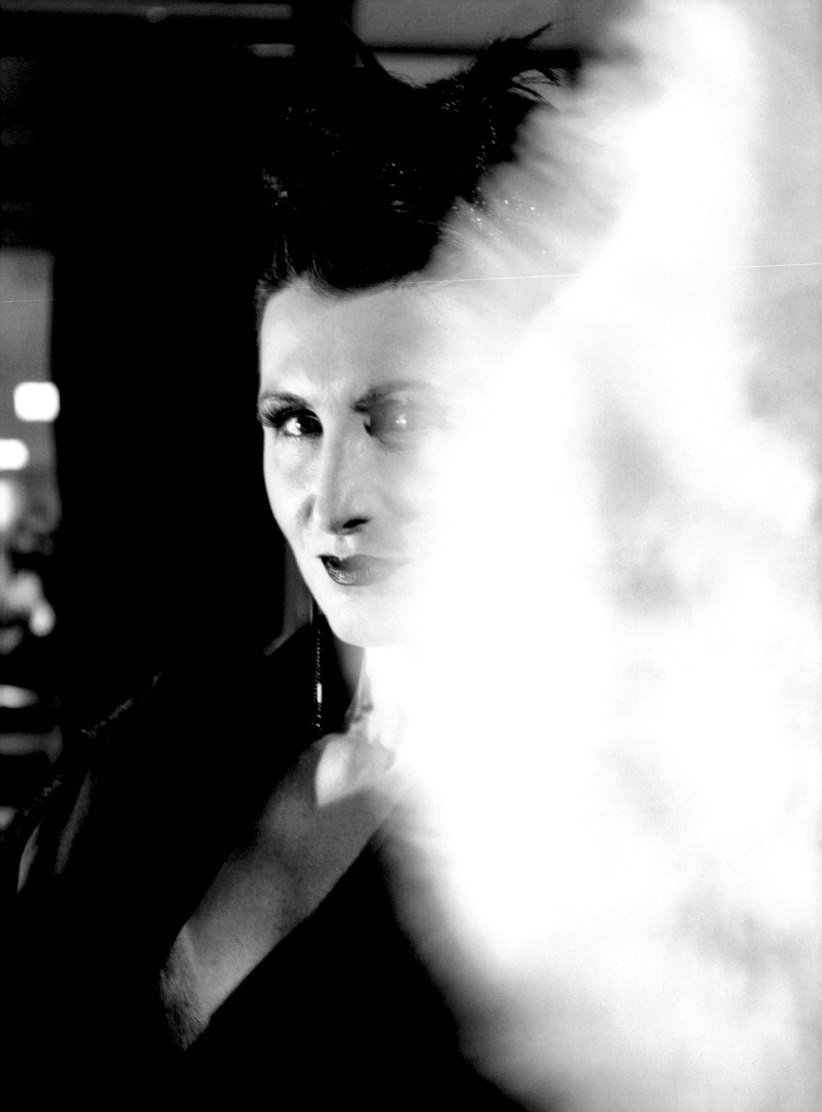

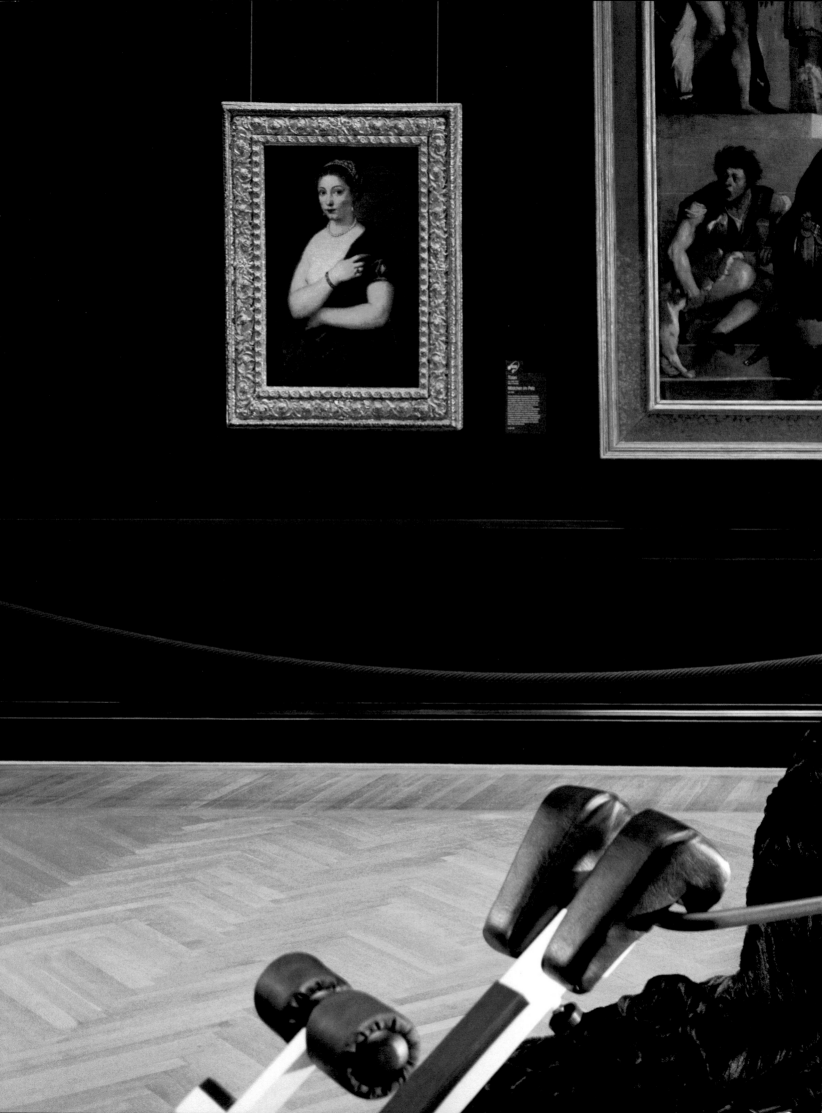

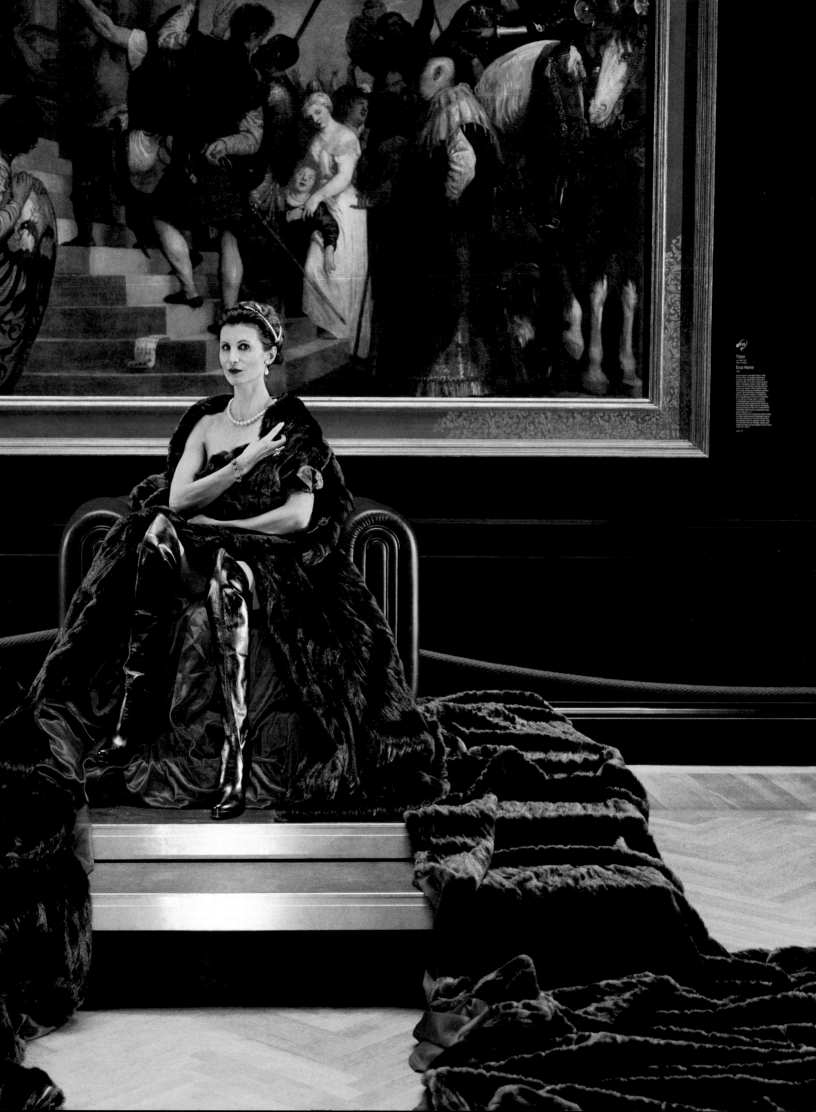

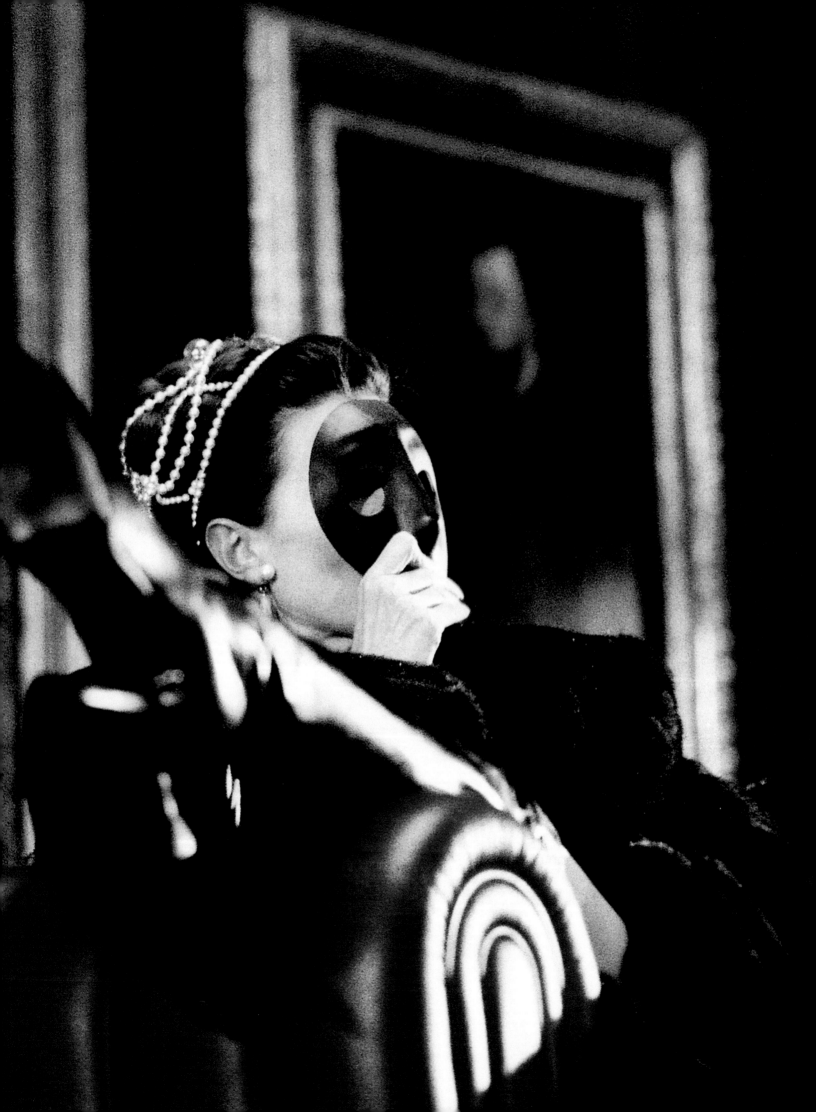

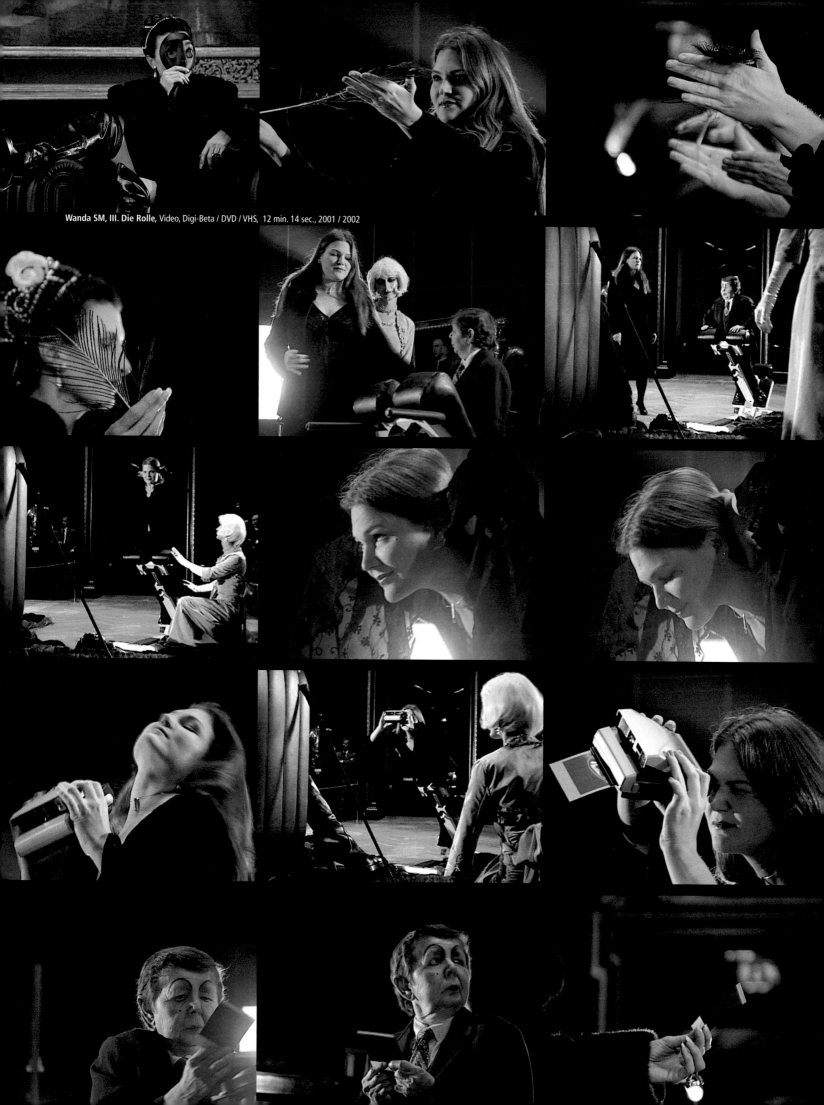

Wanda SM, III. Die Rolle, Video, Digi-Beta / DVD / VHS, 12 min. 14 sec., 2001 / 2002

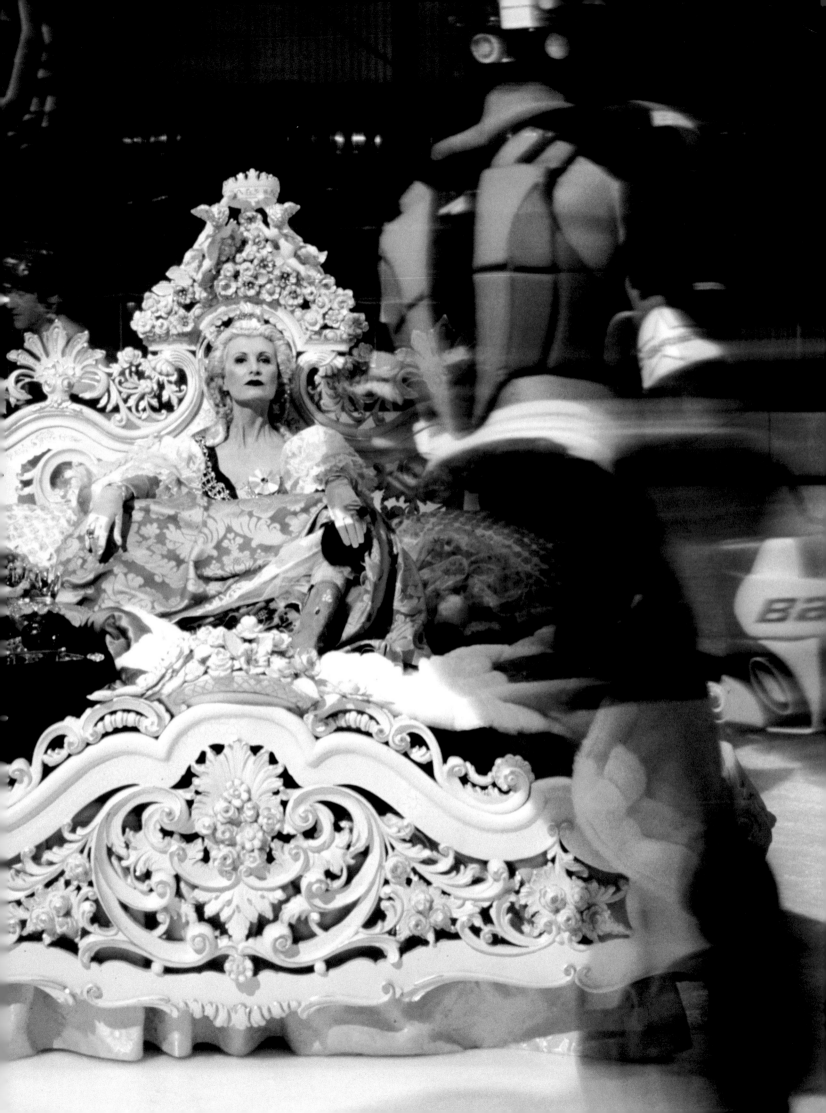

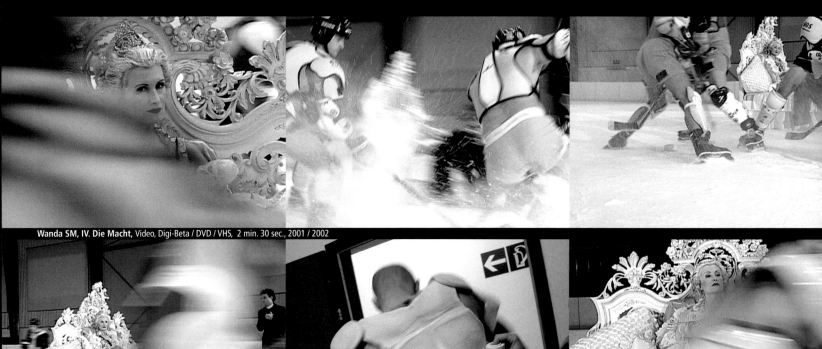

Wanda SM, IV. Die Macht, Video, Digi-Beta / DVD / VHS, 2 min. 30 sec., 2001 / 2002

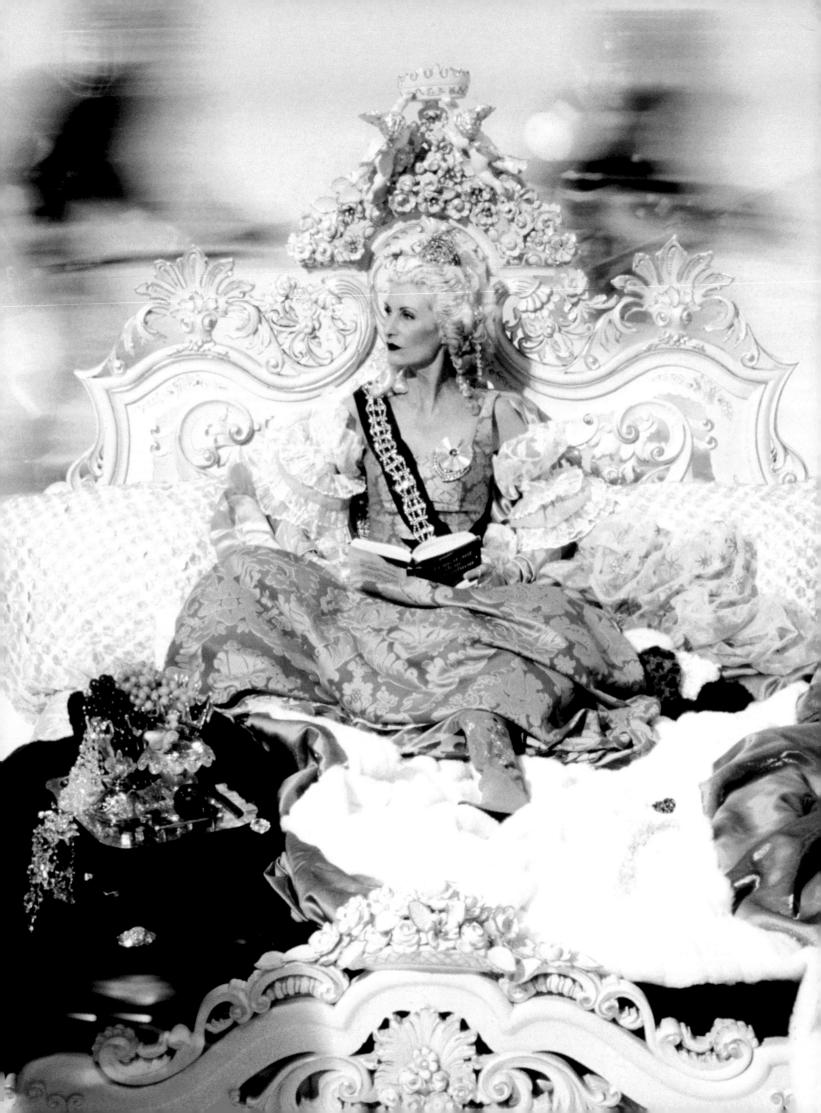

Donne Illustri, 2003

Donne Illustri, Agostina Morosini #1, Lightbox, 80 x 62 cm, 2003

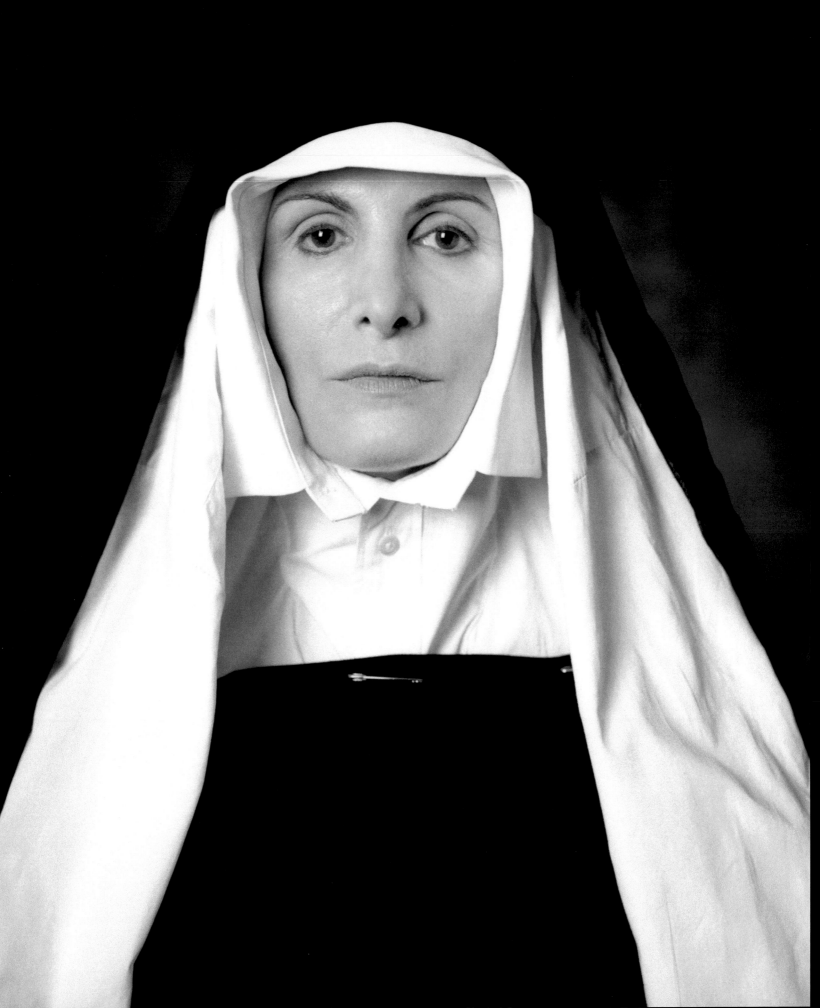

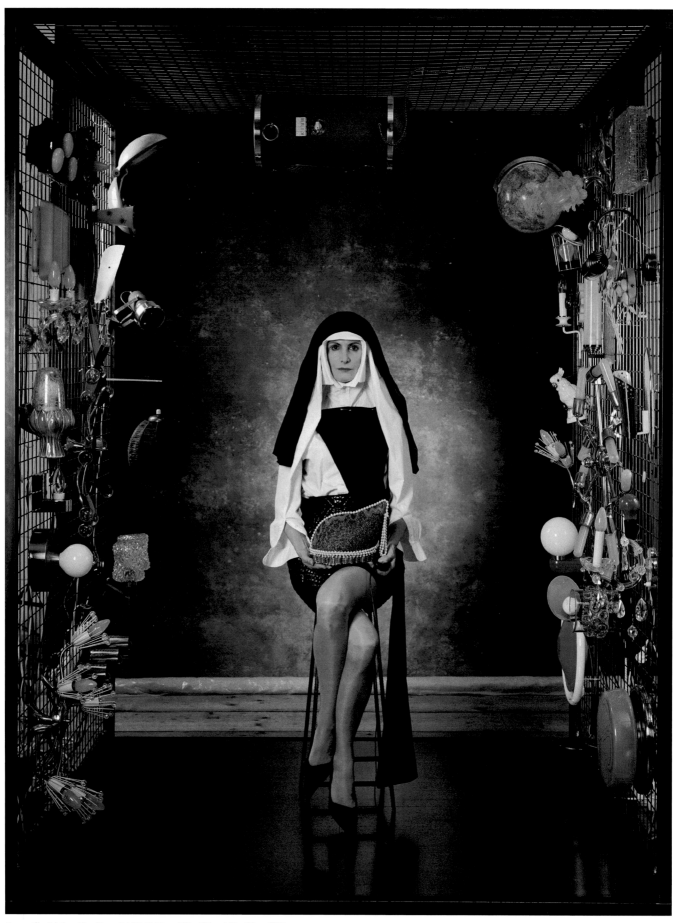

Donne Illustri, **Agostina Morosini #2,** Lightbox, 160 x 124 cm / 80 x 62 cm, 2003

Donne Illustri, **Cecilia Venier-Baffo #1,** Lightbox , 80 x 62 cm, 2003

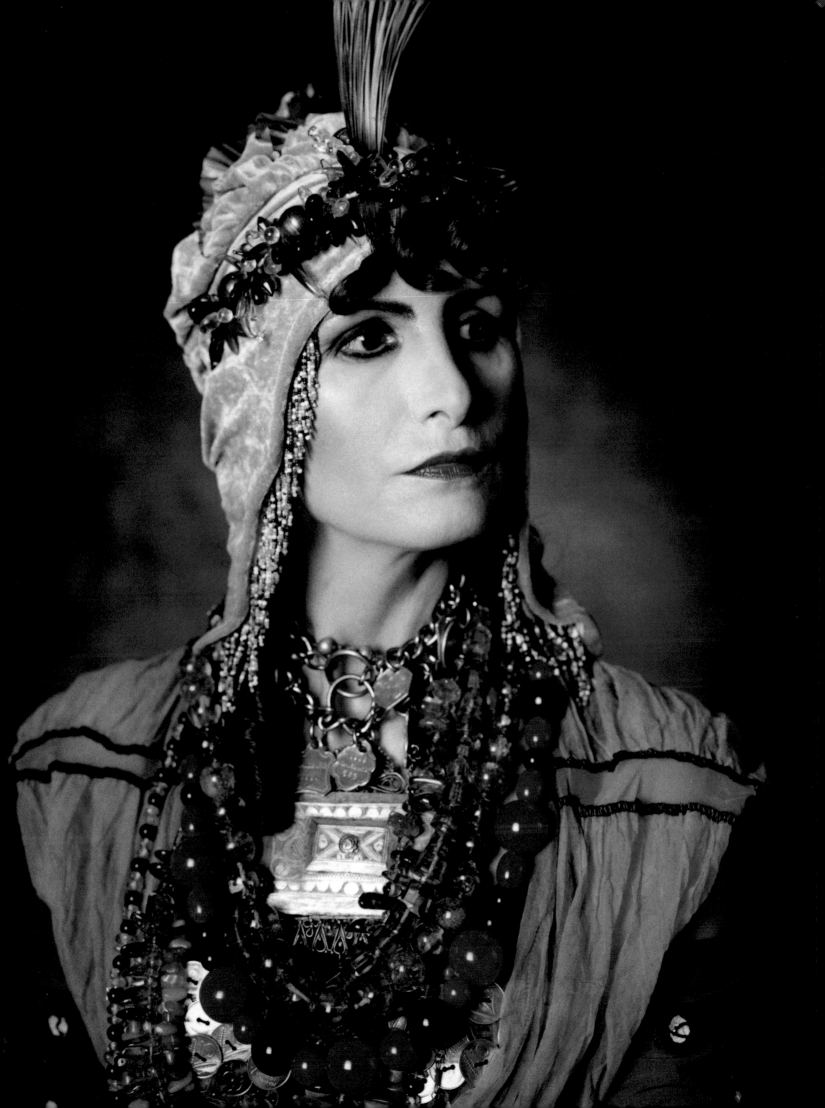

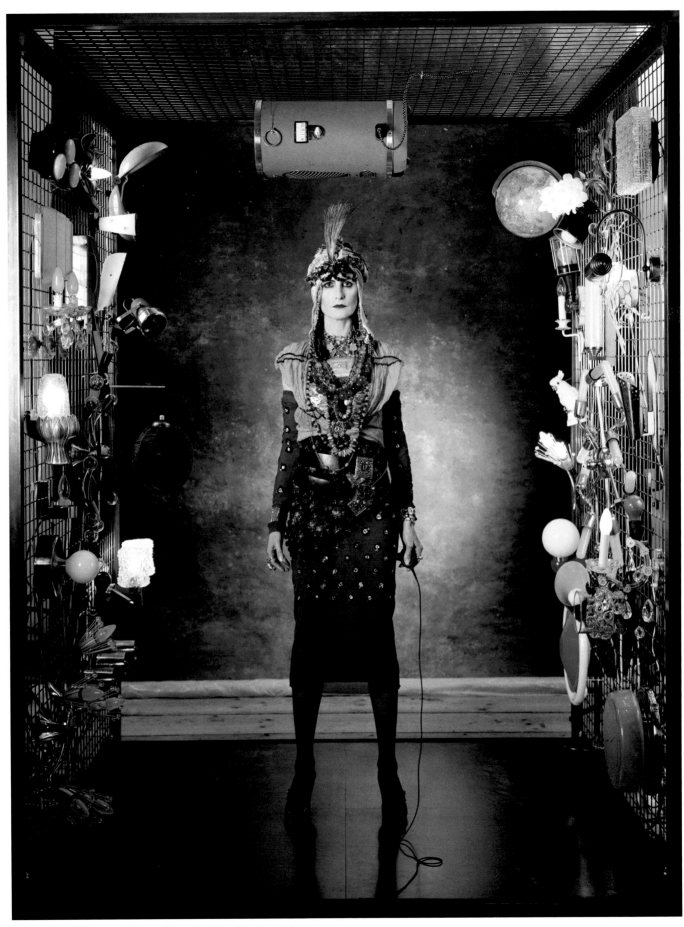

Donne Illustri, Cecilia Venier-Baffo #2, Lightbox,160 x 124 cm / 80 x 62 cm, 2003

Donne Illustri, Moderata Fonte #1, Lightbox, 80 x 62 cm, 2003

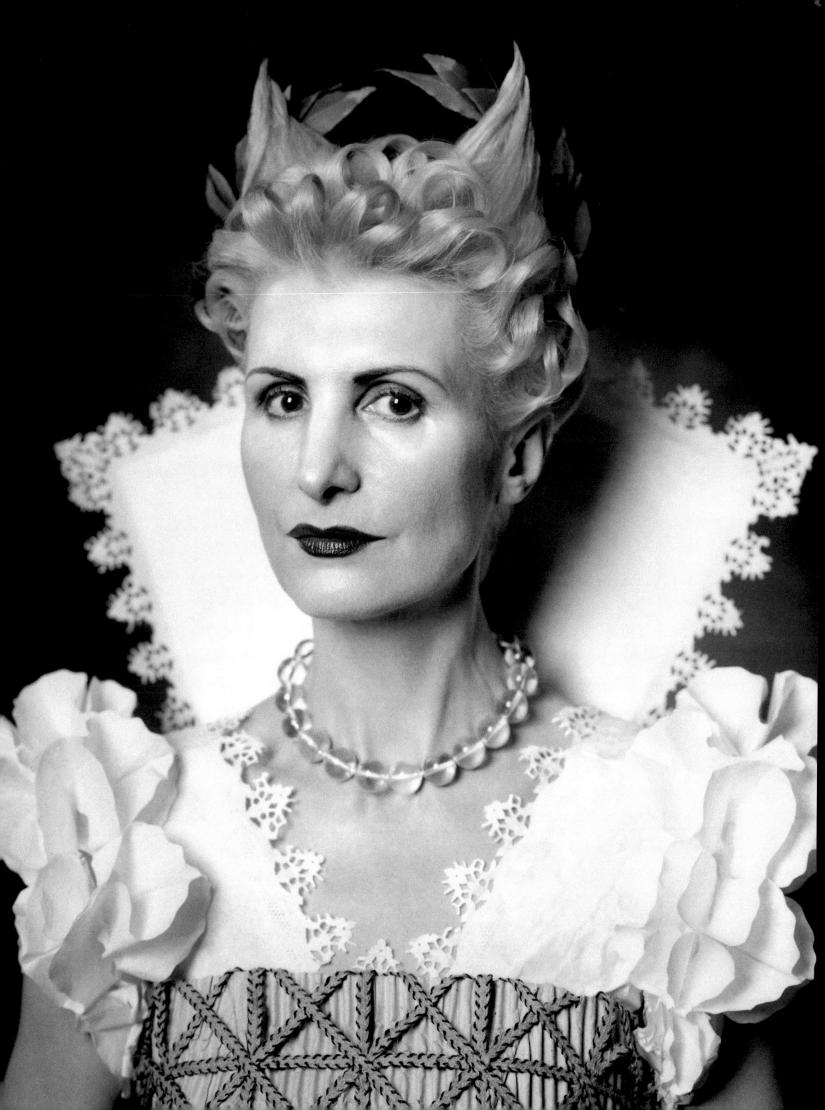

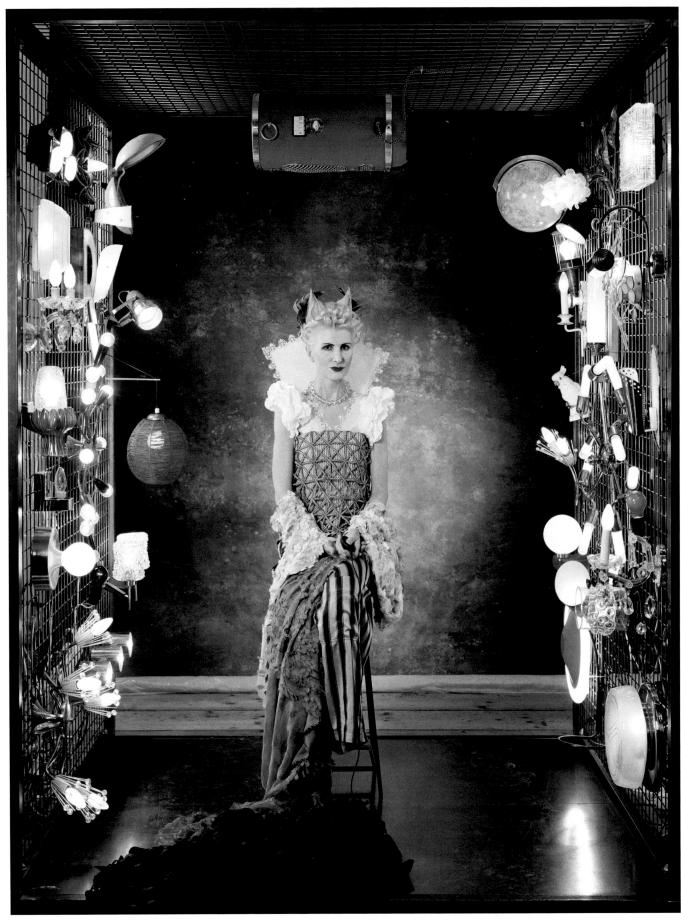

Donne Illustri, Moderata Fonte #2, Lightbox, 160 x 124 cm / 80 x 62 cm, 2003

Donne Illustri, Caterina Cornaro #1, Lightbox, 80 x 62 cm, 2003

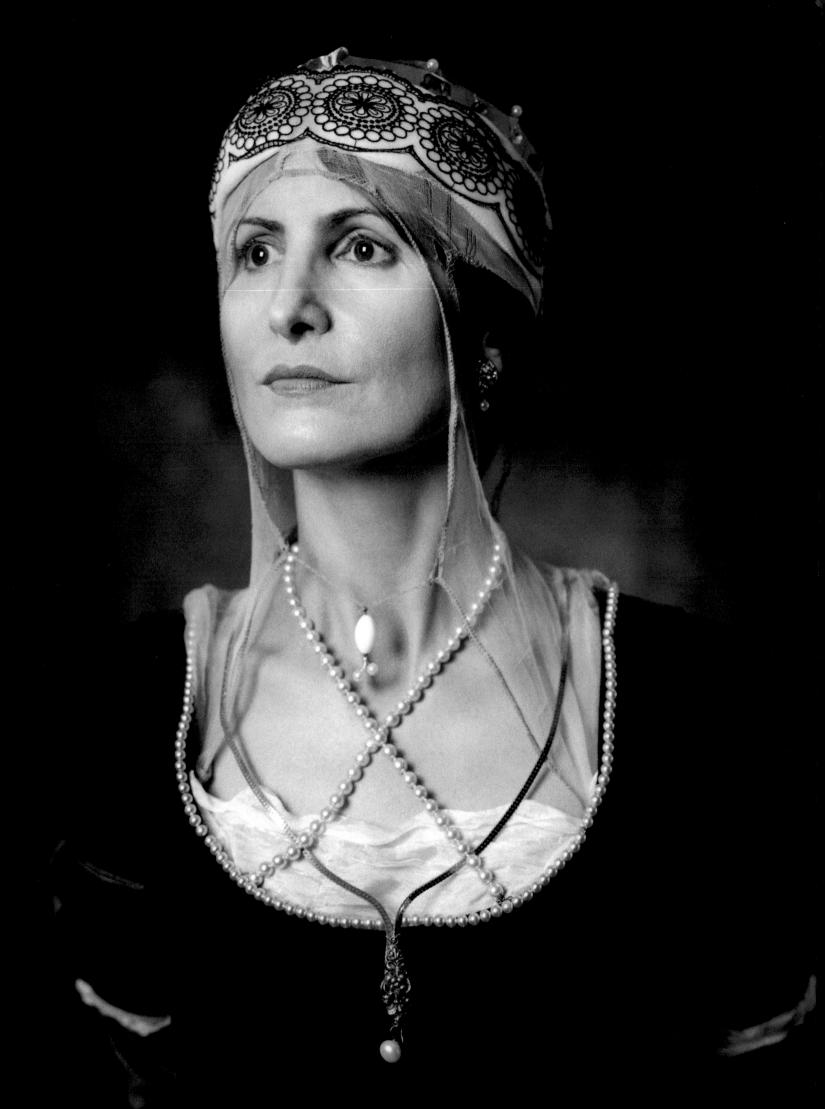

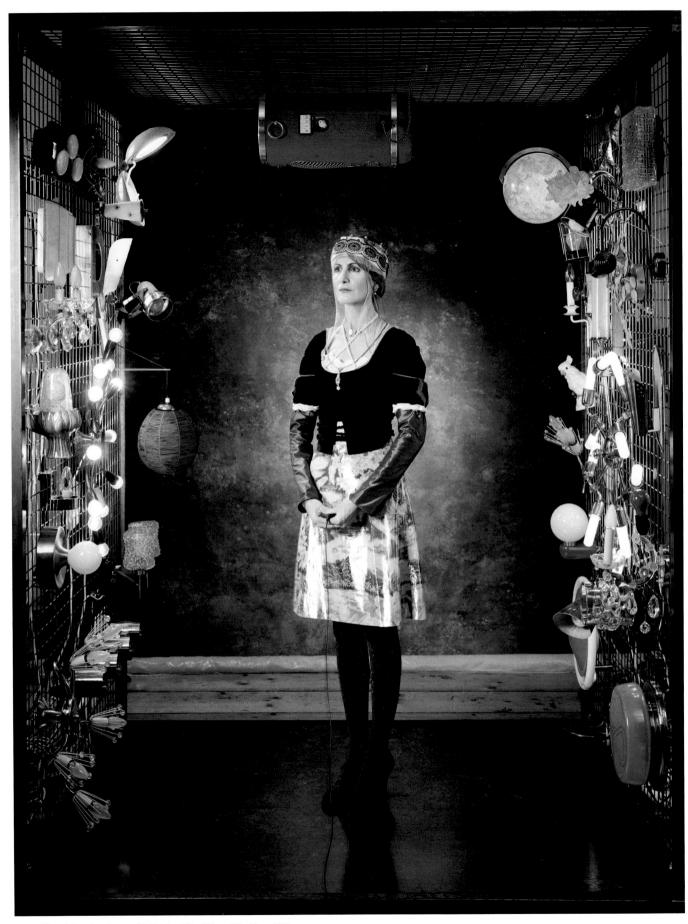

Donne Illustri, Caterina Cornaro #2, Lightbox, 160 x 124 cm / 80 x 62 cm, 2003

Donne Illustri, Marietta Robusti #1, Lightbox, 80 x 62 cm, 2003

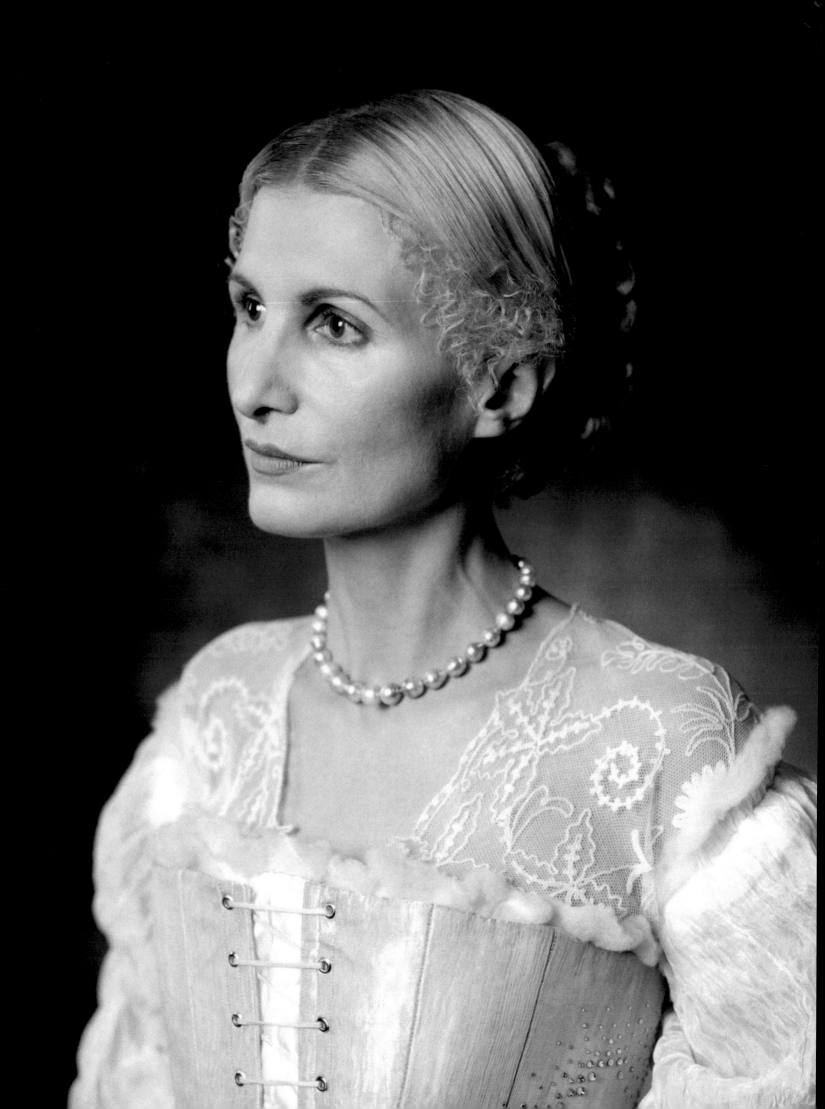

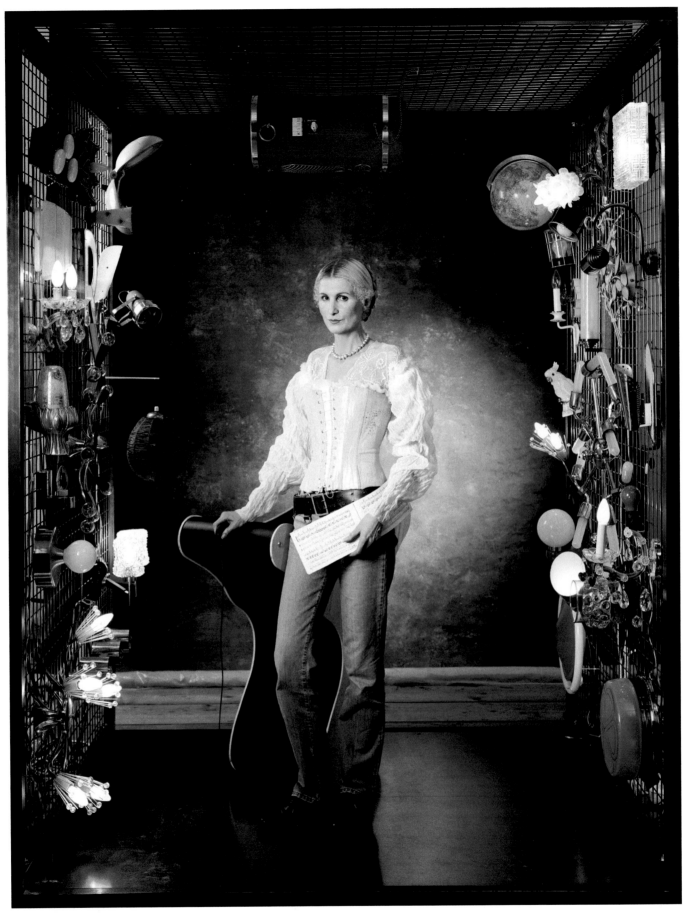

Donne Illustri, Marietta Robusti #2, Lightbox, 160 x 124 cm / 80 x 62 cm, 2003

Donne Illustri, Veronica Franco #1, Lightbox, 80 x 62 cm, 2003

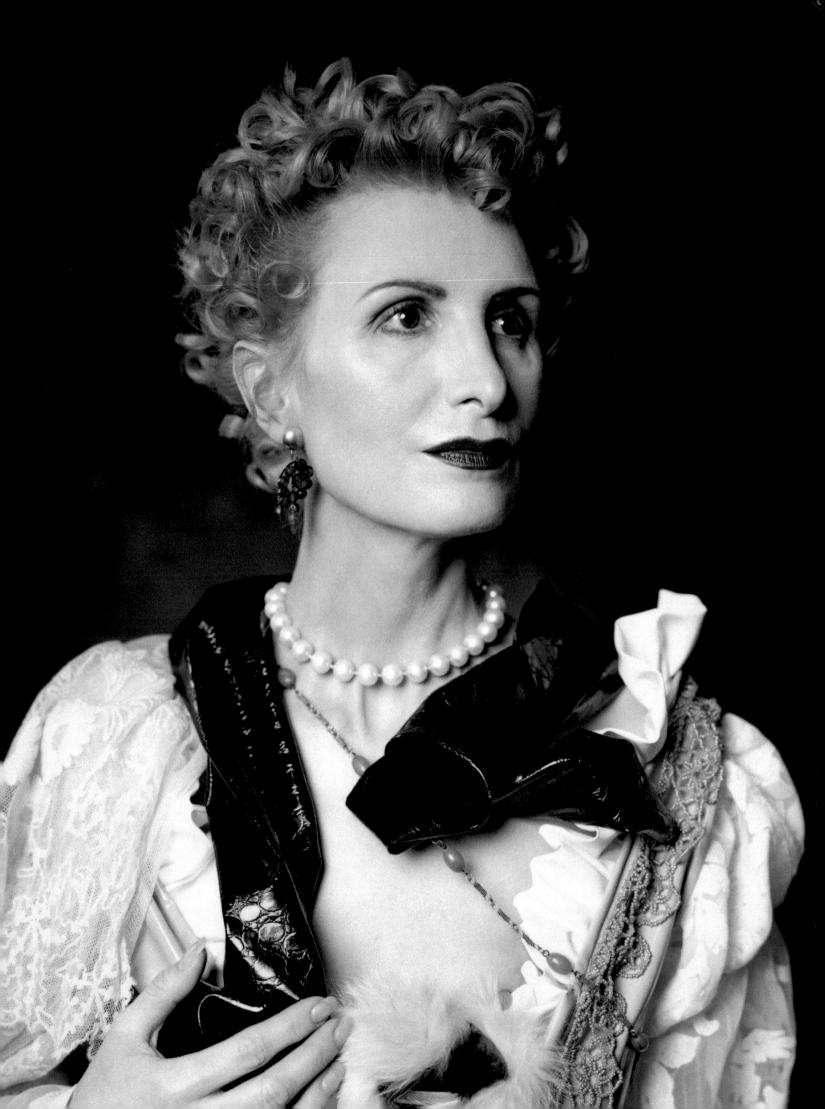

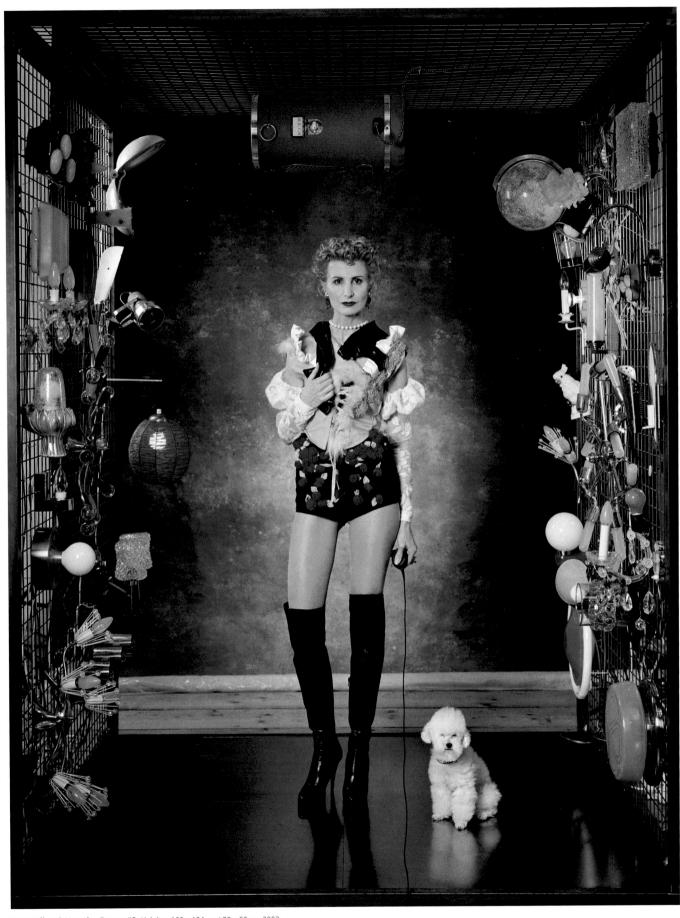

Donne Illustri, Veronica Franco #2, Lightbox, 160 x 124 cm / 80 x 62 cm, 2003

Donne Illustri, Elena Lucrezia Cornaro Piscopia #1, Lightbox, 80 x 62 cm, 2003

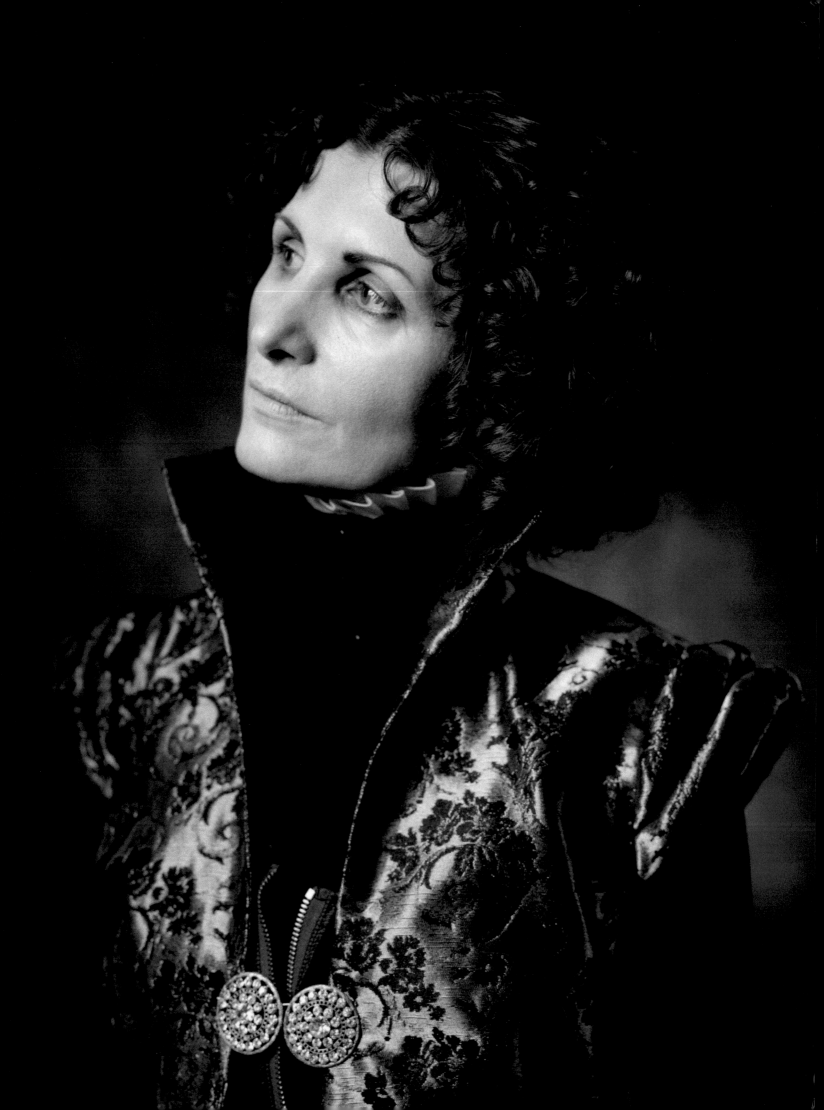

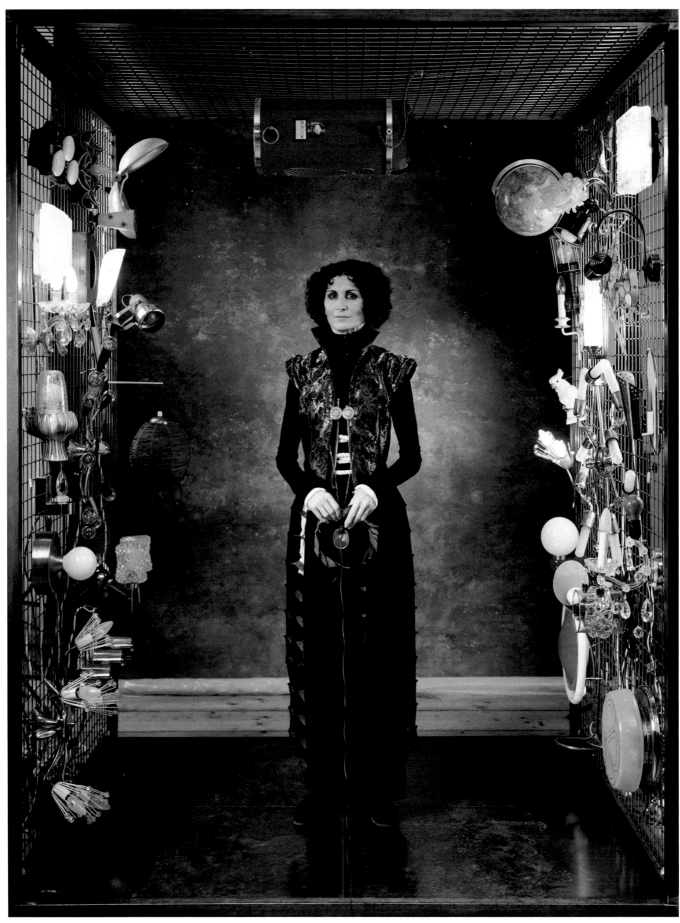

Donne Illustri, Elena Lucrezia Cornaro Piscopia #2, Lightbox,160 x 124 cm / 80 x 62 cm, 2003

Donne Illustri, Elisabetta Querini-Valier #1, Lightbox, 80 x 62 cm, 2003

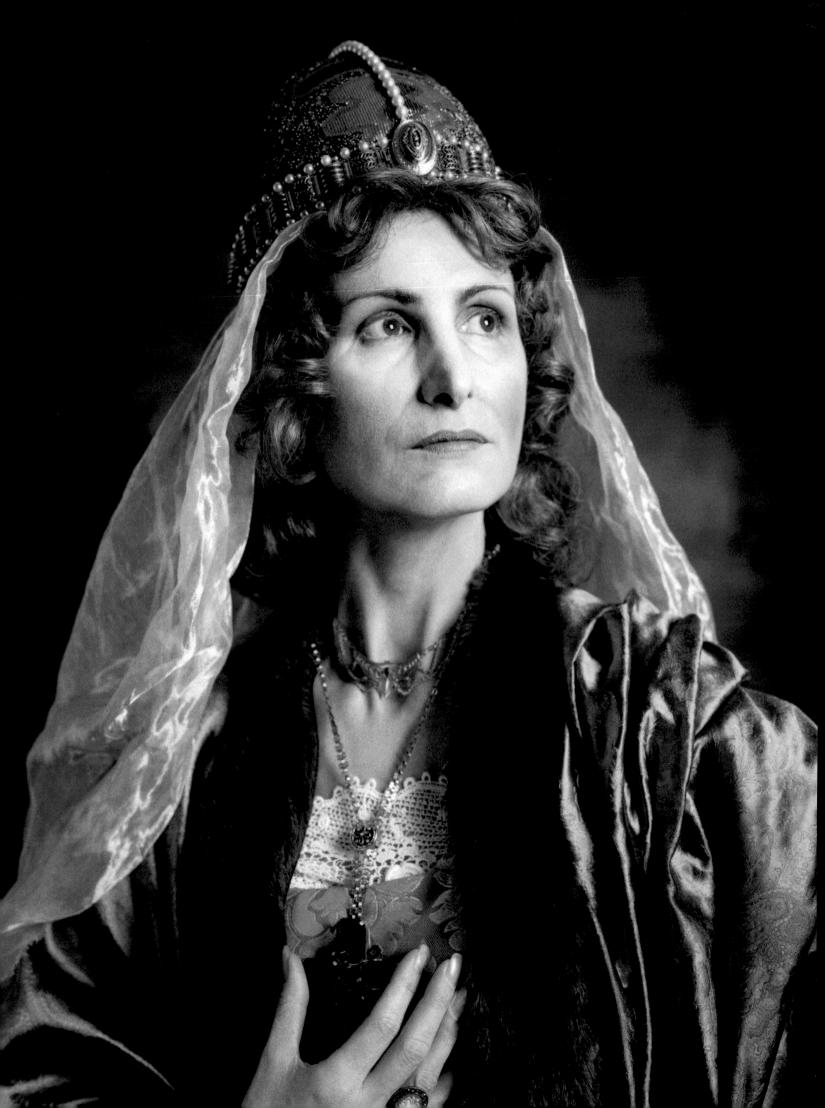

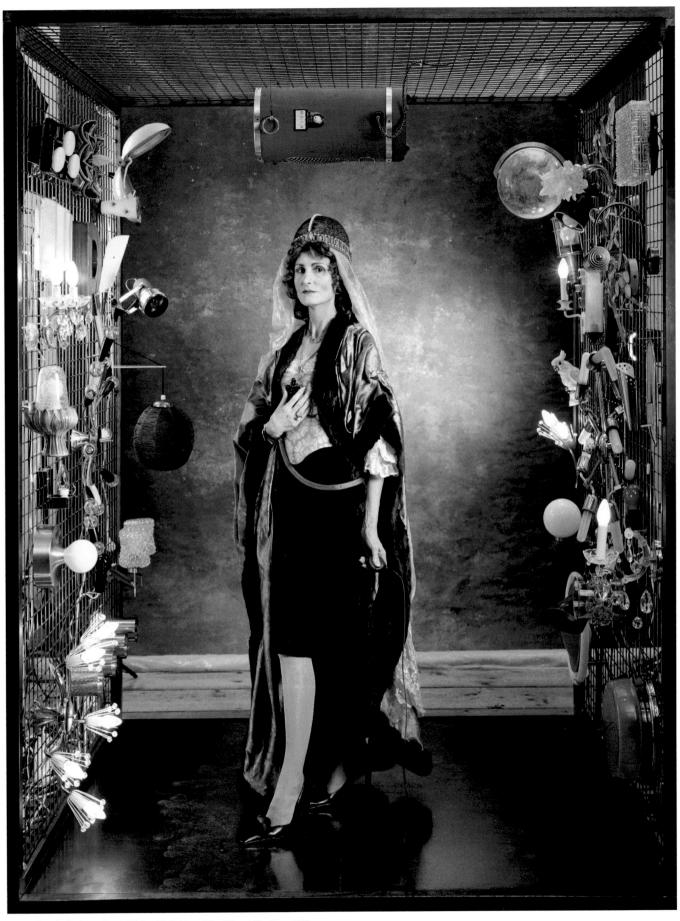

Donne Illustri, Elisabetta Querini-Valier #2, Lightbox, 160 x 124 cm / 80 x 62 cm, 2003

Donne Illustri, Barbara Strozzi #1, Lightbox, 80 x 62 cm, 2003

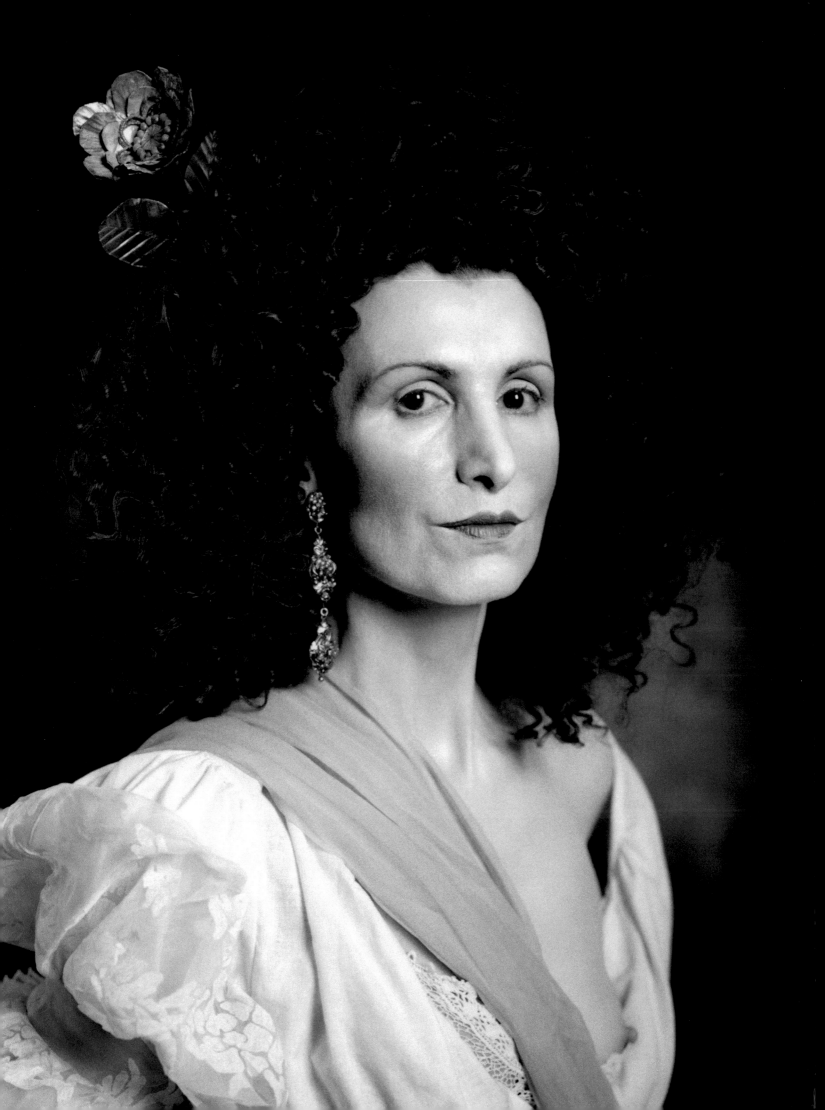

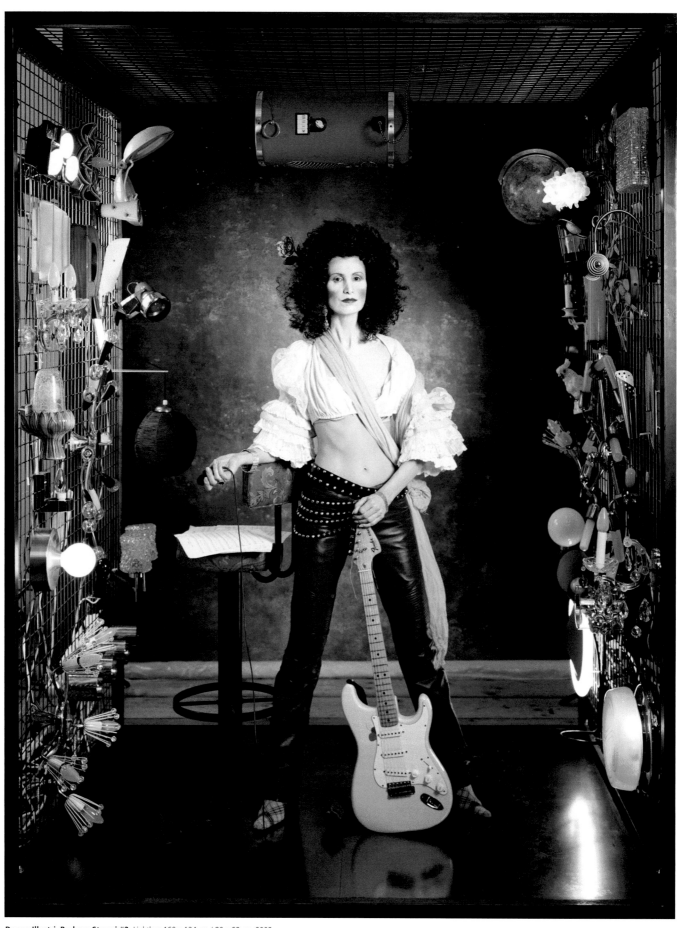

Donne Illustri, Barbara Strozzi #2, Lightbox,160 x 124 cm / 80 x 62 cm, 2003

Donne Illustri, Rosalba Carriera #1, Lightbox, 80 x 62 cm, 2003

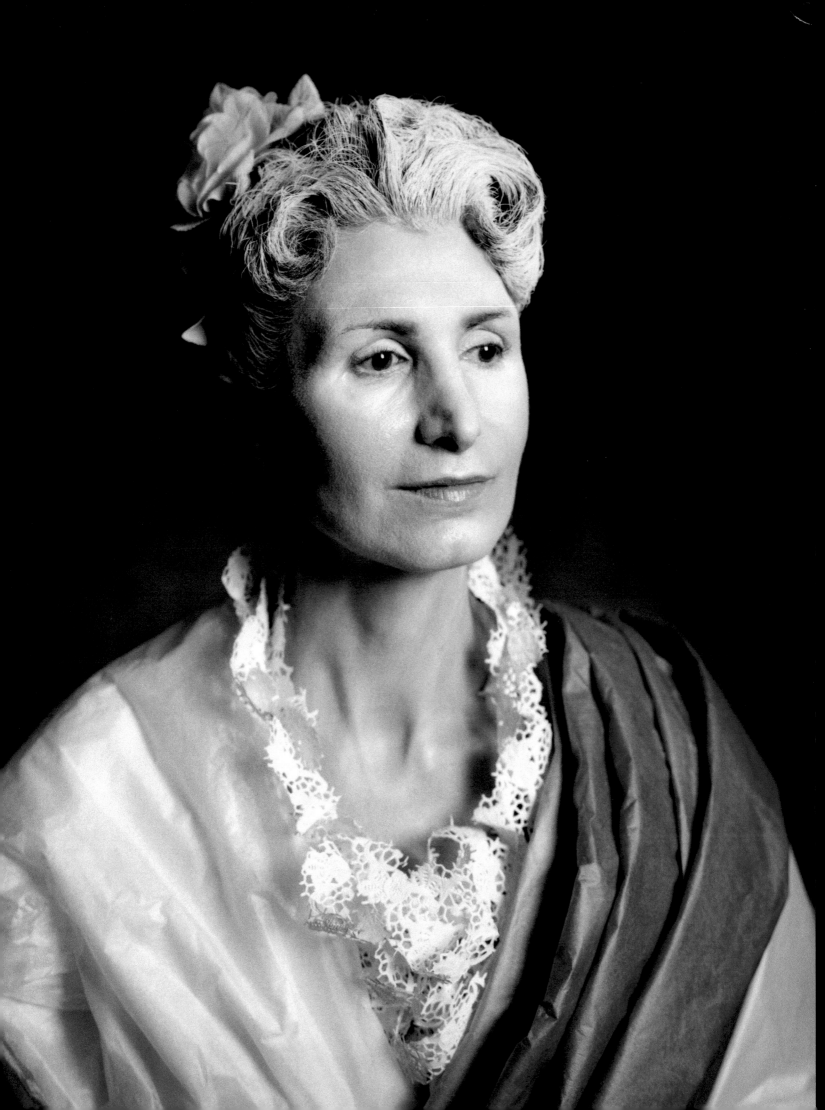

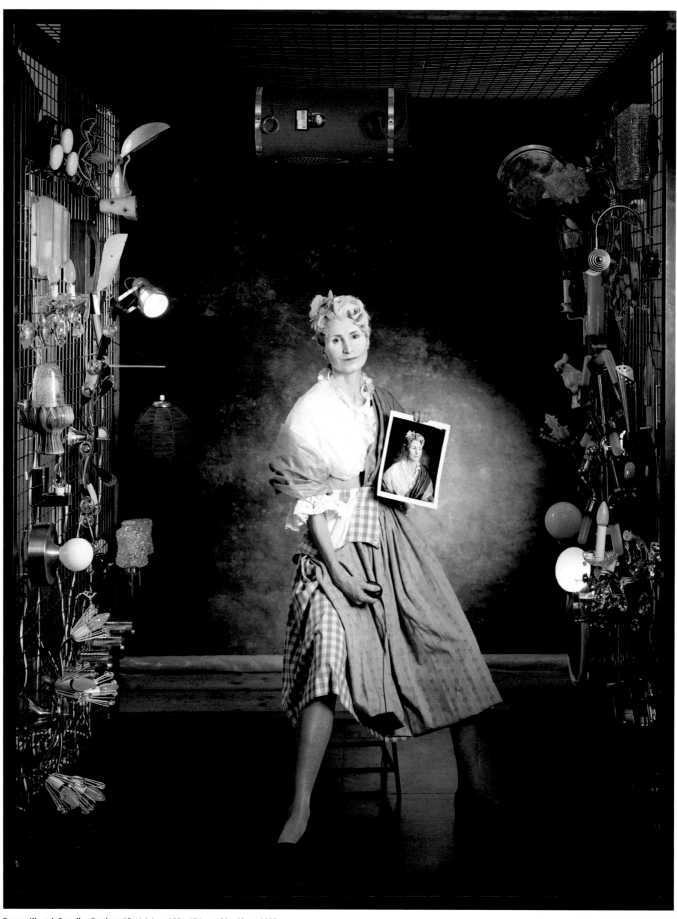

Donne Illustri, Rosalba Carriera #2, Lightbox, 160 x 124 cm / 80 x 62 cm, 2003

Die schöne Ulmerin, 2003

Die schöne Ulmerin #1, Lightbox, 160 x 124 cm, 2003

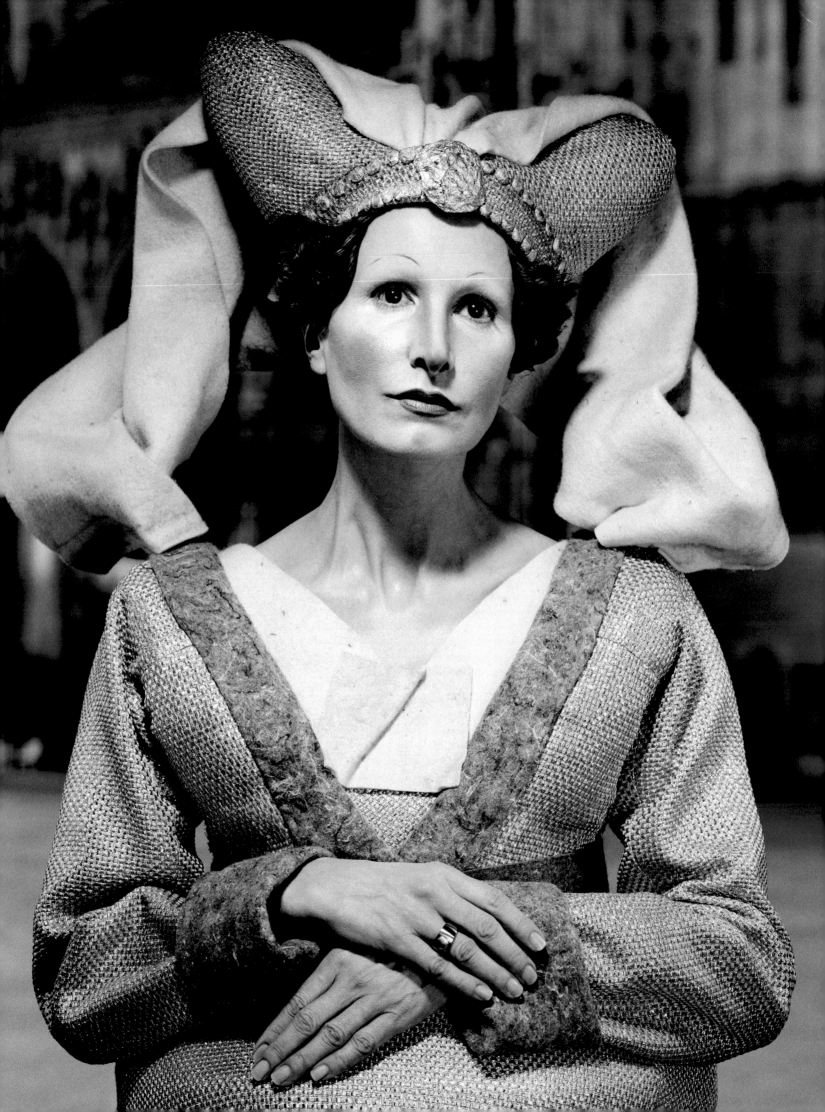

Die schöne Ulmerin

Raimund Kast

Für ihre subtile zeitgenössische Annäherung an eine historische Gestalt, ihr raffiniertes Spiel mit Wandlung und Verwandlung, hat sich Irene Andessner anlässlich ihrer Ausstellung im Stadthaus Ulm eines der bekanntesten Ulmer Frauenporträts ausgesucht: die um 1475/80 geschaffene Reliquienbüste der Hl. Maria Magdalena, einziges erhaltenes Relikt vom ehemaligen Hochaltar des spätgotischen Ulmer Münsters. Schon immer hat diese Frauenfigur den Betrachter fasziniert ob ihrer vollkommenen Durchdringung von Heiligem und Profanem, von Reliquiar und Porträt einer jungen Frau. Als „die schöne Ulmerin", als „Ulmer Leuchterweibchen" oder „Fischerweib" ist die Figur in die Kunstgeschichte eingegangen. Ursprünglich Jörg Syrlin zugeschrieben – ältere Quellen sehen in der Figur ein Porträt von Syrlins Frau – hat die Forschung sie inzwischen als Schöpfung Michel Erharts erkannt, der auch die Wangenbüsten für das Chorgestühl des Ulmer Münsters, das als das wohl großartigste der deutschen Spätgotik gilt, geschaffen hat.[1]

Zugleich lässt sich an der Geschichte dieser Figur geradezu exemplarisch die wechselvolle Geschichte der ehemaligen freien Reichsstadt Ulm nachzeichnen.

Die Gestalt der Hl. Maria Magdalena trägt eine gewisse Mehrdeutigkeit schon in sich. Maria Magdalena ist die christliche Nachfolgerin der Aphrodite, verkörpert den fleischlichen Gegenpol zur sündenlosen, entsexualisierten Gestalt der Jungfrau Maria. Als „heilige Hure", als Ehebrecherin und Verschwenderin wird sie geschildert. In der heute als Maria Magdalena verehrten Heiligen verschmelzen verschiedene Frauengestalten: die namenlose Sünderin, die Jesus mit ihren Tränen die Füße benetzt, um sie dann mit ihrem aufgelösten Haar abzutrocknen; die von sieben bösen Geistern besessene Frau aus Magdala, die sich nach ihrer Heilung dem Gefolge Christi anschließt; schließlich die Schwester von Martha und Lazarus, die den Worten Christi lauscht. „Aus königlichem Geschlecht, edel, reich und minniglich, trug ihr Gemüt hoch" – so beginnt ihre Legende und berichtet weiter, sie habe nach der Auffahrt Christi in den Himmel den Juden gepredigt. Von diesen sei sie, gemeinsam mit anderen Jüngern, in einem steuerlosen Schiff ausgesetzt worden. Erzählt wird von ihrer wunderbaren Landung und Errettung an der Küste Südfrankreichs.

Dreißig Jahre lebt sie als Einsiedlerin in einer Höhle bei Aquensis (Aix-en-Provence), um für ihre Sünden zu büßen. Freilich mit gewissen „Erleichterungen": sieben Mal täglich kommen Engel, heben sie in den Himmel hoch und nähren sie mit himmlischer Speise. Beim Büßen soll der Heiligen ein Haarkleid gewachsen sein, das ihre Gestalt ganz verhüllte. Dargestellt hat dies Tilman Riemenschneider in seinem Münnerstädter Altar; auch Hans Multscher, Schöpfer des Schmerzensmannes am Haupteingang des Ulmer Münsters, hat um 1425 eine behaarte Magdalenenfigur geschaffen, die sich heute in Berlin befindet.

Michel Erhart entschied sich für eine andere Art der Interpretation. Als Ausdruck ihres sündhaften Lebenswandels kleidet er die Heilige in die prächtige Tracht des burgundischen Hofes. Das gegürtete Gewand ist aus aufwändigem Goldbrokat gearbeitet, die Säume sind pelzbesetzt, auf dem Kopf trägt die Figur die zweispitzige burgundische Wulsthaube mit

The Ulm Beauty

Raimund Kast

For her subtle contemporary approach towards a historical form, her refined play with reformation and transformation, Irene Andessner has, on the occasion of her exhibition in the Stadthaus Ulm, selected one of the best-known Ulm portraits of women: the reliquary bust of Saint Mary Magdalene created around 1475/80, the sole surviving relic from the original high altar of the Late Gothic Ulm Minster. This female figure has always fascinated viewers on account of her complete fusion of sacred and profane, of reliquary and portrait of a young woman. The figure appears in the history of art as "the Ulm Beauty", as "Ulm Candelabra Woman" or "Fisherman's wife." Originally ascribed to Jörg Syrlin – older sources see in the figure a portrait of his wife – research since then has recognised it as the work of Michel Erhart, who also created the busts for the bays of the choir stalls of Ulm Minster, which ranks as absolutely the greatest of German Late Gothic.[1]

At the same time the history of this figure can be seen as recapitulating in a quite exemplary fashion the diverse history of the original imperial free city of Ulm.

The form of Saint Mary Magdalene carries in itself a certain ambiguity. Mary Magdalene is the Christian successor to Aphrodite, embodiment of the fleshly opposite to the sinless, desexualised form of the Virgin Mary. She was portrayed as a "holy whore," as an adulteress and spendthrift. Various female figures merge together in the holy figure revered today as Mary Magdalene: the nameless sinner who covered Jesus' feet with her tears then dried them with her loose hair; the woman from Magdala possessed by seven evil spirits, who after her healing joined the followers of Christ; finally the sister of Martha and Lazarus, who listened to the words of Christ. "From a royal line, noble, rich and versed in courtly love, she bore her soul aloft" – so begins her legend, and goes on to report that she preached to the Jews after Christ's ascent into heaven. She was abandoned by them, together with other disciples, in a rudderless ship, and it is told how she made a wonderful landing and was rescued on the coast of southern France.

She lived for thirty years as a hermit in a cave near Aquensis (Aix-en-Provence) to atone for her sins. Though of course with certain "facilities": angels came seven times a day, lifting her high into heaven and nourishing her with heavenly food. Through suffering it is said that a hair-shirt for the saint grew, which completely covered her. Tilman Riemenschneider portrayed this in his Münnerstädt altar; and Hans Multscher, creator of the "Man of Suffering" at the main entrance of Ulm Minster, created around 1425 a hirsute Magdalene figure which is today in Berlin.

Michel Erhart went for another style of interpretation. As an expression of her sinful way of life he clothed the saint in the magnificent garb of the Burgundian court. The girded robe is worked from lavish gold brocade, the hems are trimmed with fur, on the head the figure carries the Burgundian two-pointed bulging cap with shawl, the brow of which is richly set with pearls. Left and right on the cap are more ornaments with pearls and precious stones. A broach fixes the veil which falls down in rich pleats sideways over the back and shoulders, the breast covered in a white

Schultertuch, deren Stirnreif reich mit Perlen besetzt ist. Links und rechts an der Haube finden sich weitere perlen- und edelsteinbesetzte Ornamente. Eine Brosche fixiert das Schleiertuch, das in reicher Fältelung seitlich über den Rücken und die Schultern herabfällt, die Brust wird von einem weißen Tuch bedeckt. Auffallend ist das tief ausgeschnittene Rückendecolleté. Eine kleine Öffnung in der Brust, die mit einem Holzplättchen verschlossen ist, zeigt, dass die Büste ursprünglich als Reliquienbehälter genutzt wurde.

Erharts Maria Magdalena ist dabei noch ganz der Spätgotik verhaftet. Nur wenige Jahrzehnte später, um 1510, schnitzt Michel Erharts Sohn Gregor eine unbekleidete Maria Magdalena, deren Blößen nur durch die langen Haare bedeckt sind und die heute als „la belle allemande" zu den Glanzstücken des Louvre gehört: Hier offenbart sich die beginnende Renaissance, die die antike Lust an der Darstellung des Menschen in seiner ganzen Natürlichkeit wiederentdeckte. Spätere Versionen streichen vor allem das Sündige an Maria Magdalena heraus, stellen sie als Prostituierte dar. In Guido Renis 1627 gemalter „Büßende Magdalena" etwa ist die in die rote Mantelhülle der Venus gekleidete Heilige mit den lang fließenden Haaren und den entblößten Brüsten Ausdruck der ambivalenten Sexualmoral der Zeit. Ganz anders Domenico Fettis Gemälde „Die Meditation", das etwa um dieselbe Zeit entsteht. Es zeigt Maria Magdalena meditierend im gelben Übergewand ihres sündigen Gewerbes, mit aufgelöstem Haar als Symbol der Sündigkeit, mit Ketten, Ringen und anderem Schmuck als Zeichen irdischer Vergänglichkeit. Freilich betrauert sie nicht ihr sündiges Leben, sondern scheint im Gegenteil der Vergänglichkeit des eigenen Lebens nachzutrauern. Das Sündige an Magdalena hebt auch noch Lovis Corinth in seiner dramatisch-expressiven Darstellung der Heiligen hervor. Seine 1923 entstandene „Maria Magdalena mit Perlen im Haar" (heute in der Londoner Tate Gallery) ist mit nichts bekleidet als eben einer Perlenkette – Perlen waren schon seit der Antike Sinnbild der Liebe und sind bis heute signifikanter Ausdruck weiblicher Sinnlichkeit. Im Jahrhundert der sexuellen Revolution verliert die Gestalt der „heiligen Sünderin" freilich mehr und mehr an Bedeutung. Corinth ist einer der wenigen Künstler des 20. Jahrhunderts, der sich explizit mit ihr beschäftigt hat. Ein anderer ist Giorgio de Chirico, in dessen „Christus und Magdalena" betiteltem Bild die Heilige freilich ihre erotische Kraft gänzlich eingebüßt hat.[2]

Das Vielschichtige, das in dieser Heiligengestalt angelegt ist, setzt sich in der Geschichte von Michel Erharts Ulmer Magdalenenfigur fort. Ihre sakral und profan zugleich anmutende Erscheinung bewahrte sie vor dem Schicksal, das einem Großteil der Altäre und Heiligenbüsten des Münsters in der Reformation blühte. 1531 ordnete der Rat der Stadt an, die vielen Altäre, Heiligenfiguren und -büsten im Münster „alles lassen zerschlahen und armen leytten zum brenholtz geben". Jedoch stellte er es den Eigentümern frei, ihren Besitz vorher abzuholen. Wie manch anderes Bildwerk, das später in Privatbesitz wieder auftauchte, scheint auch die Büste der Hl. Maria Magdalena so gerettet worden und in Privatbesitz gelangt zu sein. Über Jahrhunderte hinweg verliert sich ihre Spur. Erst im 19. Jahrhundert taucht sie wieder auf, jetzt im Besitz des Gastwirts Heinrich. Dessen Gastwirtschaft „Zur Stadtbierhalle" war früher wohl eine Kapelle, in der die Figur in einer Nische gestanden haben soll. Jagdfreund Heinrich vollzieht die endgültige Profanisierung der Figur: Er schraubt sie an ein Hirschgeweih, um die Figur „im Stile der altdeutschen Renaissance" als dekorativen

scarf. The deeply plunging back is noteworthy. A small opening in the breast, which is closed with a wooden little wooden tile, shows that the bust was originally used as a container for a relic.

Erhart's Mary Magdalene is however not the whole of the Late Gothic. Only a few decades later, in 1510, Michel Erhart's son Gregor carved an unclothed Mary Magdalene, whose nakedness is covered only by her long hair and which today, as "la belle allemande," is one of the Louvre's pièces de résistance. Here the beginning of the Renaissance reveals itself, which rediscovered the ancient wish to portray people in their complete naturalness. Later versions stressed above all the sinfulness of Mary Magdalene, portraying her as a prostitute. In Guido Reni's "Suffering Magdalene," painted in around 1627, the saint is dressed in the red robes of Venus, with long flowing hair; the uncovered breasts an expression of the ambivalent sexual mores of the time. Quite other is Domenico Fetti's painting of "The Meditation," which belongs to roughly the same time. It shows Mary Magdalene meditating in the yellow working clothes of her profession, with her hair loose as a symbol of sinfulness and with chains, rings and other jewellery as signs of earthly transience. Admittedly she is not mourning her sinful life but rather, by contrast, appears to mourn the transitoriness of her own life. Lovis Corinth also emphasises the sinfulness of the Magdalene in his dramatic-expressive portrayal of the saint. His "Mary Magdalene mit Perlen im Haar" [Mary Magdalene with pearls in her hair] (created in 1923 and now in the Tate Gallery, London) is dressed in nothing but a rope of pearls – pearls which have been since ancient times a symbol of love and which remain today a significant expression of feminine sensuality. In the century of the sexual revolution the figure of the "holy sinner" naturally loses more and more in significance. Corinth is one of the few artists of the 20th century who explicitly concerned himself with it. Another is Giorgio de Chirico, in whose picture entitled "Christ and Magdalene" the saint clearly loses none of her erotic power.[2]

The complexity which is contained in this sacred form carries on in the history of Michel Erhart's Ulm Magdalene figure. Its appearance, simultaneously both sacred and profane, saved it from the fate that befell the majority of the cathedral altars and sacred busts during the Reformation. In 1531 the city council ordered the many altars, sacred figures and busts in the Minster "to be all smashed to pieces and given to the poor for firewood." However, it left the owners free to take away their property beforehand. Like some other images which later reappeared in private ownership, the bust of Saint Mary Magdalene also seems to have been rescued in this way and managed to pass into private hands. Over many centuries all trace of it disappeared. It first resurfaced in the 19th century, in the possession of the restaurant owner Heinrich, whose restaurant "Zur Stadtbierhalle" was once a chapel in which the figure was said to have stood in a niche. Hunting enthusiast Heinrich carried out the ultimate profanation of the figure, screwing it to a pair of antlers in order to use the figure as a decorative candlestick "in the style of the old German Renaissance." Later the candlestick found its way into the Knoderer merchant family. The heirs of Heinrich Knoderer finally sold the candlestick figure in 1916 for 16,000 marks to the Ulm Museum. There the female chandelier adorned the "Schöne Stube" [beautiful parlour], which was fitted out with splendid Renaissance furniture, until in 1934 the true provenance of the figure became known and the saint was freed from adorning an antler ornament.

Lüster zu nutzen. Später findet sich der Leuchter im Besitz der Kaufmannsfamilie Knoderer. Die Erben des Kaufmanns Heinrich Knoderer verkauften die Leuchterfigur schließlich 1916 für 16.000 Mark an das Ulmer Museum. Dort zierte das Lüsterweibchen für einige Jahre die mit prachtvollen Renaissancemöbeln ausgestattete „Schöne Stube", ehe 1934 die wahre Herkunft der Figur erkannt und die Heilige vom zierenden Geweihschmuck befreit wurde.

Die Spannung zwischen sakraler Verehrung und profaner Zweckentfremdung, zwischen Heiliger und Hure, zwischen Reliquienbüste und Lüsterschmuck – eine Spannung, die sich nicht nur in der Figur der Maria Magdalena selbst, sondern eben auch im Schicksal der Figur widerspiegelt –, all dies hat Irene Andessner in ihrer beide Seiten zeigenden Deutung von Michel Erharts Hl. Maria Magdalena subtil nachgezeichnet. Die aktuelle Interpretation, der Gegensatz zwischen historischem Gegenstand und zeitgemäßer medialer Vermittlung, macht dabei deutlich, dass es sich, wie schon Peter Laub anlässlich der Ausstellung „Frauen zu Salzburg" festgestellt hat, auch bei Andessners Inszenierung der „schönen Ulmerin" eben nicht um bloße Rekonstruktionsversuche, „sondern um eine eigene ästhetische Konstruktion handelt."

The tension between sacred veneration and profane misuse, between saint and whore, between reliquary bust and candlestick decoration – a tension which is mirrored not only in the figure of Mary Magdalene herself but precisely in the fate of the figure – all this Irene Andessner has subtly worked over in her reading of Michel Erhart's Saint Mary Magdalene, a reading which shows both sides. This latest interpretation, the opposition between historical object and contemporary media communication, makes clear that, as Peter Laub already established on the occasion of the exhibition "Frauen zu Salzburg" [Women of Salzburg], with Andessner's staging of "the Ulm Beauty," too, it is not a question of a simple search for reconstruction, "but rather of its own aesthetic construction."

1. Der aktuelle Forschungsstand zur Büste der Maria Magdalena findet sich in:
 Michel Erhart & Jörg Syrlin d. Ä. Katalog zur Ausstellung im Ulmer Museum. Stuttgart: Theiss, 2002, S. 267–270.

2. Zur Entwicklung der Maria Magdalena in der Kunst siehe: Maria Magdalena. Die heilige Sünderin. Frankfurt: Ullstein Taschenbuch, S. 161–196.

1. The current state of research into the busts of Mary Magdalene can be found in:
 Michel Erhart & Jörg Syrlin the Elder: catalogue of the exhibition in Ulm Museum, Stuttgart: Theiss, 2002, pp. 267–270.

2. For the development of Mary Magdalene in art, see: Maria Magdalena. Die heilige Sünderin. Frankfurt: Ullstein Taschenbuch, pp. 161–196.

Die schöne Ulmerin #2, Lightbox, 160 x 124 cm, 2003

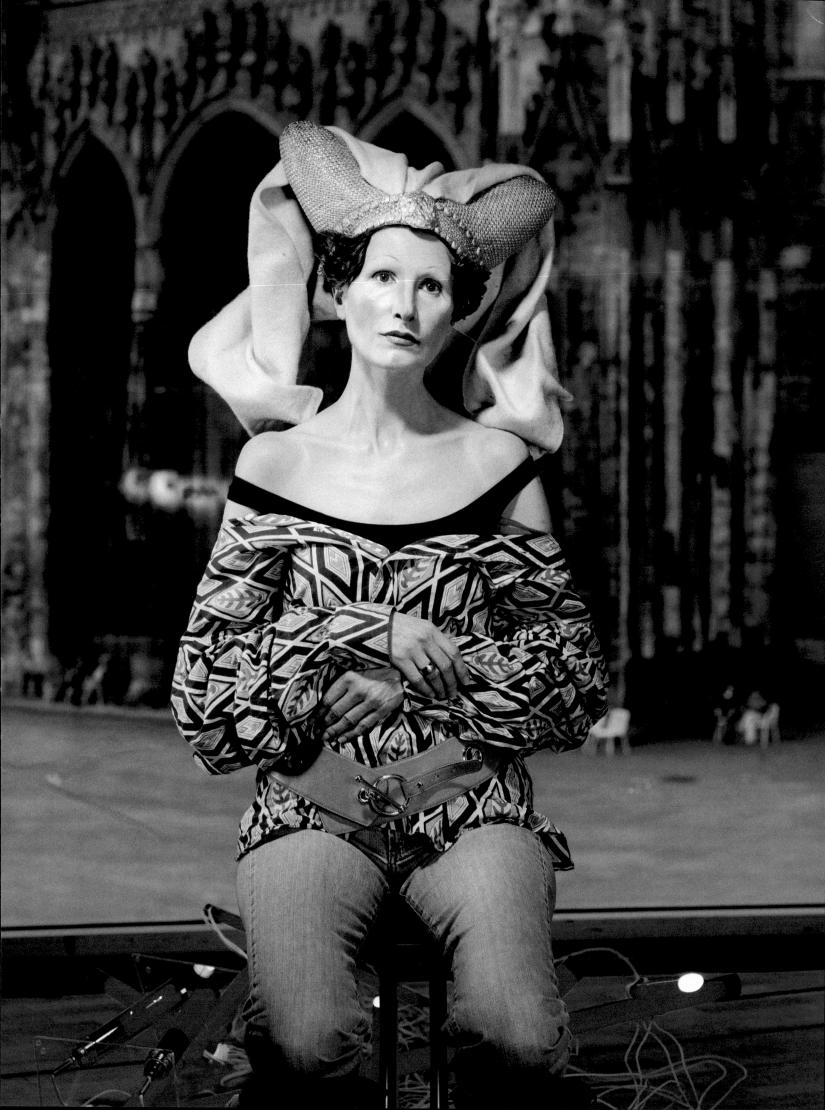

IRENE ANDESSNER

	Geboren in Salzburg
1978/79	Akademie der Bildenden Künste Venedig
	(Emilio Vedova)
1979–1985	Akademie der Bildenden Künste Wien
	(Max Weiler, Arnulf Rainer)
1982/83	Arbeitsstipendium Rom
1989–2000	Atelier in Köln
	Lebt und arbeitet in Wien und Venedig

KURZPROFIL

Nach ihrem Studium an den Kunstakademien in Wien (bei Max Weiler und Arnulf Rainer) und Venedig (Emilio Vedova) sowie einem Stipendiumsjahr in Rom (1982) konzentriert sich die gebürtige Salzburgerin Irene Andessner zunehmend auf das Thema Selbstporträt. Von der gestischen Malerei im Zeitgeist der „Jungen Wilden" ausgehend, verknüpft sie bald die klassische Maltechnik (Öl auf Leinwand) mit konzeptuell als „Datumsbilder" lesbaren Selbstporträts.

Ab Mitte der 1990er Jahre setzt sie ihre Konzepte in den Techniken Fotografie und Video um. Die Selbstinszenierung mit Rollenspiel tritt an die Stelle des gemalten Selbstporträts. „Nachbilder" von kunst- und zeitgeschichtlichen Vorbildern wie Sofonisba Anguissola oder Constanze Mozart entstehen, auch heilige (Schwarze Madonna) und fiktive (Rachel aus „Bladerunner") Personen sowie moderne Mythen (Marlene Dietrich). Im Projekt „I.M. Dietrich" geht die Rollenidentifikation bis zur Annahme des Familiennamens des Vorbildes durch eine reale Heirat. Als „Wanda" (re)produziert sie das Idealbild, das Leopold von Sacher-Masoch von der Frau hatte.

Irene Andessner gilt als Künstlerin, die das Genre Selbstporträt originär weiterentwickelt. Peter Sloterdijk dienen ihre Bilder als Anschauungsbeispiel für seine Begriffsbestimmung vom „Détrait" – mit dem der Philosoph die Gegenposition zum Porträt, nämlich die Auflösung und damit die Austauschbarkeit der bildnerischen Darstellung von Persönlichkeit, markiert. „Das Gesicht ist nur zufällig meines", sagte Andessner 1994 in einem Interview über eine Selbstporträtreihe, deren Spannung aus der Unterschiedlichkeit der Selbstdarstellungen resultiert.

Überlieferte, erinnerte, vorgestellte, idealisierte, selbst „wahrgenommene" Bilder … das Bild der Frau, der sie ihr wandelbares Gesicht leiht, „ist immer fiktiv – in den Augen des Betrachters wie der Gesellschaft" (Andessner). Nicht „I was", sondern „I am" (wie sie ihr Produktionsteam nennt) ist das Motto der Künstlerin. Ein Credo, mit dem sie selbst historische Gestalten sehr gegenwärtig zum Ausdruck bringt – und eine Art Gegen-Gegenwart anbietet.

IRENE ANDESSNER

	Born in Salzburg
1978–1979	Akademie der Bildenden Künste, Venice
	(Emilio Vedova)
1979–1985	Akademie der Bildenden Künste, Vienna
	(Max Weiler, Arnulf Rainer)
1982–1983	Working scholarship in Rome
1989–2000	Studio in Cologne
	Lives and works in Vienna and Venice

BRIEF PROFILE

Following her studies at the Kunstakademie in Vienna (with Max Weiler and Arnulf Rainer) and in Venice (Emilio Vedova), and a scholarship year in Rome (1982), the Salzburg-born Irene Andessner has increasingly concentrated on the self-portrait theme. Taking off from gestural painting in the spirit of the "Jungen Wilden" she soon linked classical painting techniques (oil on canvas) with self-portraits which can be conceptually read as "date pictures."

Since the mid-90s she has translated her concepts into the techniques of photography and video. Self-staging through role-play has taken the place of the painted self-portrait. She produces "After-images" of art-historical and time-historical examples such as Sofonisba Anguissola or Constanze Mozart, as well as sacred (Black Madonna) and fictional (Rachel from "Blade Runner") individuals and modern myths (Marlene Dietrich). In the "I.M. Dietrich" project the role identification goes so far as the assumption of the exemplar's family name through a real marriage. As "Wanda" she reproduces Leopold of Sacher-Masoch's ideal image of woman.

Irene Andessner is an artist who has advanced the self-portrait genre in an original way. For the philosopher Peter Sloterdijk her pictures serve as an illustrative example of his definition of "détrait," with which he indicates a standpoint opposite to that of the portrait: namely, the disintegration and thereby the interchangeability of the artistic representation of personality. "The face is only mine by chance," said Andessner in an interview in 1994 about a series of self-portraits whose tension results from the way the self-depictions vary.

Handed down, remembered, imagined, idealised, self "perceived" images … the image of the woman to whom she lends her changeable face "is always a fiction – in the eyes of the beholder as much as of society" (Andessner). Not "I was" but "I am" (as she calls her production team) is the artist's motto. A credo through which she herself gives absolutely contemporary expression to historical figures. And offers an art which counterpoints the contemporary.

WERKGRUPPEN

„Mumien, Dämonen, Totenköpfe, Portraits", 1982–1985

„Gotische Kirchenfiguren", 1985/86

„Die Kämpfer", 1986–1988

„Selbstportraits", 1989–1992

„Portraits" (Kölner Zyklus), 1993/94

„Neue Selbstportraits", 1994/95

„Mein Murano", 1995

„Vorbilder", 1995–1998

„Malerhut", 1997

„Barbara Blomberg", 1998

„Cyberface", 1998

„Frauen zu Salzburg", 1999

„Wasserfest", 1999/2002

„Milli Stubel-Orth"/„Irrlichter", 2000

„Cyber-Irma"(Irma von Troll-Borostyani), 2001

„Portrait – Détrait", 2000

„I.M. Dietrich", 2001

„Portraitprojekt ", 2001 ff

„Wanda SM", 2001–2003

„Donne Illustri", 2002/2003

„Die schöne Ulmerin", 2003

VIDEOPRODUKTIONEN / VIDEOINSTALLATIONEN

„39 1/2 < 27°", VHS-Video 1,5 min (Endlosschleife), für die Ausstellung „Die verlassenen Schuhe" im Rheinischen Landesmuseum Bonn, 1993

„Vorbilder", Videoinstallation, (VHS-Video und CD-ROM 5 min., Endlosschleife), Galerie Carol Johnssen, München, 1996, Galerie Claudia Böer, Hannover, 1997

„Cyberface", Videoinstallation, Lutz Teutloff Galerie auf dem Artforum Berlin 1998; Podewil – Zentrum für aktuelle Künste, Berlin, 1999 u.a.

„Frauen zu Salzburg", Videoinstallation (VHS-Video 17 min. 15 sec.), Museum Carolino Augusteum, Salzburg, 1999

„Malerhut", Video 5 min. 10 sec.,1998

„Irrlichter", Videoinstallation, 23 min. 30 sec., 2000

„I.M. Dietrich", Video 45 min., 2001/2002

„Wanda SM", Videoinstallation, DVD, 38 min., 2003

„Donne Illustri", Video Making of, 2003

„Die schöne Ulmerin", Video Making of, 2003

WORKS

"Mumien, Dämonen, Totenköpfe, Portraits," 1982–1985

"Gotische Kirchenfiguren," 1985–1986

"Die Kämpfer," 1986–1988

"Selbstportraits," 1989–1992

"Portraits" (Cologne series), 1993–1994

"Neue Selbstportraits," 1994–1995

"Mein Murano," 1995

"Vorbilder," 1995–1998

"Malerhut," 1997

"Barbara Blomberg," 1998

"Cyberface," 1998

"Frauen zu Salzburg," 1999

"Wasserfest," 1999/2002

"Milli Stubel-Orth"/"Irrlichter," 2000

"Cyber-Irma" (Irma von Troll-Borostyani), 2001

"Portrait – Détrait," 2000

"I.M. Dietrich," 2001

"Portraitprojekt," 2001 ff

"Wanda SM," 2001–2003

"Donne Illustri,"2002–2003

"Die schöne Ulmerin," 2003

VIDEO PRODUCTIONS / VIDEO INSTALLATIONS

"39 1/2 < 27°," VHS video 1 min. 30 sec. (continuous loop), for the "Die verlassenen Schuhe" exhibition in the Rheinischen Landesmuseum Bonn, 1993

"Vorbilder," video installation (VHS video and CD-ROM 5 min, continuous loop), Galerie Carol Johnssen, Munich, 1996, Galerie Claudia Böer, Hanover, 1997

"Cyberface," video installation, Lutz Teutloff Galerie at the Artforum Berlin 1998; Podewil – Zentrum für aktuelle Künste, Berlin, 1999 etc.

"Frauen zu Salzburg," video installation (VHS video 17 min. 15 sec.), Museum Carolino Augusteum, Salzburg, 1999

"Malerhut," video 5 min. 10 sec., 1998

"Irrlichter," video installation, 23 min. 30 sec., 2000

"I.M. Dietrich," video 45 min., 2001/2003

"Wanda SM," video installation, DVD, 38 min, 2003

"Donne Illustri," video making of, 2003

"Die schöne Ulmerin," video making of, 2003

KATALOGE / PUBLIKATIONEN / FEUILLETONS / FEATURES (Auswahl)

„Ren C. Andessner", Klaus Honnef, Hrsg. Ferdinand Maier, Galerie Zeitkunst, Kitzbühel, Katalog, 1991

„Porträts von Irene Andessner", Enno Stahl, Apex No. 18, 1993

„Irene Andessner", Interview von Marion Hövelmeyer, im Ausstellungskatalog „für sie(h)", Galerie im Turm, Kulturzentrum Schlachthof, Bremen, 1995

„Die Überwindung der Nähe", Ulrike Jagla-Blankenburg, KunstZeit 2/1997

„Irene Andessner – Vorbilder", Textbeiträge: Peter Baum, Peter Watzl; Neue Galerie der Stadt Linz, Katalog mit CD-ROM, 1998

„Austrian Spotlight", S. 14/15, Artothek Wien 1998

„Sphären – Mikrosphärologie", Band 1 (S. 194 ff), Peter Sloterdijk, Suhrkamp Verlag, 1998

„Voorbij de schone schijn", Filip Luyckx, Sint-Lukasgalerij, Brüssel, 4/1999

„Light Boxes – Leuchtkastenkunst" (S. 27, 40, 77, 79, 83, 84, 122, 123, 150), Stephan Trescher, Verlag für moderne Kunst Nürnberg, 1999

„Irene Andessner – Frauen zu Salzburg", Textbeiträge: Wolfram Morath, Peter Laub, Alfred Zellinger; Hrsg. Carolino Augusteum, Salzburg 1999

„Hotelsoli – Frauen zu Salzburg", Textbeiträge: Klaus Honnef, Peter Watzl; Hrsg. Helga Rabl-Stadler, Salzburg, Katalog, 1999

„Irene Andessner: Im Badehaus", Hrsg. Werner Wolf, Museum der Wahrnehmung, Folder 1999

„Majestät, Mätresse und immer sie selbst", Gunder Clauss, Art 2/2000

„CYBERFACE...REN", Hrsg. Dr. Klaus Wölfer, Österreichisches Kulturinstitut Rom, Folder 2000

„Irene Andessner – Cyberface „Ohne Spiegel leben – Sichtbarkeiten und posthumane Menschenbilder", S. 191 ff, Andreas Leo Findeisen, Wilhelm Fink Verlag, München 2000

„Die vielen Gesichter der Irene Andessner", Werner Horvath, Kunststücke, Feature 20 min., ORF 2000

„New Austrian Spotlight", S. 1, Artothek Wien 2000

„Milch vom ultrablauen Strom – Strategien österreichischer Künstler 1960–2000", S. 97 ff, Hrsg. Wolfgang Denk, Kunsthalle Krems, 2000

„Photographie – die Sammlung", S. 22, Hrsg. Peter Baum, Lentos Kunstmuseum Linz, 2000/2001

„Irene Andessner", Micky Kwella, Katalog „Podewil Artists-in residence", Berlin 2000/2001

„Die ephemere Figur", S. 32/33, Exhibition Gallery of Provisonal, Municipal Council of Macau (VRC), 2001

„M. heiratet Dietrich", Ulla Rogalski, Handelsblatt/Galerie, 28.12.2001

„I.M. Dietrich", Werner Horvath, Treffpunkt Kultur, Feature 8'40 min., ORF 2001

„Von Kopf bis Fuß auf Dietrich eingestellt", Gunder Clauss, Art 2/2002

„Irene Andessner", Interview Alexander Pühringer, Frame Jan-Mar 2002

„Marlene Dietrich und Venus im Pelz: Frau inszeniert sich als Vorzeigefrau", Hans Haider, Die Presse 23.9.2002

„Donne Illustri – Irene Andessner", Katalog, Hrsg. Stefano Stipitivich, Caffè Florian, Venedig, 2003

„Meine Lebensbeichte", Wanda Sacher-Masoch, Künstlerbuchedition mit Bildmaterial aus Irene Andessners „Wanda SM"-Produktion und einem Dossier, Belleville Verlag, München 2003

„I am Irene Andessner", Textbeiträge: Raimund Kast, Peter Sloterdijk, Gerald Matt, Michaela Knapp, Peter Fabian; Hatje Cantz Verlag, Ostfildern-Ruit 2003

CATALOGUES / PUBLICATIONS / ARTS PAGES / FEATURES (selection)

"Ren C. Andessner," Klaus Honnef, edited by Ferdinand Maier, Galerie Zeitkunst, Kitzbühel, catalogue, 1991

"Porträts von Irene Andessner," Enno Stahl, Apex No. 18, 1993

"Irene Andessner," interview by Marion Hövelmeyer, in the exhibition catalogue "für sie(h)," Galerie im Turm, Kulturzentrum Schlachthof, Bremen, 1995

"Die Überwindung der Nähe," Ulrike Jagla-Blankenburg, KunstZeit 2/1997

"Irene Andessner – Vorbilder," texts by Peter Baum, Peter Watzl; Neue Galerie der Stadt Linz, catalogue with CD-ROM, 1998

"Austrian Spotlight," pp. 14/15, Artothek Wien 1998

"Sphären – Mikrosphärologie," vol. 1 (pp. 194 ff), Peter Sloterdijk, Suhrkamp Verlag, 1998

"Voorbij de schone schijn," Filip Luyckx, Sint-Lukasgalerij, Brussels, 4/1999

"Light Boxes – Leuchtkastenkunst" (pp. 27, 40, 77, 79, 83, 84, 122, 123, 150), Stephan Trescher, Verlag für moderne Kunst Nürnberg, 1999

"Irene Andessner – Frauen zu Salzburg," texts by Wolfram Morath, Peter Laub, Alfred Zellinger; edited Carolino Augusteum, Salzburg 1999

"Hotelsoli – Frauen zu Salzburg," texts by Klaus Honnef, Peter Watzl; edited by Helga Rabl-Stadler, Salzburg, catalogue, 1999

"Irene Andessner: Im Badehaus," edited by Werner Wolf, Museum der Wahrnehmung, Folder 1999

"Majestät, Mätresse und immer sie selbst," Gunder Clauss, Art 2/2000

"CYBERFACE...REN," edited by Dr. Klaus Wölfer, Österreichisches Kulturinstitut Rom, Folder 2000

"Irene Andessner – Cyberface "Ohne Spiegel leben – Sichtbarkeiten und posthumane Menschenbilder," pp. 191 ff, Andreas Leo Findeisen, Wilhelm Fink Verlag, Munich 2000

"Die vielen Gesichter der Irene Andessner," Werner Horvath, Kunststücke, feature 20 min., ORF 2000

"New Austrian Spotlight," p. 1, Artothek Wien 2000

"Milch vom ultrablauen Strom – Strategien österreichischer Künstler 1960–2000," pp. 97 ff, edited by Wolfgang Denk, Kunsthalle Krems, 2000

"Photographie – die Sammlung," p. 22, edited by Peter Baum, Lentos Kunstmuseum Linz, 2000/2001

"Irene Andessner," Micky Kwella, catalogue "Podewil Artists-in residence," Berlin, 2000/2001

"Die ephemere Figur," pp. 32/33, Exhibition Gallery of Provisonal, Municipal Council of Macau (VRC), 2001

"M. heiratet Dietrich," Ulla Rogalski, Handelsblatt/Galerie, 28.12.2001

"I.M. Dietrich," Werner Horvath, Treffpunkt Kultur, feature 8'40 min., ORF 2001

"Von Kopf bis Fuß auf Dietrich eingestellt," Gunder Clauss, Art 2/2002

"Irene Andessner," interview by Alexander Pühringer, Frame Jan-Mar 2002

"Marlene Dietrich und Venus im Pelz: Frau inszeniert sich als Vorzeigefrau," Hans Haider, Die Presse 23.9.2002

"Donne Illustri – Irene Andessner," catalogue, edited by Stefano Stipitivich, Caffè Florian, Venice, 2003

"Meine Lebensbeichte," Wanda Sacher-Masoch, artist book edition with illustrations from Irene Andessner's "Wanda SM" production and dossier, Belleville Verlag, Munich, 2003

"I am Irene Andessner," texts by Raimund Kast, Peter Sloterdijk, Gerald Matt, Michaela Knapp, Peter Fabian; Hatje Cantz Verlag, Ostfildern-Ruit, 2003

Vorbilder, 1995–1998

Fasziniert von Künstlerinnen, die sich – wie sie selbst – oft vor dem Spiegel gemalt haben, studiert Irene Andessner deren Biographien und Werkkonzepte, beginnend mit der Renaissance – seit bildende Künstlerinnen in der Kunstgeschichte registriert wurden. Das Ölbild „Selbstportrait 1554", 1995 gemalt nach einem Selbstporträt von Sofonisba Anguissola, fällt in die Vorbereitungsphase des Projektes „Vorbilder", das Andessner nur noch mittels Video und Fotografie umsetzen sollte. Neben dem großen Vorbild der Renaissance-Malerin sind es Selbstporträts von Angelica Kauffmann, Gwen John, Frida Kahlo, die Andessner in Licht- und Farbstimmung, Haltung und Gesichtsausdruck nachvollzieht und im jeweiligen Stil der Kleidung mit heutiger Mode nachempfindet. Die Szenerien wechseln entsprechend den Vorlagen, der Gesichtsausdruck ist von Motiv zu Motiv verschieden. Der „Blick in den Spiegel" reflektiert die (vom männlichen Selbstporträtblick abweichende) Gemeinsamkeit der Künstlerinnen, über 500 Jahre Neuzeit hinweg – auch, wenn an Stelle des Spiegels eine Video- oder Fotokamera steht. Die Videosequenzen zeigen, wie Andessner die Positionen einnimmt, in denen sich ihre Vorgängerinnen verewigt haben.

Ausstellungen:
„Vorbilder", Galerie Carol Johnssen, München, 1996
„Vorbilder", Galerie Claudia Böer, Hannover, 1997
„... und der Stuhl dazu", Galerie Siegfried Sander, Kassel, 1997
„Irene Andessner", Lindinger + Schmid, Regensburg, 1998
„Vorbilder", Neue Galerie der Stadt Linz, 1998
„Vorbilder #1 Sofonisba Anguissola", Lutz Teutloff Galerie im Projektraum Trafohaus, Berlin, 1998
„Vorbilder", Galerie Monika Beck, Homburg/Saar, 1998
„Vorbilder", Galerie Thomas Gehrke, Hamburg, 1999
„Vorbilder #1", PhotoConcept, Frankfurter Buchmesse, Courtesy Lutz Teutloff Galerie, 1999

Editionen:
„Vorbilder / Negative", Wandlampen, Galerie Claudia Böer, Hannover
„Vorbilder Leuchtkästen", Dialeuchtkästen, 5 Motive, Artikel Editionen
„Vorbilder Wandlampen", Duratrans/Plexiglas, 5 Motive, Artikel Editionen
„Vorbilder #3 (Gwen John)", Siebdruck auf Aluminium, Artikel Editionen
„Vorbilder Bild & Stuhl #3 (Gwen John)", Duratrans/Plexiglas/Stahl, Artikel Editionen
„Vorbilder #1 (Sofonisba Anguissola)", Digiprint/Holzleuchtkasten, Artikel Editionen

Publikation:
„Irene Andessner – Vorbilder", Katalog mit CD-ROM, Hrsg. Peter Baum, Neue Galerie der Stadt Linz, 1998

Öffentliche Sammlungen (1998):
„Vorbilder # 1–5" (Videostills) und „Vorbilder/Gwen John", (Leuchtkasten-Stuhlobjekt), Österreichisches Bundeskanzleramt, Sektion Kunst, Wien
„Vorbilder" (6 Leuchtkästen, Videoinstallation) und „Vorbilder/GwenJohn", (Leuchtkasten-Stuhlobjekt), Neue Galerie der Stadt Linz / Wolfgang Gurlitt Museum, Linz
„Vorbilder # 1–5", 5 Leuchtkästen, Rupertinum, Salzburg
„Vorbilder #1", Leuchtkasten, Land Salzburg
„Vorbilder/Gwen John", (Leuchtkasten-Stuhlobjekt), Wiener Städtische Versicherung, Wien (2003)

Vorbilder [models], 1995–1998

Fascinated by female artists who – like herself – often painted themselves in front of the mirror, Irene Andessner studied their biographies and work programmes, beginning with the Renaissance – the time when female visual artists first became noticed in the history of art. The oil painting "Selbstportrait 1554" [self-portrait], painted in 1995 after a self-portrait by Sofonisba Anguissola, falls into the preparatory phase of the "Vorbilder" project which Andessner was to undertake using only video and photography. Alongside the huge example of the Renaissance painters there are self-portraits by Angelica Kauffmann, Gwen John, Frida Kahlo, which Andessner comprehends in the atmosphere of light and colour, bearing and facial expression, adapting the style of clothing of each to today's fashion. The settings change according to the presentation, the facial expression is different from motif to motif. The look in the mirror reflects (in contrast to the male self-portrait view) the common ground of the women artists, over 500 years distant from modern times – even when a video or photo camera takes the place of the mirror. The video sequences show how Andessner takes up the positions in which her predecessors immortalised themelves.

Exhibitions:
"Vorbilder," Galerie Carol Johnssen, Munich, 1996
"Vorbilder," Galerie Claudia Böer, Hanover, 1997
"... und der Stuhl dazu," Galerie Siegfried Sander, Kassel, 1997
"Irene Andessner," Lindinger + Schmid, Regensburg, 1998
"Vorbilder," Neue Galerie der Stadt Linz, 1998
"Vorbilder #1 Sofonisba Anguissola," Lutz Teutloff Galerie in the Trafohaus project room, Berlin, 1998
"Vorbilder," Galerie Monika Beck, Homburg/Saar, 1998
"Vorbilder," Galerie Thomas Gehrke, Hamburg, 1999
"Vorbilder #1," PhotoConcept, Frankfurt Book Fair, courtesy Lutz Teutloff Galerie, 1999

Editions:
"Vorbilder / Negative," wall lamps, Galerie Claudia Böer, Hanover
"Vorbilder Leuchtkästen," transparency light box, 5 motifs, Artikel Editionen
"Vorbilder Wandlampen," Duratrans/Plexiglas, 5 motifs, Artikel Editionen
"Vorbilder #3 (Gwen John)," aluminium screen print, Artikel Editionen
"Vorbilder Bild & Stuhl #3 (Gwen John)," Duratrans/Plexiglas/steel, Artikel Editionen
"Vorbilder #1 (Sofonisba Anguissola)," digiprint/wooden light box, Artikel Editionen

Publication:
"Irene Andessner – Vorbilder," catalogue with CD-ROM, edited by Peter Baum, Neue Galerie der Stadt Linz, 1998

Public Collections (1998):
"Vorbilder # 1–5" (video stills) and "Vorbilder/Gwen John" (light box chair piece), Österreichisches Bundeskanzleramt, Kunst section, Vienna
"Vorbilder" (6 light boxes, video installation) and "Vorbilder/Gwen John," (light box chair piece), Neue Galerie der Stadt Linz/Wolfgang Gurlitt Museum, Linz
"Vorbilder # 1–5," 5 light boxes, Rupertinum, Salzburg
"Vorbilder #1," light box, Land Salzburg
"Vorbilder/Gwen John," (light box chair piece), Wiener Städtische Versicherung, Vienna (2003)

Malerhut, 1997

In seinem „Selbstporträt in der Werkstatt" trägt Goya Hut, die Krempe mit brennenden Kerzen besetzt, um nachts an der Staffelei arbeiten zu können. In Kirk Douglas' Van-Gogh-Darstellung (1956) ist es ein Strohhut. Irene Andessner hat das Kuriosum des „Malerhuts" bildnerisch dargestellt. Die Videokameras liefen, während das Stroh Feuer fing. Fünf Film-Stills – Duratrans-Dias in strohbezogenen Holzleuchtkästen – zeigen den dramatischen Ablauf im Zeitraffer. Im Videoclip ist zu sehen, wie der von der Künstlerin im letzten Moment vom Kopf gerissene Strohhut am Boden weiterbrennt.

Ausstellungen:
Galerie Monika Beck, Homburg/Saar, 1998
Kunstmessen: Art Multiple/Artikel Editionen,1998; Kunst Zürich/Galerie Böer, 1999

Editionen:
„Malerhut Tortenkiste", Holzleuchtkasten/Torte, Artikel Editionen mit Galerie Claudia Böer
„Malerhut 1–5", Holz-Strohleuchtkästen, 5 Motive, mit Videotape, Artikel Editionen

Barbara Blomberg, 1998

Barbara Blomberg (1527–1597), Regensburger Bürgerstochter, Geliebte von Kaiser Karl V. Ab 1551 lebt die Mutter von Don Juan de Austria in Brüssel, in dessen Museum der Schönen Künste das „Frauenporträt mit Blumenstrauß" hängt (dat. 1564, Adriaen Thomasz Key zugeschr.). Dieses Bild einer vornehmen Patrizierin dient Irene Andessner als Vorlage für das fiktive Porträt der Feldherrenmutter, von der kein Bild überliefert ist. Eine ortsbezogene Arbeit anlässlich einer Ausstellung in Regensburg.

Ausstellungen:
„Irene Andessner", Galerie Lindinger + Schmid, Regensburg, 1998
„Critical Elegance", Galerie Sint-Lukasstichting, Brüssel, 1999

Editionen:
„Barbara Blomberg Wärmeflasche", Holzkassette, Artikel Editionen
„Barbara Blomberg Souvenir", Holzleuchtkasten, Artikel Editionen

Öffentliche Sammlung:
„Barbara Blomberg", Leuchtkasten, Museen der Stadt Regensburg, 1998

Malerhut [painter's hat], 1997

In his "Self-Portrait in the Studio" Goya is wearing a hat, the brim set with candles so that he can work at the easel at night. In Kirk Douglas' 1956 Van Gogh portrayal this becomes a straw hat. Irene Andessner has pictorially captured the oddity of the "painter's hat." The video cameras roll while the straw catches fire. Five film stills – Duratrans slides in straw-covered wooden light boxes – show the dramatic sequence of events in time-lapse. In the video clip it can be seen how the straw hat, snatched from his head by the artist at the last moment and thrown to the ground, goes on burning.

Exhibitions:
Galerie Monika Beck, Homburg/Saar, 1998
Art fairs: Art Multiple/Artikel Editionen,1998; Kunst Zürich/Galerie Böer, 1999

Editions:
"Malerhut Tortenkiste," wooden light box/cake, Artikel Editionen with Galerie Claudia Böer
"Malerhut 1–5," wood and straw light boxes, 5 motifs, with video tape, Artikel Editionen

Barbara Blomberg, 1998

Barbara Blomberg (1527–1597), daughter of a Regensburg burgher, lover of Emperor Charles V. From 1551 the mother of Don Juan de Austria lived in Brussels, in whose Museum of Fine Arts hangs the "Frauenporträt mit Blumenstrauß" [portrait of a woman with bunch of flowers] (dated 1564, attributed to Adriaen Thomasz Key). This picture of an elegant patrician provides Irene Andessner with the model for the fictional portrait of the commander's mother, no picture of whom has been handed down. A work specific to this place on the occasion of an exhibition in Regensburg.

Exhibitions:
"Irene Andessner," Galerie Lindinger + Schmid, Regensburg, 1998
"Critical Elegance," Galerie Sint-Lukasstichting, Brussels, 1999

Editions:
"Barbara Blomberg Wärmeflasche," wooden case, Artikel Editionen
"Barbara Blomberg Souvenir," wooden light box, Artikel Editionen

Public Collection:
"Barbara Blomberg," light box, Museen der Stadt Regensburg, 1998

Cyberface, 1998

Bildende Künstlerin spielt Schauspielerin, die einen Kunstmenschen darstellt. „Rachel", die Replikantin aus dem Film „Bladerunner" (1981), steht für den gemachten Menschen, wie er seit den 1960er Jahren im Science-Fiction-Filmgenre aufersteht; Vorläufer sind die Frankenstein-Verfilmungen seit 1931 (auf Basis des Romans „Frankenstein oder der moderne Prometheus" von Mary Shelley, 1818). Die romantische Vorstellung vom intelligent/stark/schön manipulierten bzw. produzierten Menschen korrespondiert mit der Entwicklung der Computertechnologie – noch unabhängig von gentechnisch geleiteten Forschungsfantasien.

Chip-gefütterte, software-gesteuerte Hardware. Eine Ingenieurleistung, mit der der Management-Terminus „Human Engineering" eine organische Designdimension erhält. Menschenhaftes Vorleben findet auf dem Monitorreißbrett statt – in Form von 3D-animierter Vektorgraphik, mit der der evolutionäre Try-and-error-Vorgang antizipiert wird.

Irene Andessner inszeniert sich als Probandin für die Manipulierbarkeit, aber auch die Unberechenbarkeit des Echtmenschen. Die Befehlsgewalt über das selbstschöpferische Gelingen oder Misslingen behält sie sich vor: Mit „COPY", „IGNORE!", „ERROR", „RESET" entstehen, scheitern und verschwinden Vorschläge für ein mengentaugliches Konterfei. Das Video „Cyberface" lässt sich als Manipulation, Replikation und Eliminierung des Selbstporträts betrachten. Oder als Statement einer Replikantin, die auf Selbstporträts spezialisiert ist.

Ausstellungen:
Kojeninstallation, **Lutz Teutloff Galerie** auf dem Artforum Berlin, 1998
Podewil – Zentrum für aktuelle Künste, Berlin, 1999
Galerie Giuseppe Casagrande, Rom, 2000
International Symposium „Predictive Medicine", Seeon, 2001

Publikation:
„CYBERFACE...REN", Folder, Hrsg. Klaus Wölfer, Österreichisches Kulturinstitut Rom, 2000

Öffentliche Sammlungen:
„Cyberface", 7 Leuchtkästen, Telekom AG/Schaltzentrale, Frankfurt am Main
„Cyberface", 3 Leuchtkästen plus Video, Rupertinum, Salzburg

Frauen zu Salzburg, 1999

Irene Andessner thematisiert prominente Salzburgerinnen: Kaiserwitwe Caroline Auguste (1792–1873), Mozart-Witwe Constanze (1762–1842), Mozart-Schwester Anna Maria Mozart alias Nannerl (1751–1829), die „Hundsgräfin" Emilia Viktoria Kraus (1785–1845), die Porträtistin Barbara Krafft (1764–1825). Mit Referenz an historische Porträtgemälde produziert Andessner fünf Bildszenarien, in denen sie die ursprünglichen Darstellungen in Haltung und Ausdruck, Ausschnitt, Raum- und Lichtstimmung (ohne historisierende Kostüme und Dekorationen) nachvollzieht. Neben diesen Fotoarbeiten inszeniert sie in den Rollen der fünf Personen die Filmsequenzen „Ich suche einen Mann!"– Vorstellungsmonologe im Stil der Partnervermittlungsvideos, die als Großprojektionen im Museum und auch über das Internet laufen; die Antworten der Interessenten gehen online in die Museumsausstellung.

Cyberface, 1998

A female artist plays the actress, portraying an artificial human being. "Rachel," the replicant from the film "Blade Runner" (1981), represents the created human as he or she has been rising from the dead in the sci-fi film genre since the 60s; predecessors include the filmed Frankensteins since 1931 (based on Mary Shelley's "Frankenstein, or The Modern Prometheus," 1818). The romantic idea of manipulated or manufactured humans, intelligent/strong/beautiful, corresponds to the development of computer technology – it still has no dependency on research fantasies fuelled by genetic technology.

Chip-fed, software-guided hardware. An engineering achievement through which the management term "human engineering" acquires an organic design dimension. Previous humanoid life takes place on the monitor drawing board – in the form of 3D animated vector graphics with which the evolutionary process of trial and error is anticipated.

Irene Andessner portrays herself as a guinea pig for the work of manipulation, but also for the unpredictability of real humans. She keeps hold of the command over the self-creative successes or un-successes: proposals for a likeness suitable for mass-production come into being, fail and disappear with "COPY," "IGNORE!," "ERROR," "RESET." The "Cyberface" video can be regarded as the manipulation, replication and elimination of the self-portrait. Or as the statement of a replicant who specialises in self-portraits.

Exhibitions:
Kojeninstallation, **Lutz Teutloff Galerie** at the Artforum Berlin, 1998
Podewil – Zentrum für aktuelle Künste, Berlin, 1999
Galerie Giuseppe Casagrande, Rome, 2000
International Symposium "Predictive Medicine," Seeon, 2001

Publication:
"CYBERFACE...REN," folder, edited Klaus Wölfer, Österreichisches Kulturinstitut Rome, 2000

Public Collections:
"Cyberface," 7 light boxes, Telekom AG/Schaltzentrale, Frankfurt am Main
"Cyberface," 3 light boxes plus video, Rupertinum, Salzburg

Frauen zu Salzburg [women of Salzburg], 1999

Irene Andessner takes as her central theme prominent Salzburg women: The widow of the Austrian emperor, Caroline Auguste (1792–1873), Mozart's widow Constanze (1762–1842), his sister Anna Maria, alias Nannerl (1751–1829), "Hundsgräfin" [hound countess] Emilia Viktoria Kraus (1785–1845), portraitist Barbara Krafft (1764–1825). With reference to historical portrait paintings Andessner produces five picture scenes in which she takes in the original portrayals as regards bearing and expression, detailing, room and light ambience, but without historicizing costumes and decorations. Alongside this photographic work she stages, in the roles of the five people, the film- sequences "Ich suche einen Mann!"[I'm looking for a man!] – performance monologues in the style of dating agency videos, which run as large projections in the museum and also on the Internet; the replies of prospective partners go online in the museum exhibition.

Ausstellungen:

„**Frauen zu Salzburg**", Einzelausstellung im Museum Carolino Augusteum, Salzburg, 1999

„**Hotel-Soli**", begleitende Making-of-Fotoausstellung im Haus des Projektsponsors Resmann Couture, Salzburg

„**Frauen zu Salzburg**", Rauminstallation für Lutz Teutloff Galerie auf dem Artforum Berlin, 1999

Editionen:

„**Frauen zu Salzburg P.E.**", Preview Edition, Wandlampe, Artikel Editionen

„**Caroline Auguste**", Brosche, Artikel Editionen

„**Carolinen-Trüffel**", Praline, Artikel Editionen

Publikationen:

„**Irene Andessner – Frauen zu Salzburg**", Hrsg. Wolfram Morath, Carolino Augusteum, Salzburg, 1999

„**Hotel-Soli – Frauen zu Salzburg**", Hrsg. Helga Rabl-Stadler, Salzburg, 1999

Exhibitions:

"**Frauen zu Salzburg**," solo exhibition in the Museum Carolino Augusteum, Salzburg, 1999

"**Hotel-Soli**," accompanying "making-of" photographic exhibition in the premises of the project sponsors Resmann Couture, Salzburg

"**Frauen zu Salzburg**," room installation for Lutz Teutloff Galerie at the Artforum Berlin, 1999

Editions:

"**Frauen zu Salzburg P.E.**," preview edition, wall lamp, Artikel Editionen

"**Caroline Auguste**," broach, Artikel Editionen

"**Carolinen-Trüffel**," chocolate, Artikel Editionen

Publications:

"**Irene Andessner – Frauen zu Salzburg**," edited by Wolfram Morath, Carolino Augusteum, Salzburg, 1999

"**Hotel-Soli – Frauen zu Salzburg**," edited by Helga Rabl-Stadler, Salzburg, 1999

Wasserfest, 1999–2002

Selbstporträts unter Wasser, ungeschminkt und unbekleidet. Gesicht und Körper verschwimmen, Ausdruck und Haltung verzerren sich mit den selbst verursachten Wasserbewegungen. Eine entrückte Perspektive des Selbstporträts. Künstler und Betrachter durch ein Grundelement getrennt. Die optisch gebrochene Wahrnehmung beruht auf Gegenseitigkeit.

Ausstellungen:

„**Im Badehaus**", Museum der Wahrnehmung, Graz (A), 1999

„**Portrait–Détrait**", Transmediale, Podewil, Zentrum für aktuelle Künste, Berlin 1999/2000, Podewil, Berlin (D)

Arbeiten im öffentlichen Raum:

„**Wasserfest**", 25 Meter-Lichtwand-Installation, Wettbewerbsarbeit, Oberösterreichische Landes-Nervenklinik Wagner-Jauregg, Linz 2002

Editionen:

„**Wasserfest Brosche**", Artikel Editionen

„**Wasserfest (1–75)**", Künstlerbrosche in Glycerinseife

Publikation:

„**Irene Andessner: Im Badehaus**", Folder, Hrsg. Werner Wolf, Museum der Wahrnehmung, Graz 1999

Öffentliche Sammlung:

„**Wasserfest**", Leuchtkasten, Volpinum, Wien

Wasserfest [water festival], 1999–2002

Self-portraits under water, without make-up or clothes. Face and body become blurred, expression and posture are distorted by the movement generated in the water. An enraptured perspective on the self-portrait. Artist and viewer separated by a basic element. The sense of optically broken perception is mutual.

Exhibitions:

"**Im Badehaus**," Museum der Wahrnehmung, Graz (A), 1999

"**Portrait–Détrait**," Transmediale, Podewil, Zentrum für aktuelle Künste, Berlin 1999/2000 Podewil, Berlin (D)

Works in Public Spaces:

"**Wasserfest**," 25-metre screen installation, competition work, Oberösterreichische Landes-Nervenklinik Wagner-Jauregg, Linz 2002

Editions:

"Wasserfest Brosche," Artikel Editionen

"Wasserfest (1–75)," artist broach in glycerine soap

Publication:

"**Irene Andessner: Im Badehaus**," folder, edited by Werner Wolf, Museum der Wahrnehmung, Graz 1999

Public Collection:

"**Wasserfest**," light box, Volpinum, Vienna

Milli Stubel-Orth – Irrlichter, 2000

Ludmilla Hildegard („Milli") Stubel (1852–1890) war Balletteuse an der Wiener Hofoper. Die Österreich-Chronik verzeichnet ihre lebenslange Beziehung zu Erzherzog Johann Salvator von Habsburg, der sich ab 1889 (nach seinem Gmundener Schloss) Johann Orth nannte und seine bürgerliche Milli ehelichte. Ab 1890, nach ihrer Schiffsreise um Kap Horn, galten beide als verschollen.

Unter dem Pseudonym Johann Traugott hatte Johann bereits 1883 das Ballett „Die Assassinen" geschrieben. In der Wiener Uraufführung agierte Milli Stubel von Kopf bis Fuß illuminiert mit Edisons neuen Glühlampen. Im Millenniumsjahr 2000 interpretiert die Künstlerin Irene Andessner dieses (nur schriftlich überlieferte) Szenarium der Milli Stubel an mehreren Schauplätzen – in Fotoproduktionen am Altausseer See und am Traunsee vor dem Schloss Orth sowie mit einer Performance in der (damals noch unrenovierten) Reithalle des Wiener MuseumsQuartiers Wien. Es entstehen großformatige Polaroids, Leuchtkästen, C-Prints und das Video „Irrlichter".

Ausstellungen:
„Elektrische Juwelen", Galerie Feichtner & Mizrahi, Wien 2000
„Milli Stubel-Orth", Galerie 422, Gmunden 2000
„Irrlichter", Galerie Beck + Priess, Berlin 2000

Editionen:
„Irrlichter", Feuerzeug, MuseumsQuartier Wien/Artikel Editionen
„Milli Stubel-Orth", Holzleuchtkasten, Artikel Editionen

Öffentliche Sammlungen:
„Irrlichter – Milli Stubel-Orth", 3 Motive/C-Prints 60 x 50 cm, Stadt Wien
„Irrlichter", 4 Polaroids, Volpinum, Wien

I.M. Dietrich, 2001

Für ein Artist-in-residence-Projekt des Podewil, Zentrum für aktuelle Künste Berlin, befasst sich Irene Andessner ein Jahr lang mit dem „Mythos Marlene" – den Marie Magdalene Dietrich (1901–1992) bereits im Alter von elf Jahren durch eigenmächtiges Zusammenziehen ihrer Vornamen namentlich begründet, dann strategisch aufgebaut, später als (weibliche) Waffe gegen Hitler-Deutschland eingesetzt hat. Das Rollenkonzept Andessners: schrittweise Verwandlung in eine Frau, die behauptet, „die Dietrich" zu sein – beobachtet von Fotografen und Kameraleuten. Performances und Produktionen in Wien, München, Köln, Berlin. In der Identifizierung geht Andessner über eine mentale Einstimmung, die körperliche Verwandlung und Darstellungen (z.B. Auftritte auf einer Kölner Travestiebühne) hinaus, heiratet am 24. Novemberg 2001 (nach Ausschreibung an 450 Berliner [„M sucht Dietrich"] und Casting aus 28 Bewerbern) Arnim Dietrich, um mit ihrem zweiten Vornamen Maria – die Arbeitsergebnisse mit „I.M. Dietrich" zu signieren – eine Signatur, die sich wie „I am Dietrich" aussprechen lässt.

Ihr Frack kommt aus dem Atelier von Marlene Dietrichs Lieblingsschneider Knize. Die Brautfotos (im Papier-Remake des Brautkleids aus „Flame Of New Orleans") schießt Gunter Sachs.

Milli Stubel-Orth – Irrlichter [will-o'-the-wisp], 2000

Ludmilla Hildegard ("Milli") Stubel (1852–1890) was a ballet dancer with the Vienna Hofoper. The Österreich-Chronik recorded her lifelong relationship with Archduke Johann Salvator von Habsburg, who from 1889 called himself Johann Orth (after his Gmundener castle) and wed the commoner Milli. After 1890, following their sea voyage to Cape Horn, both were regarded as missing.

In 1883, under the pseudonym Johann Traugott, Johann wrote the ballet "Die Assassinen" [The Assassins]. At the Vienna premiere Milli Stubel appeared on stage illuminated from head to foot by Edison's new light bulbs. In the millennium year 2000 Irene Andessner gave a dramatic interpretation of this Milli Stubel scenario (which has only been handed down in written form) in several theatrical venues: at the Altausseer See and the Traunsee (in front of the Schloss Orth) and in a performance in the Reithalle of the MuseumsQuartier Vienna (at that time still not renovated). Large-format Polaroids, light boxes and C-prints are available, as well as the video "Irrlichter."

Exhibitions:
"Elektrische Juwelen," Galerie Feichtner & Mizrahi, Vienna, 2000
"Milli Stubel-Orth," Galerie 422, Gmunden, 2000
"Irrlichter," Galerie Beck + Priess, Berlin, 2000

Editions:
"Irrlichter," lighter, MuseumsQuartier Wien/Artikel Editionen
"Milli Stubel-Orth," wooden light box, Artikel Editionen

Public Collections:
"Irrlichter – Milli Stubel-Orth," 3 motifs/C-prints 60 x 50 cm, Stadt Wien
"Irrlichter," 4 Polaroids, Volpinum, Vienna

I.M. Dietrich, 2001

For an artist-in-residence project at Podewil, Zentrum für aktuelle Künste Berlin, Irene Andessner immersed herself for a year in the "Myth of Marlene." Marie Magdalene Dietrich (1901–1992) had already firmly established this at the age of eleven, in particular through a high-handed contraction of her first names; she then strategically developed it, later using it as (feminine) weapon against Hitler's Germany. Andessner's role concept is a step-wise transformation into a woman who claims to be "the Dietrich" – watched by photographer and cameramen. Performances and productions in Vienna, Munich, Cologne, Berlin. In the identification Andessner went through a mental process of tuning in, going beyond bodily transformation and portrayals (such as appearances on a Cologne transvestite stage). She married Arnim Dietrich on 24 November 2001 (after writing to 450 Berlin men ["M sucht Dietrich" (M looks for Dietrich)] and casting from 28 applicants), in order to sign, using her second Christian name Maria, the resulting works with "I.M. Dietrich" – a signature which allowed her to say "I am Dietrich."

Her tails came from the workshop of Marlene Dietrich's favourite tailor, Knize. The wedding photos (in the paper re-make of the wedding dress from "Flame Of New Orleans") were shot by Gunter Sachs.

Porträts nach Sternberg-Fotografien macht Alex Majewski. Unter den Künstlern, die das bildnerische Ergebnis der Werkgruppe mit definieren, finden sich Matthias Herrmann, Kiddy Citny, Wolf D. Wolf. Damit entfernt sich die „Selbstporträtkünstlerin" Andessner nicht nur vom eigenen Aussehen, sondern auch vom herkömmlichen Autorenbegriff.

Ausstellung:
„I.M. Dietrich", Ausstellung im Gotischen Saal des Viktoria Quartiers, Berlin, Courtesy Galerie Bernhard Knaus, Mannheim, 2001
„I.M.Dietrich-Zimmer", Hotel Chelsea, Köln, 2001 ff

Edition:
„I.M. Dietrich/Rückläufer", „M sucht Dietrich" Kartenversand-Rückläufer, Artikel Editionen, Berlin 2001
„I.M. Dietrich"/„I am Andessner", Foto/Multiple-Edition mit Katalogbuch „I am Andessner", Hatje Cantz Verlag, Ostfildern-Ruit 2003

Wanda SM, 2003

Für Graz 2003 Kulturhauptstadt Europas rückt Irene Andessner die erste Ehefrau Sacher-Masochs ins Blickfeld: Wanda von Sacher-Masoch, geborene Angelica Aurora Rümelin (1845–vermutl. 1908), verkörperte für ihren Mann die grausame Wanda aus dessen Roman „Venus im Pelz". In der dramaturgischen Gestaltung der Figur folgt Andessner Wanda von Sacher-Masochs „Lebensbeichte" (1906), der Replik des Sacher-Masoch-Sekretärs Carl Felix von Schlichtegroll („Wanda ohne Maske und Pelz", 1906) sowie den Tagebüchern und Briefen der Sacher-Masochs.

Ihre Videoinstallation im Dom im Berg (einer 560 qm großen Kuppelhalle) hat Irene Andessner mit mehreren Performances vorbereitet. Als Locations dienten unter anderem die Unterbühne des Wiener Raimundtheaters, die Schaufenster eines Brautmodengeschäftes, der Tizian-Saal des Kunsthistorischen Museums Wien, eine Eishockeyhalle. Es entstanden die Szenenblöcke „Der Vertrag", „Das Idealbild", „Die Rolle", „Die Macht", die über vier Videobeamer synchron und rhythmisch wechselnd auf vier Wände projiziert werden. Auf der fünften Wand, die aus 64 Monitoren besteht, ist der polnische Maler Piotr Dluzniewski via Webcam in der Rolle des Gregor zu beobachten, während er im ehemaligen Verlies im Glockenturm des Schlossbergs Fetischzeichnungen im Auftrag seiner „Herrin" Andessner macht.

Ausstellung:
„Wanda SM", Videoinstallation mit Interaktion: Dom im Berg, Graz 2003
„Wanda Sacher-Masoch-Zimmer", Rauminszenierung mit „Wanda SM"-Motiven im Hotel Erzherzog Johann, Graz 2003 ff

Editionen:
„Meine Lebensbeichte", Wanda Sacher-Masoch, Künstlerbuchedition mit Bildmaterial aus Irene Andessners „Wanda-SM"-Produktion und einem Dossier, Belleville Verlag, München 2003
„Wanda Sacher-Masoch-Torte", Torte, ausgestattet mit einem Wanda/Andessner-Porträtbild, Café Hotel Erzherzog Johann, Graz 2003 ff

Alex Majewski took portraits based on Sternberg photographs. Among the artists who together defined the pictorial outcome of the working group were Matthias Herrmann, Kiddy Citny and Wolf D. Wolf. Thus Andessner the "self-portrait artist" departed not only from her own appearance, but also from conventional concepts of authorship.

Exhibitions:
"I.M. Dietrich," exhibition in the Gotischen Saal of the Viktoria Quartier, Berlin, courtesy Galerie Bernhard Knaus, Mannheim, 2001
"I.M.Dietrich-Zimmer," Hotel Chelsea, Cologne, 2001 ff

Editions:
"I.M. Dietrich/Rückläufer," "M sucht Dietrich" card dispatch-return, Artikel Editionen, Berlin 2001
"I.M. Dietrich"/"I am Andessner," photo/multiple edition with catalogue-book "I am Andessner," Hatje Cantz Verlag, Ostfildern-Ruit 2003

Wanda SM, 2003

For Graz, 2003 Cultural Capital of Europe, Irene Andessner brought the first wife of Sacher-Masoch to centre stage: Wanda von Sacher-Masoch, born Angelica Aurora Rümelin (1845 – prob. 1908), embodied for her husband the cruel Wanda from his novel "Venus im Pelz" [Venus in furs]. In the dramatic shaping of the figure Andessner follows Wanda from Sacher-Masoch's "Lebensbeichte" [confessions] (1906), the reply of Sacher-Masoch's secretary Carl Felix von Schlichtegroll ("Wanda ohne Maske und Pelz" [Wanda without make-up and furs], 1906), as well as the diaries and letters of Sacher-Masoch.

Irene Andessner prepared her video installation in the Dom im Berg (a 560-square-metre domed hall) with various performances. Locations included below stage at the Raimundtheater in Vienna, the display window of a wedding attire shop, the Titian Room of the Kunsthistorisches Museum in Vienna and an ice hockey arena. It comprises the scenes "Der Vertrag," "Das Idealbild," "Die Rolle," "Die Macht" [the contract, the ideal image, the role, the power], which are simultaneously projected, changing in rhythm, via four video projectors onto four walls. On the fifth wall, consisting of 64 monitors, the Polish painter Piotr Dluzniewski can be seen via webcam in the role of Gregor, while he creates fetish drawings in the former dungeon of the Schlossberg bell tower at the instigation of his "mistress" Andessner.

Exhibitions:
"Wanda SM," interactive video installation: Dom im Berg, Graz 2003
"Wanda Sacher-Masoch-Zimmer," room staging with "Wanda SM" motifs in the Hotel Archduke Johann, Graz 2003 ff

Editions:
"Meine Lebensbeichte," Wanda Sacher-Masoch, artist book edition with pictorial material from Irene Andessner's "Wanda SM" production and a dossier, Belleville Verlag, Munich, 2003
"Wanda Sacher-Masoch-Torte," cake, decorated with a Wanda/Andessner portrait image, Café Hotel Erzherzog Johann, Graz 2003 ff

Donne Illustri, 2003

Caffè Florian am Markusplatz in Venedig: Im „Saal der berühmten Männer" (Sala degli Uomini Illustri) hängen zehn Ölgemälde von Giulio Carlini (1826–1887). Dessen postum gemalte Porträts der berühmten Venezianer – von Marco Polo über Tizian bis Goldoni – konfrontiert Irene Andessner mit zehn Venezianerinnen, darunter der Stadt berühmteste Komponistin (Barbara Strozzi), Malerin (Rosalba Carriera) und teuerste Kurtisane (Veronica Franco) sowie die erste Doktorin (Elena Lucrezia Cornaro Piscopia) und die erste Frauenrechtlerin der Welt (Moderata Fonte). Mit dieser Intervention verwandelt sich die Sala degli Uomini Illustri in die Sala delle Donne Illustri (Salon der berühmten Frauen). Eine vexierbildartige Irritation: Von Maske, Garderobe, Licht, Dekoration und Bildausschnitt abgesehen, weichen Andessners Darstellungen von den historischen Bildreferenzen der zehn Frauenfiguren ab: Sie hat nicht die Haltung und Blicke der Frauen, sondern der Männer aus den zu überhängenden Porträts nachvollzogen. Damit ist das Selbstverständnis, die Präpotenz, der männlichen Pendants gebrochen.

Ein weiterer Raum, Saletta Liberty, erhält einen Leuchtkasten mit einem Fonte/Andessner-Ganzkörper-Fotoporträt und einem „Fonte"-Porträt in Öl auf Leinwand, für das Andessner im Atelier von Marinella Biscaro Modell gesessen hat.

„7 Gentildonne": Im Vorfeld der Ausstellung beruft Andessner im Herrensalon des Caffè Florian ein Treffen von sieben Italienerinnen ein – inspiriert von Moderata Fontes Streitgespräch im Roman „Verdienst der Frauen", dokumentiert als Videoarbeit. In der Fotoproduktion für das Venedig-Projekt entstehen zusätzlich Ganzkörper-Porträts, die die historisierenden (in der Rauminstallation nur in ovalen Büsten-Ausschnitten sichtbaren) Frauendarstellungen mittels Styling vollends in unsere Gegenwart transponieren. In diesen Bildern ist auch zu sehen, dass die Künstlerin den Kameraauslöser in der Hand hält, also – im Gegensatz zu früheren Produktionen – selbst das Bild auslöst, und zwar genau in dem Moment, in dem sie sich der jeweiligen Rolle innerlich so gewachsen fühlt, dass sie sich sicher ist, die Persönlichkeit der jeweiligen Vorbild-Frau perfekt zum Ausdruck zu bringen. Diese Arbeitsweise entspricht den historischen Venezianerinnen, die ihre Profession ebenfalls selbstbestimmt und selbstständig, unabhängig von Männern, entwickelt und gelebt haben. Die Ganzkörper-Selbstporträts sind als Leuchtkästen ausgeführt.

Das Projekt „Donne Illustri" findet, kuratiert von Stefano Stipitivich, im Rahmen des Kunstprogrammes des Caffè Florian statt. In der vor 15 Jahren von der Caféhausbesitzerin und Kunstsammlerin Daniela Gaddo Vedaldi gestarteten Ausstellungsreihe waren bisher Künstler wie Mimmo Rotella (1990), Fabrizio Plessi (1993 und 2001) und Luca Buvoli (1997) vertreten.

Ausstellungen/Performances:
„**Donne Illustri",** Streitgespräch-Inszenierung mit Videodokumentation, Venedig 2003
„**Sala delle Donne Illustri",** und „**Saletta di Moderata Fonte"**Rauminstallation im Caffè Florian, Venedig, 2003 (zur Biennale di Venezia)
„**I am Andessner",** Retrospektive im Stadthaus Ulm, 2003

Publikation:
„**Irene Andessner – Donne Illustri",** Katalog, Hrsg. Daniela Gaddo Vedaldi, Kunstprogramm Caffè Florian, Venedig 2003

Peter Fabian, April 2003

Donne Illustri, 2003

Caffè Florian on St Mark's Square in Venice: in the "Sala degli Uomini Illustri" (salon of famous men) hang ten oil paintings by Giulio Carlini (1826–1887). Irene Andessner confronts these posthumously painted portraits of famous Venetians – ranging from Marco Polo to Titian to Goldoni – with ten Venetian women, among them the city's most famous composer (Barbara Strozzi) and painter (Rosalba Carriera) and the most expensive courtesan (Veronica Franco), as well as the first female doctor (Elena Lucrezia Cornaro Piscopia) and the world's first female lawyer (Moderata Fonte). Through this intervention the Sala degli Uomini Illustri is transformed into the Sala delle Donne Illustri (salon of famous women). A picture puzzle-like disturbance: disregarding make-up, wardrobe, light, decoration and pictorial detail, Andessner's portrayals differ from the historical picture references of the ten female figures in that she has not copied the bearing and look of the women, but rather of the men from the portraits hanging above. Thus the self-perception, the prepotency of the male counterparts is broken.

A further room, the Saletta Liberty, is turned into the "Moderata Fonte Room" with a Fonte/Andessner photographic full-length self-portrait in a light box. Opposite this portrait Andessner places a "Fonte" portrait painted in oil on canvas, for which she sat as model in the workshop of Marinella Biscaro.

"7 Gentildonne": as a preliminary to the exhibition Andessner convened a meeting of seven Italians in the Caffè Florian men's salon – inspired by Moderata Fonte's debate in the novel "Verdienst der Frauen" [merit of women], documented as a video work. In the photo production for the Venice project there are additional full-length portraits, which transpose into our time the historicised portrayals of women (only visible in oval bust details in the room installation) by means of complete styling. In these images it can also be seen that the artist has the camera shutter release in her hand; which means – in contrast to earlier productions – she releases the image herself in just that moment when she herself inwardly feels the particular role so fully that she is sure she is bringing the personality of that model woman perfectly to expression. This way of working corresponds to the historical Venetian women, who likewise developed and lived out their professions self-determined and self-employed, independent of men. The full-length self-portraits are executed as light boxes. The "Donne Illustri" project, curated by Stefano Stipitivich, is part of the Art Programme of Caffè Florian. Started over 15 years ago by the café owner and art collector Daniela Gaddo Vedaldi, the series of exhibitions has so far presented artists such as Mimmo Rotella (1990), Fabrizio Plessi (1993 and 2001) and Luca Buvoli (1997).

Exhibitions/Performances:
"**Donne Illustri,"** staged debate with video documentation, Venice, 2003
"**Sala delle Donne Illustri"** and "**Moderata Fonte Room,"** room installation in the Caffè Florian, Venice, 2003 (for the Venice Biennale)
"**I am Andessner,"** solo exhibition at Stadthaus Ulm (Germany), 2003

Publication:
"**Irene Andessner – Donne Illustri,"** catalogue, edited by Daniela Gaddo Vedaldi, art programme Caffè Florian, Venice, 2003

Peter Fabian, April 2003

Fotografie/Photography

Wasserfest
S. 13/14/15/16/17: **Alex Majewski**

Cyberface
S. 19/21/23: **Alex Majewski**

Vorbilder
S. 33/36/37: **Alex Majewski**, S. 41: **Rainer Schmidt**

Barbara Blomberg
S. 43: **Alex Majewski**

Frauen zu Salzburg
S. 45/48/49/52/53/56/57/60/61/64/65: **Alex Majewski**

Irrlichter
S. 67: **Jolly Lang**, S. 68/69/70/71/72/73/74/75/76/77/78/79/80/81: **Alex Majewski**

I.M. Dietrich
S. 85/92/93/95/101: **Alex Majewski**

Wanda SM
S. 108/109/110/111: **Alex Majewski**, S. 112/113: **Udo Otto**, S. 114: **Thomas Wirthensohn** S. 116/117/119: **Studio Trizeps / Josef Fallnhauser, Michael Langoth**

Donne Illustri
S. 121/122/123/124: **Peter Kubelka**, 125/126/127/128/129/130/131/132/133/134/135/136/137138/139/140: **Dieter Brasch**

Die schöne Ulmerin
S. 143/147: **Dieter Brasch**

Video-Kamera/Videocamera:

Cyberface
S. 20/22/24/25: **Hraban Pörtner**

Vorbilder
S. 27/28/29/30/31: **Robbi de Decker**

Frauen zu Salzburg
S. 47/51/55/59/63: **Norbert Aistleitner**

Irrlichter
S. 82/83: **Oliver Petro, Ralf Rabenstein**

I.M. Dietrich
S. 96/97/98/99/100: **Clemens Berndorfer, Werner Berndorfer, Marion Bierling, Carrotti, Kiddy Citny, Christa Filser, Mark Hennicke, Alex Majewski, Wolf D. Wolf**

Wanda SM
S. 103/104/110/115/118: **Irmin Kerck, Oliver Kunz**, S. 118: **Peter Putz**

Mit freundlicher Unterstützung von/With kind support from:

FRITZ&MACZIOL : INFOMA®
Software, Systeme und Dienstleistungen

SchwabenCard
Die Vorteilskarte!

T · ·Mobile·

vienna**paint**

BUNDY
BUNDY

TOSTMANN
TRACHTEN

Collection of contemporary art, Vienna

Dank an/Acknowledgments:

Cäcilia Andessner
Olli Aigner
Gabriele Albert-Wurst
All About Eve
Backhausen GmbH
Michael Bartsch
Constantin de Beauclair
Belleville Verlag
Make up For Ever
Peter Baum
Mirva Bertan
Ingrid Bierling
Marinella Biscaro
Blauer Engel Berlin
Borislav Bojkov
Günther Broda
Wolfgang Denk
Arnim Dietrich
Herbert Distl
Evelyne Dörtbudak-Kneissl
Orhun Dörtbudak
Franck-Christian Dolboise
Ina Drewes
Jürgen Drewes
Otto Droegsler
Jörg Ehrlich
Er-Ich/Erich Joham
Patricia Essl
Falke Salzburg
Fogal AG
Severin Frey
Willi Geloneck
Die Mietbar
Georg Geyer
Graz 2003, Kulturhauptstadt Europas
Guerlain
Helene Habacher
Ingo Hanghofer
Hemden Herzog Gino Venturini, Wien
Matthias Herrmann
Martina Hölzl
Wilhelm Holzbauer
Hotel Chelsea, Köln/Werner Peters
Hotel Erzherzog Johann, Graz
Jutta Itzinger
Jan Jansen
Matz Jiszda
Karglmayer KG
Knips Fotofachhandel
Knize & Comp. C.M. Frank
Kunsthalle Wien
Kunsthistorisches Museum Wien
Nikolaus Lehner
Willibald Maierhofer
Marlene Dietrich Collection, Berlin
Die Maske Köln/Bernd Bauer
Christian Minichshofer

Franz Morgenbesser
Christina Murer
MuseumsQuartier Wien
Ute Neuber
Robert Niederle
Michal Nocón
Jozefa Pabis
C.O. Paeffgen
Paptex/Stefan Grabher
Johannes Patzak
Rotraud A. Perner
Tom Pohanka
Polaroid Europe
Franz Pomassl
Peter Putz
Helga Rabl-Stadler
Ludwig Reiter
Resmann Couture Salzburg
Stefan Rothleitner
Hanni u. Otto Patronski
Gunter Sachs
Silvia Scardocci
Schau Schau Brillen Wien
Josef Schinkowitsch
Hans Schmid
Anton Schmölzer
Schullin Juweliere Graz
Juwelier Schullin Wien
Udo Schuster
Jutta Skokan
Slach Bildtechnik
Karin Slama / Tostmann Trachten
Regina Sloterdijk-Haslinger
Ingrid Spörk
Stefano Stipitivich
Oliver Stoth
Ernst Stromberger
Erika Swarovski
Melanie Swarovski
Lutz Teutloff Collection
Hotel Timp Künstlerklause Köln
Norbert Tischler
Bjoern Friedrich
Hotel Urania/Herbert Rausch
Café Urania Wien
Vidicon
Sabine Weichel
Andreas Westermeyer
Wienweb
Günther Wimmer
Wolford AG
Wolf Wondratschek
Michael Wüst
Schuhaus Wunderl Sollenau
Alfred Zellinger
Myriam Zerbi
Sylvia Zolly-Dauer

Diese Publikation erscheint anlässlich der Ausstellung
This book is published in conjunction with the exhibition
"I am Irene Andessner"
Stadthaus Ulm
06.07. – 31.08. 2003

Herausgeber/Editor:
Stadthaus Ulm/Dr. Raimund Kast

Redaktion/Editing:
Peter Fabian

Übersetzung/Translation (Deutsch–Englisch)/(German–English):
Anthony Hills, Alan Rettedal

Grafische Gestaltung, Herstellung und Satz/Graphic design, layout and typesetting:
Florian Rutter

Gesamtherstellung/Printed by:
Dr. Cantz'sche Druckerei, Ostfildern-Ruit

Umschlagabbildungen/Cover illustrations:
Irene Andessner, "Irrlichter"/"Cyberface"
Fotografie/Photography:
Alex Majewski
Irene Andessner, "Donne Illustri"
Fotografie/Photography:
Dieter Brasch

Es erscheinen zwei unterschiedliche, jeweils signierte und nummerierte
Vorzugsausgaben. Nähere Infomationen erhalten Sie direkt beim Verlag
unter 07 11/4 40 51 35.
Two different signed and numbered collector's editions are available.
For more information please call 00 49/7 11/4 40 51 35.

Erschienen im/Published by
Hatje Cantz Verlag
Senefelderstraße 12
73760 Ostfildern-Ruit, Deutschland/Germany
Tel. 00 49/7 11/4 40 50
Fax 00 49/7 11/4 40 52 20
www.hatjecantz.de

Distribution in the US
D.A.P., Distributed Art Publishers, Inc.
155 Avenue of the Americas, Second Floor
New York, N.Y. 10013-1507, USA
Tel. +1/212/627 1999
Fax +1/212/627 9484

ISBN 3-7757-1287-9
Printed in Germany

Stadthaus Ulm
Münsterplatz 50
89073 Ulm

Leitung/Director:
Dr. Joachim Gerner

Ausstellung/Exhibition:

Projektleitung/Project management:
Dr. Raimund Kast

Organisation/Organization:
Karla Nieraad, Dr. Sabine Presuhn

Öffentlichkeitsarbeit/Public relations:
Anja Göbel

Technik/Set up:
Paul Stauber, Joachim Fischl, Franz Nägele

Sekretariat/Secretary:
Sabine Schwarz

Verwaltung/Administration:
Lieselotte Thurner, Renate Siehler